FERTILE
FORTUNE

To Mary, with love

First published in Great Britain in 2003

This edition published in Great Britain by
National Trust Books 2006

ISBN-13: 978 1 90540040 9
ISBN-10: 1 90540040 3

A CIP catalogue record for this book is available from the British Library.

10 9 8 7 6 5 4 3 2 1

Illustrations reproduced by permission of the copyright holders listed on page 183.

Designed and managed for the National Trust by Brookes Forty
Consultant project manager: Paul Forty
Designed and typeset in Garamond by Amanda Brookes
Copy-editor: Kate Quarry
Proofreader: Sue Phillpott
Indexer: Diana LeCore
Printed and bound by Artes Gráficas Toledo, Spain

Illustrations
Right (page 5): A stained-glass pattern in the Chapel.
Page 6: The garden door from the veranda.
Page 8: Tyntesfield from the Lower Park, 1902, showing the Conservatory.
Pages 10 & 11: The West Front of Tyntesfield

Contents

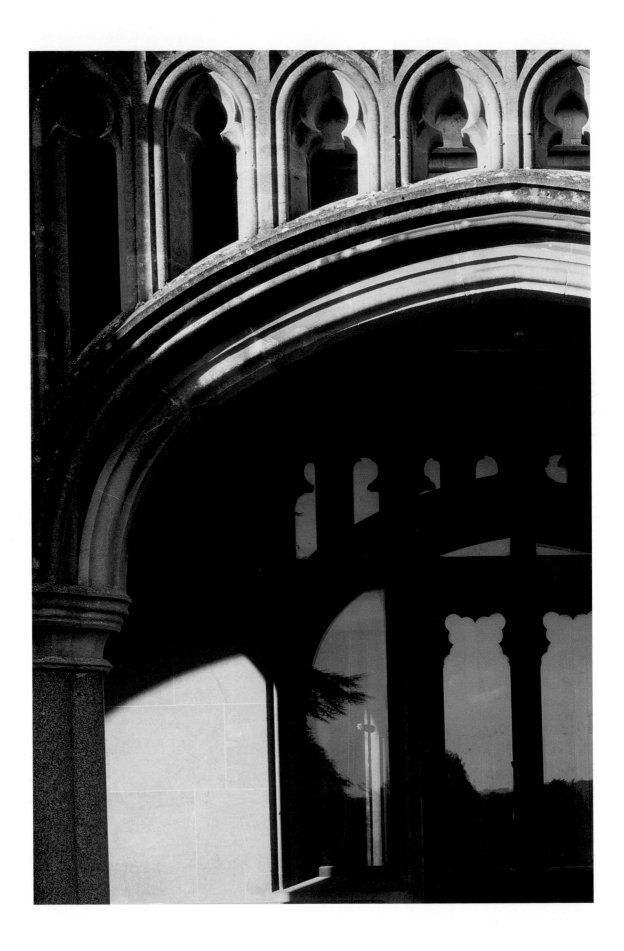

Foreword

Tyntesfield is a truly remarkable property, not only for its architectural and historical interest, but also for the unusual and dramatic way in which it was acquired by the National Trust. The house and its contents unexpectedly came on the market in 2002, and in my memory there are three things from that time that seemed to unite the Trust, the National Heritage Memorial Fund and, most exceptionally, an extraordinary 70,000 individual donors in our campaign to save them from being sold and dispersed.

First was the historic importance of this remarkable house, estate and buildings – as well as virtually all the clutter of four generations.

Second was the sense of discovery – and a compelling need to share this with our many supporters. Their enthusiasm to see the house just as it came to us was irresistible. So we opened to our first visitors only six weeks after taking possession. Tens of thousands of people have already had their first glimpse, expertly looked after and guided by our marvellous volunteers. Through a radical new approach, we plan to share with visitors as much of the process of conservation and development as possible, even if half the library is shrouded for repairs, pictures are propped against walls or the staff are found having lunch in the kitchen.

Third, and even more exciting, was the opportunity for Tyntesfield to enrich the lives of people of all ages, abilities and backgrounds. We see every aspect of the development and operation of the estate being geared around opportunity. Conservators and builders will be working with students, apprentices and local young people to train them while they work here, gaining recognised skills to reach their potential. At Tyntesfield we are already working in partnership with other organisations to bring people back into the workplace after a break or a breakdown, and with colleges to help people gain relevant experience, whether by working in our offices or by serving visitors.

It is an extraordinary place with an extraordinary vision, and one which, thanks to so many people's support, is already beginning to be realised.

I would like to thank everyone who contributed to the campaign to save Tyntesfield, and the thousands of people who are still contributing to the project. Our work has only just begun, though, and funds are still urgently needed. Proceeds from this book will contribute to the Tyntesfield fund, and I am sure that reading this wonderful story and seeing the house through these pages will inspire you as a reader, just as the house itself has already inspired so many others.

Fiona Reynolds
Director-General, National Trust

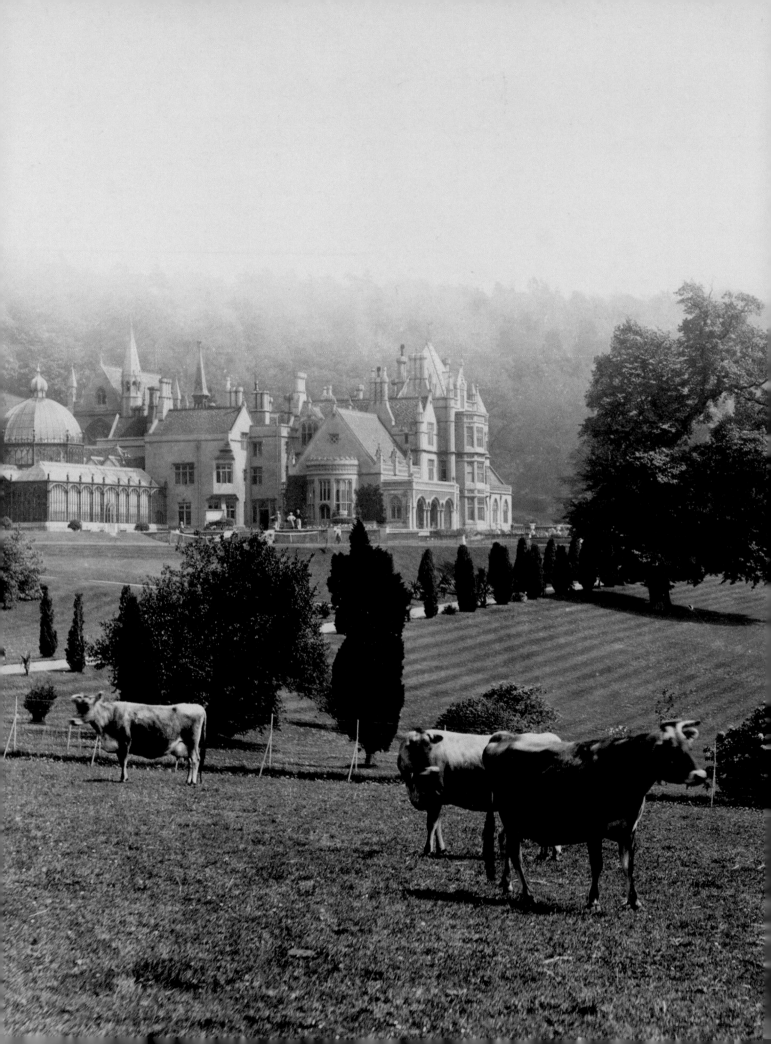

The Gibbs Family

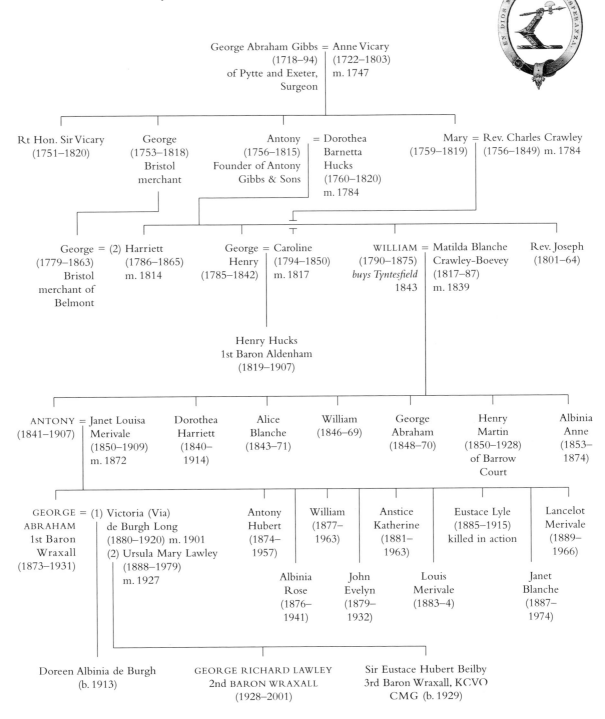

George Abraham Gibbs = Anne Vicary
(1718–94) (1722–1803)
of Pytte and Exeter, m. 1747
Surgeon

Rt Hon. Sir Vicary George Antony = Dorothea Mary = Rev. Charles Crawley
(1751–1820) (1753–1818) (1756–1815) Barnetta (1759–1819) (1756–1849) m. 1784
 Bristol Founder of Antony Hucks
 merchant Gibbs & Sons (1760–1820)
 m. 1784

George = (2) Harriett George = Caroline WILLIAM = Matilda Blanche Rev. Joseph
(1779–1863) (1786–1865) Henry (1794–1850) (1790–1875) Crawley-Boevey (1801–64)
Bristol m. 1814 (1785–1842) m. 1817 *buys Tyntesfield* (1817–87)
merchant of 1843 m. 1839
Belmont

Henry Hucks
1st Baron Aldenham
(1819–1907)

ANTONY = Janet Louisa Dorothea Alice William George Henry Albinia
(1841–1907) Merivale Harriett Blanche (1846–69) Abraham Martin Anne
 (1850–1909) (1840– (1843–71) (1848–70) (1850–1928) (1853–
 m. 1872 1914) of Barrow 1874)
 Court

GEORGE = (1) Victoria (Via) Antony William Anstice Eustace Lyle Lancelot
ABRAHAM de Burgh Long Hubert (1877– Katherine (1885–1915) Merivale
1st Baron (1880–1920) m. 1901 (1874– 1963) (1881– killed in action (1889–
Wraxall (2) Ursula Mary Lawley 1957) 1963) 1966)
(1873–1931) (1888–1979)
 m. 1927 Albinia John Louis Janet
 Rose Evelyn Merivale Blanche
 (1876– (1879– (1883–4) (1887–
 1941) 1932) 1974)

Doreen Albinia de Burgh GEORGE RICHARD LAWLEY Sir Eustace Hubert Beilby
(b. 1913) 2nd BARON WRAXALL 3rd Baron Wraxall, KCVO
 (1928–2001) CMG (b. 1929)

Owners of Tyntesfield in CAPITALS

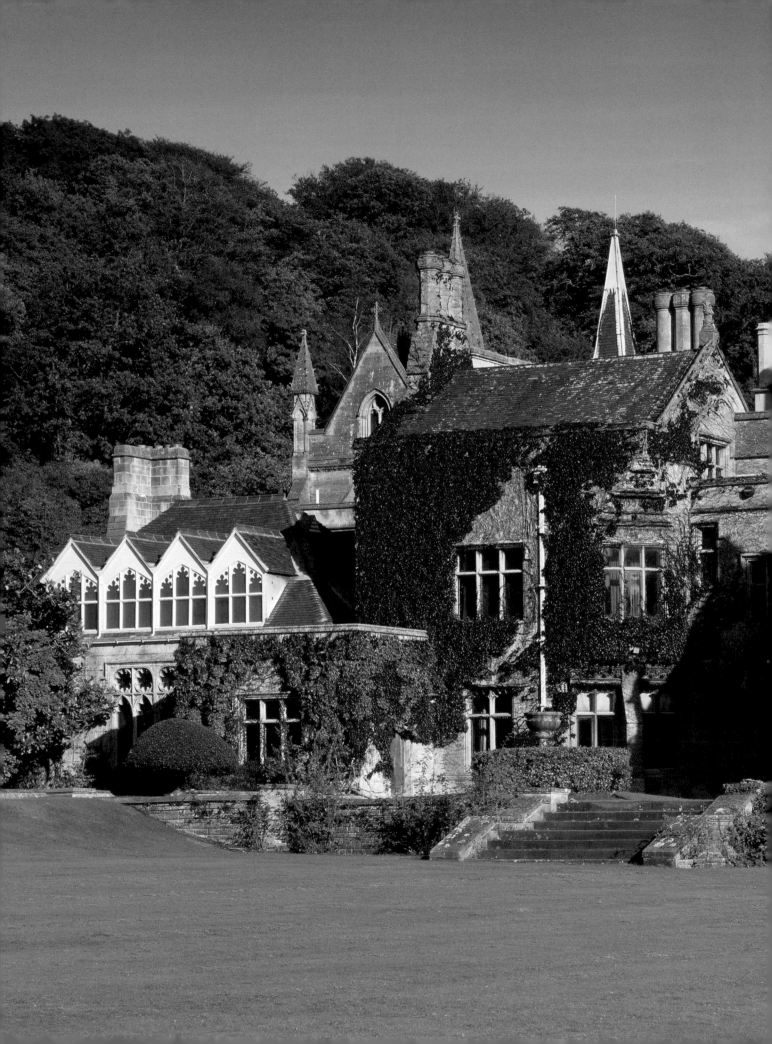

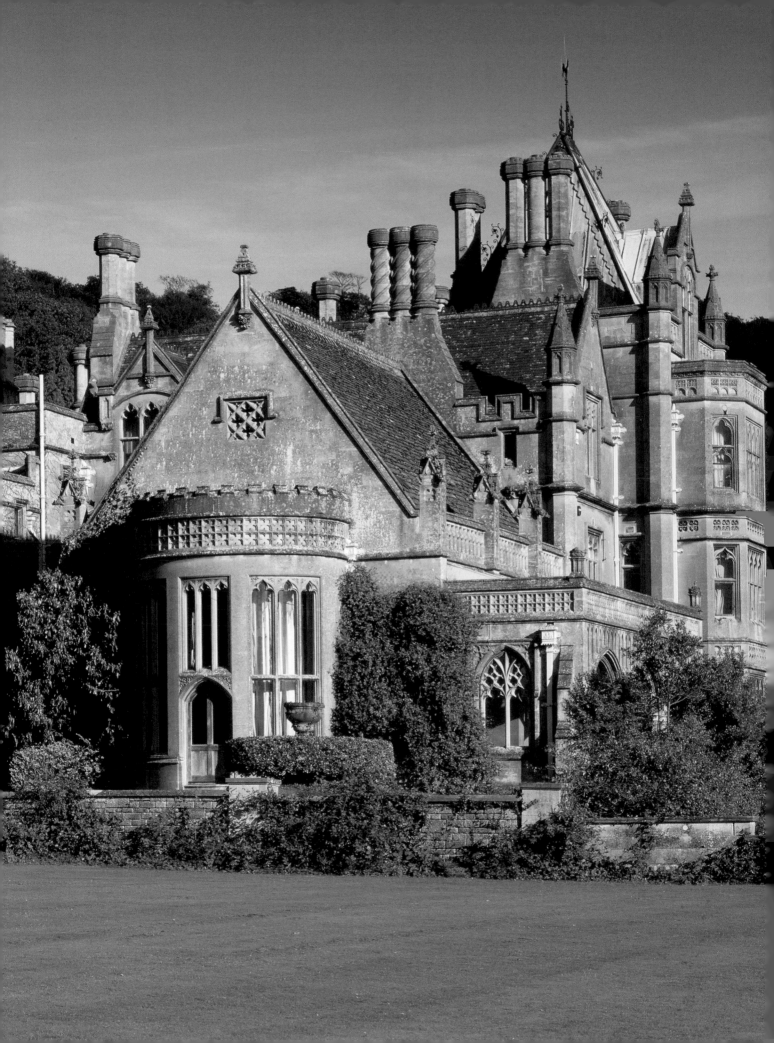

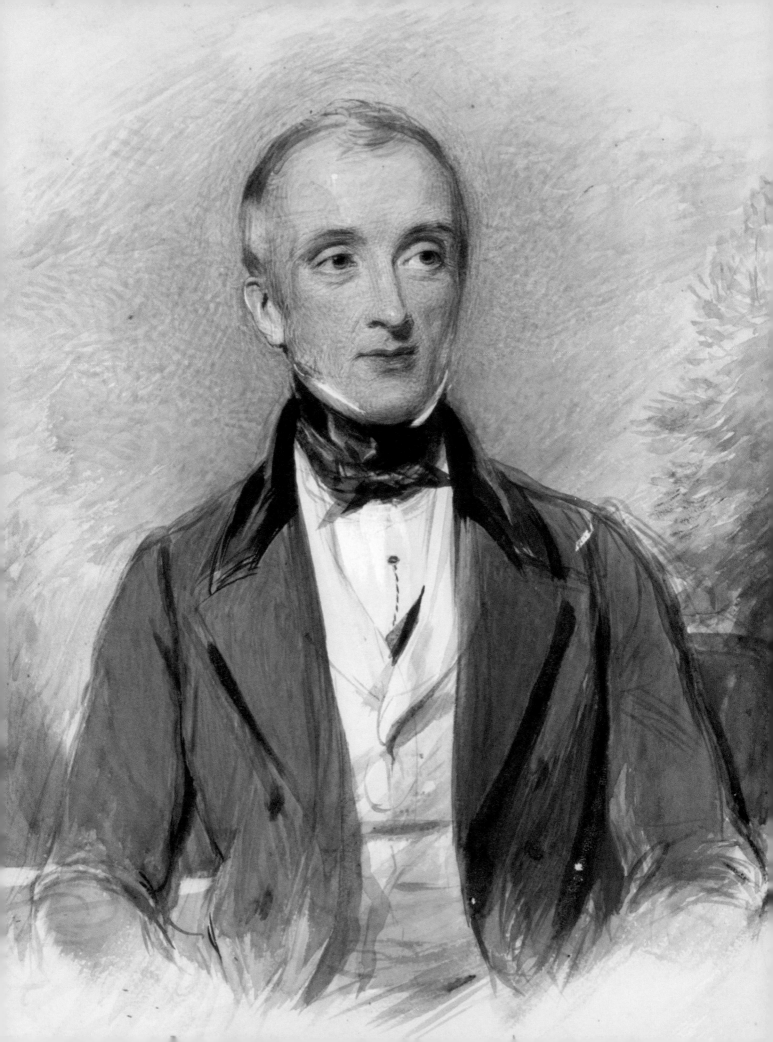

An Unlikely Undertaking

I t was all very unlikely. In 1837, when Queen Victoria ascended the throne, William Gibbs was already 47, a well-respected but not unduly prosperous businessman. He was firmly based in London and, seemingly, a confirmed bachelor. His habits were businesslike, regular and metropolitan, save for occasional excursions to the Continent. He rose early and, having breakfasted, would leave his brother's house – 11 Bedford Square, where he lived – and go to the offices of Antony Gibbs & Sons in the City. His nephew John Lomax Gibbs recorded this early family life: 'I can remember my father reading prayers in the dining room before breakfast. I remember too his rat-at-tat-tat on the knocker at the front door when he returned from the City in the late afternoon and I can see him and Uncle William . . . driving off to his compting house in the newly invented Hansom Cab.'[1] It was a quiet, dignified life not likely to be interrupted by daydreams of a country estate. Yet William's circumstances changed so radically that within six years he was married with a growing family. He had become the sole owner of the family business and that business was suddenly, to everybody's surprise, including his own, one of the most prosperous in the kingdom. And in that year, 1843, he acquired Tyntes Place in Somerset, west of Bristol, where he was to create Tyntesfield, one of the greatest Gothic houses ever built in England.

It was all very unlikely for a further reason. In 1790, the year of William Gibbs's birth, there was no large house and estate of Tyntesfield. Certainly, a small house nestled on the hillside above the village of Wraxall, but this was no gentleman's residence. Its only claim to interest was the natural beauty of its position: sheltered by the wooded hillside above, looking over the beautiful verdant vale of Nailsea below, with the River Land Yeo meandering along its floor. This small house, dating back to the seventeenth century, was originally part of the adjacent Manor of Wraxall, which had belonged

Above: Tyntes Place, the residence of the Reverend Mr Seymour, 1836.

Left: William Gibbs by George Richmond, RA, 1845.

A view of Tyntesfield from the park, showing the house before John Norton's remodelling, and the early terrace gardens, *c.*1850.

to the Gorges family since the reign of Henry III. In 1813, George Penrose Seymour, who lived further along the same escarpment at Belmont, bought the house for his eldest son, the Reverend George Turner Seymour. He and his wife Marianne Billingshurst built a new house here that they named Tyntes Place, after the Tyntes family who had lived near Wraxall in the sixteenth century.

The original architect for their charming house is unknown, though subsequent improvements and additions were made by Robert Newton of nearby Nailsea. It provided sufficient space for the rapidly growing Seymour family of five sons and four daughters. The style was picturesque Elizabethan, in contrast to the severe classical form of Belmont. A sepia drawing, dated 1836, shows the first house before Newton's additions, without towers on the west front, no bay windows to the Drawing Room, and no terraced gardens. Fortunately, two

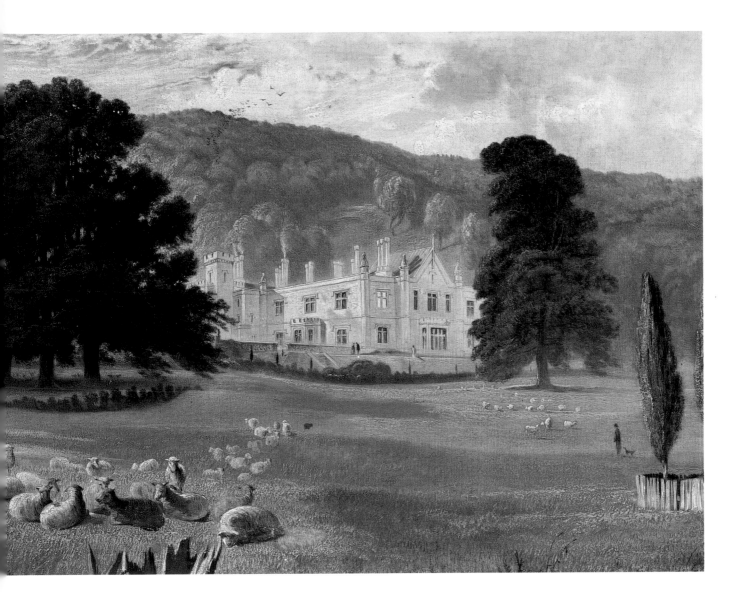

further watercolours survive to show the outlines of the house twenty years later. The entrance front, as now, faced the drive from Belmont, with a centrally placed entrance tower with two-storeyed elevations on either side. The service wing was at the back, jutting into the hillside. The south front rose to a two-storeyed gabled centrepiece, with two bay windows taking in the panoramic view across the valley. The building may well have been stuccoed, with cast Gothic decorative details, including ogee pinnacles that look like pawns on a chessboard, peppering the skyline.

A sense of Tyntes Place can still be caught at Tyntesfield today, embedded in the later house. At the back, the Butler's Pantry with the corridor and small bathrooms above date from the seventeenth-century house. The three central rooms at the front of the house, on all floors, date from the Reverend Seymour's house and largely retain their

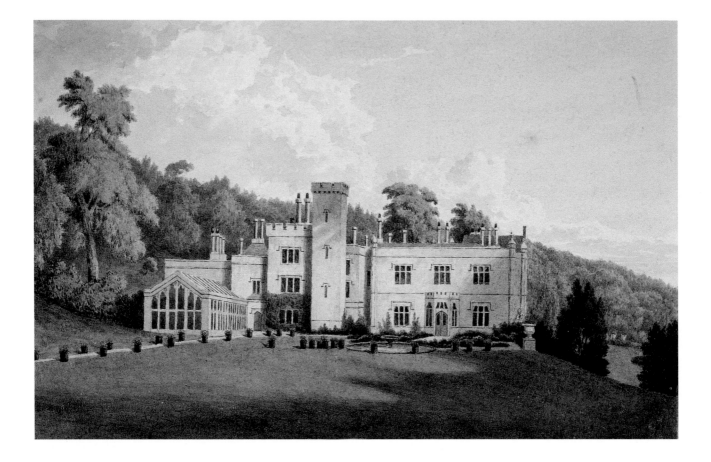

Tyntesfield from the west; a watercolour from Matilda Blanche Gibbs's album, *c.*1845.

original early nineteenth-century character. On the ground floor, the Oak Study, Morning Room and Ante-room were his original reception rooms. In the Oak Study even his fine grey marble fireplace survives. It is, however, in the Stuart Bedroom on the first floor that one gets the clearest sense of Seymour's rooms, which were remarkably plain with simple mouldings and cornices, and panelled doors. This restraint, a word that will seldom be used again to describe the interiors, is matched by the simple white marble fire surround in the Gothic style.

For nearly twenty years the Seymour family lived peaceably at Tyntes Place, a peace shattered by the deaths of two of their sons. In 1842, however, the Reverend and Mrs Seymour decided to move to the Isle of Wight, buying a house named Farringford, near Freshwater Bay. This would in turn become famous when sold a decade later to the Poet Laureate, Alfred, Lord Tennyson. The future of Tyntes Place was again determined by the residents of Belmont. In 1828 (on the death of the Reverend Seymour's father) the house had been leased to George Gibbs of Bristol and his wife Harriett, sister of William Gibbs. William, the London businessman who was to buy Tyntes Place, particularly enjoyed walking in the woods along the hillside, where he would have presumably encountered the strange sight of poems

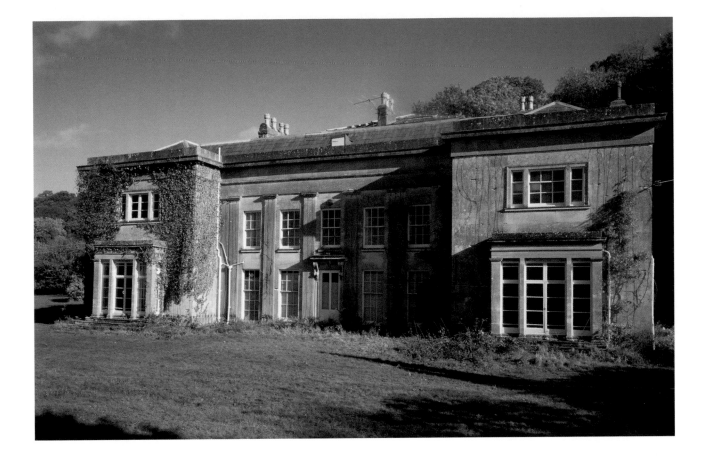

Belmont, the seat of Mr Seymour and later the home of George Gibbs and his wife Harriett.

inscribed on boards attached to the trees. These were the outpourings of the bluestocking poetess Hannah More, who had been wooed by Seymour's paternal uncle, Mr Turner of Belmont. In the same woods William and his cousins rehearsed madrigals, and he had certainly grown to love the place, surrounded by his sister and cousins, but had not considered buying a country estate of his own.

However, just at the time the Seymours were thinking of selling, William's life had altered almost beyond recognition. He had grown exceedingly rich and was getting richer by the year; he had also made the happiest of marriages, and by 1843 had a growing family of three children. The purchase of Tyntes Place would allow him to continue to enjoy the company of his cousins and the landscape of Somerset. Above all, it was a new house that required no rebuilding or even redecorating – at least for the moment.

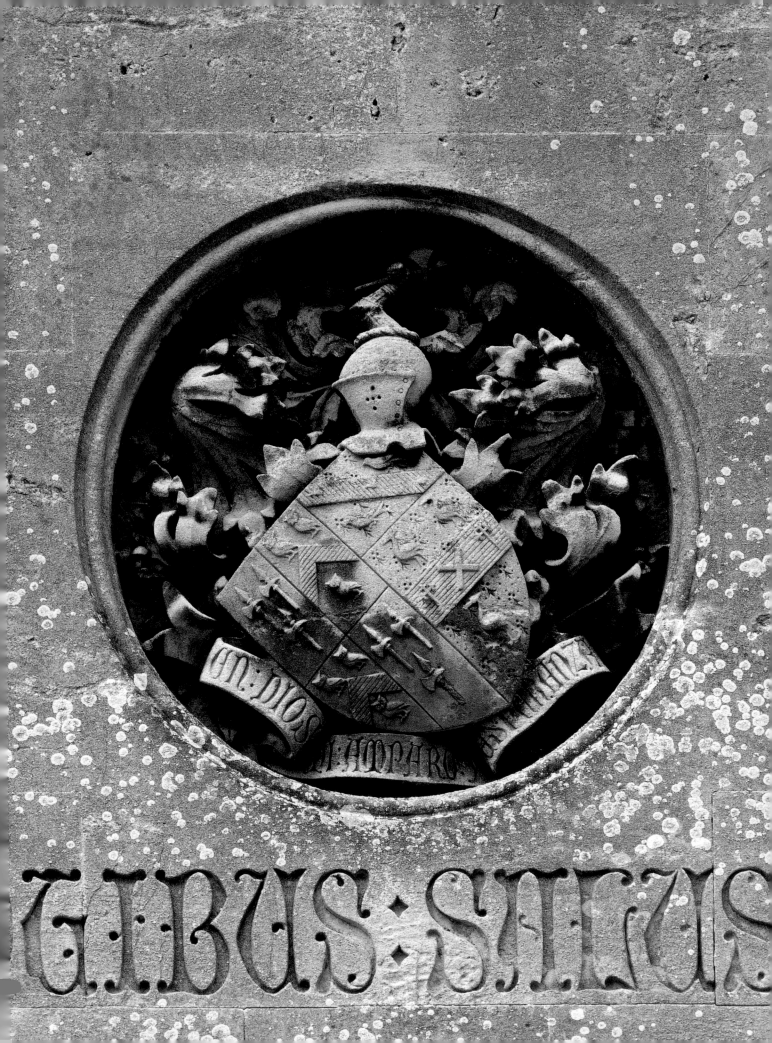

EN DIOS ESPERANZA

AMPARO

GABUS · SATAS

The Money

At the offices of Antony Gibbs & Sons, in the heart of the City of London, there was something approaching panic. Towards the end of 1840 rumours were reaching the partners that their agents in South America had signed binding government contracts not discussed with head office. This in itself was not unusual, as the company's trading houses in Peru and Chile had to have a certain degree of independence. However, these contracts were different. First, they bound the company, as sole importers of one particular commodity, for five years; secondly, the governments of Peru and Bolivia had demanded large down-payments against potential sales; and, lastly, the commodity itself – the dried droppings of sea birds, known as guano – was of questionable value.

William Gibbs may well have been dismayed. He and his brother George Henry (always known as Henry) had worked hard to establish the reputation of the company founded by their father in 1808. For over thirty years they had built up a business based on trade with the former Spanish colonies that had enjoyed fluctuating success; however, by 1840 they were at last reaping the rewards. Their acuteness as merchants, their ability to cope with the unstable political situation in South America, and their sheer determination, had paid off. Never had they deviated from the path of hard work, nor the principles they had established at the outset. 'You [Antony, their father], I and William,' wrote the youthful Henry, 'have decidedly agreed that smuggling in any shape whatsoever was dishonourable. We settled it as a rule for our conduct of business that we should always avoid doing anything of the propriety of which there rests the least doubt.'

In the rooms and passages of the Compting House, 47 Lime Street, from where William ran the London end of the business, there was talk of a financial disaster. It had to be averted, and to this end it was decided to set aside the whole profit of the previous year against the anticipated losses. The partners knew that they would simply have to

Above: A stained-glass panel in the Chapel.

Left: The armorials of the Gibbs family carved above the front door at Tyntesfield.

do their best to ride out the financial storm. It must have seemed ironic that at the very moment the company regained complete financial respectability, it looked as though it might lose its footing again. In addition to the previous year's success, in 1840 the brothers had also finally discharged the ancient family debts of honour, always referred to as *Las Deudas Sagradas* ('The Sacred Debts'), or in the abbreviated banking form, the 'DS Account'.

Their father, Antony Gibbs, had first become an independent merchant in 1788. During the previous four years he had been apprenticed to Mr Brook of Exeter, whose business was built on the export of local woollen cloth to the Spanish mainland. The excellent Devonian wool was loaded on to ships moored on the River Exe, near Topsham, and the same ships returned with goods purchased in the Spanish ports – citrus fruits, red wine and small luxuries from Spain and her colonies, to be sold on the Exeter quays. Young Antony developed a similar business, and initially prospered, as he had a natural enthusiasm and worked hard. However, he overstretched himself, the business collapsed, and he was declared bankrupt. It was a disaster that left an indelible mark not only on Antony, but also on his sons. The debts hung around the business like an albatross, not to be discharged during Antony's lifetime. In 1818, three years after his death, the two brothers set up the independent DS Account, and worked to pay back all the investors who had suffered from the collapse of this venture. The principal casualty of Antony's bankruptcy had been his own father, George Abraham, who had guaranteed the business. He was forced to sell not only his Exeter house with all its furniture, but also the ancient family house and lands at Pytte, close to Clyst St George, to the east of the city, where the Gibbs family had lived since the 1560s.

Antony's reversal of fortune ran counter to all that had been achieved in the previous fifty years. His father had risen to become the chief surgeon at the Royal Devon and Exeter Hospital. He had married Anne, daughter of Antony Vicary, also of Exeter, and they had a large family of eleven children, of whom Antony was the youngest son. Antony's eldest brother, Vicary, had won a scholarship to Eton and from there went to King's College, Cambridge. He decided on a career in law, and entered Lincoln's Inn in 1769. His abilities as an advocate marked him out for preferment. In 1794 he and Thomas Erskine brilliantly defended John Horne Tooke, Thomas Hardy and John Thelwall at the Old Bailey on charges of treason. Their clients were acquitted to great acclaim. The special medal struck in their honour still remains at Tyntesfield. Partly as a consequence of this, Vicary became Solicitor-General to the Prince of Wales. He was made a

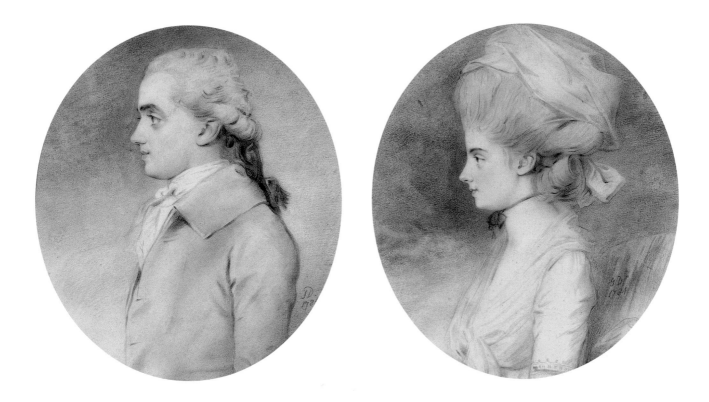

Antony Gibbs (1756–1815)
and his wife Dorothea Barnetta
Hucks (1760–1820) by
John Downman, ARA, c.1785.

bencher of Lincoln's Inn and became the Inn's Treasurer in 1805, the
same year he was knighted. He entered Parliament for Totnes in 1804,
and William Pitt made him Attorney-General, a position he held again
under the Duke of Portland. The Rt Hon. Sir Vicary Gibbs, as he
became, was tireless in his support of his family through the financial
difficulties occasioned by Antony's bankruptcy. Today his slightly stern
face stares across the Staircase Hall at Tyntesfield: his nephew, William,
commissioned Ivan Lindle to paint this copy of an original portrait by
William Owen, which still hangs in the College Hall at Eton.

At Tyntesfield, further portraits, some by the Devonian artist John
Downman, survive from an earlier, happy period. First amongst them
is that of Abraham Gibbs, George Abraham's second son, painted in
1781, by which time he had established his own trading position in
Genoa. Four years later Downman painted a double portrait of
Abraham's brother Antony with his young bride Dorothea Barnetta
Hucks. She was the daughter of a merchant from Knaresborough in
Yorkshire, whom Antony had met on his travels.

Missing from these portraits is the third son George (1753–1818),
who had moved to Bristol when a young man. He was the first of the
Devon branch of the family to do so, although in the sixteenth and
seventeenth centuries other members of the family had been important
city merchants. George was apprenticed to Samuel Munckley, and in

1789 he was made a partner in Munckley, Gibbs & Richards which, with its successors, traded goods principally in the Americas. Many of these goods, in particular cotton and woollen fabrics, were manufactured in the north of England, so a subsidiary branch of the company, Gibbs, Thompson & Co., was founded in 1805 in the growing port of Liverpool. In due course this company would become the principal shipping agents for Antony Gibbs & Sons in South America. In Bristol, a new partnership was established in 1818, when Richard Bright, another city merchant and partner in Harford's Bank, joined the company. The business was renamed Gibbs, Bright & Gibbs: Merchants & Bankers, the second Gibbs being George's son, also named George, who took over the business on his father's death in 1818. Ten years later this George Gibbs married William Gibbs's sister Harriett, and rented Mr Seymour's house, Belmont.

Following the financial debacle of 1789, Antony Gibbs redoubled his efforts to rebuild the family fortunes he had so unwittingly brought to the brink of disaster. He wrote, 'God in his mercy grant that you [Dorothea, his wife] may live to see me expiate in some measure by the steadiness of my present conduct for the folly of what is past.'[1] It was not to be easy. The political upheavals erupting from the French Revolution and the ensuing wars were to bedevil his ceaseless mercantile activities. He returned to the markets he knew on the Spanish mainland, although here plague and bad harvests affected the business, and the armies of Napoleon and, later, Wellington upset his carefully laid plans. He lived and worked in Spain with only fleeting visits back to Devon; his principal trade was carried out in Cádiz and Málaga. Trading houses were established in both these cities, the latter under the name Juan Pomar Gibbs y Cia. He certainly showed *tenax propositi* ('strength of purpose'), the phrase taken as the family's motto. In Madrid his reputation for diligence and honesty under almost intolerable circumstances led him to be made Agent for British Manufacturers.

Matters political went from bad to worse. In 1804, conscious of the likely outbreak of war with Spain, Antony arranged for trading stock with a market value of £20,000 to be sent from Cádiz, Málaga and Seville to a trusted friend, a Spanish merchant, who would secure it against its being sequestered as enemy property. This shrewd move was undermined by his agent, William Branscombe, who thought he knew better. The change in arrangements led to years of frustration before the goods were finally liquidated. Again Antony had come near to financial disaster, and he returned to London to salvage what he could. He desperately needed a new market for his goods, and the market he saw potentially lay in the Spanish colonies in South America.

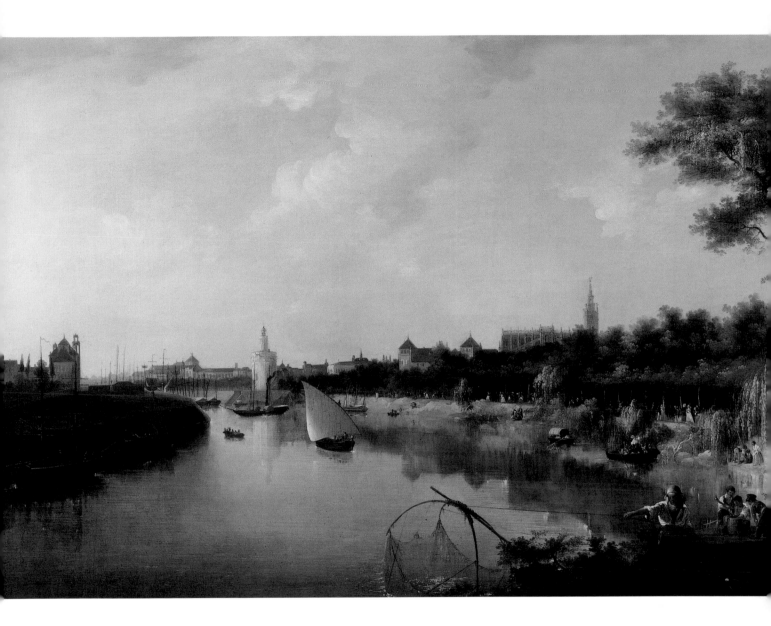

A view of Seville from the Guadalquivir, 1846, by Manuel Barron y Carrillo.

Years of trading in Cádiz had given Antony an unusual insight into the lucrative South American trade, supposedly a total Spanish monopoly; only Spanish ships could enter the ports and only Spanish merchants could carry out trade. His first speculative venture was a response to this very particular problem, but it laid the groundwork for later developments. Antony had commodities on a ship in Cádiz which, if landed under a British flag, might well have been impounded. The goods could be despatched on a Spanish vessel and traded in South America by Antony's Spanish company, but the risk was that, when leaving the harbour, the vessel would be captured or even sunk by the British fleet, which was blockading the port. He applied to his brother Vicary who, as Attorney-General, was in a position to make the necessary arrangements. At last Antony's charter vessel, the

Hermosa Mexicana, sailed from Cádiz unmolested, and made her way to Lima on the Peruvian coast. There her goods were sold and the hoped-for profit (albeit small) was made. It was a beginning.

Both Antony's sons worked alongside their father. George Henry, always known as Henry, was the eldest, born in Exeter in 1785. After schooling there he joined his father, first in Spain and latterly in Portugal. William was born in Madrid in 1790. It was a harbinger of his early life, half of which was to be spent in Spain. His education, though, took place in Devon, at Blundell's Grammar School in Tiverton, but by 1802 he was back in Spain assisting his father in Cádiz. In 1806 he went as an apprentice clerk to his uncle's firm, Gibbs, Bright & Gibbs, in Bristol. Here he quickly acquired the business habits that were to be his hallmark. At the end of his long life, these habits were characterised by the *Manchester Guardian*: 'The intellectual side of Mr Gibbs's character was almost entirely practical. It was his clear sound judgement, his robust common sense, his unwearing industry in carrying his point, his methodical business-like habits, which lifted him to one of the merchant princes of our country'[2]

In 1808 Antony Gibbs finally had to leave Spain and return to England, although to London rather than Exeter. Here, Sir Vicary had become a figure of considerable importance, and helped Antony to establish a new trading company, Antony Gibbs & Sons. The business was based at 13 Sherborne Lane, off Lombard Street, and Antony became one of the four commissioners whose task it was to manage the Portuguese property and funds that had been hurriedly sent to London by the Prince Regent of Portugal when he fled to Brazil as the French overran his country. Working alongside their father, Henry and William acquired a working knowledge of the City. They met and had to deal with shipping agents, bankers, insurance brokers and fellow merchants – it was a rapid, intensive business education, and one that they both took to heart. By 1813 Henry had been made a partner in the family firm managing the London office, and young William returned to Spain to co-ordinate activities there. With the collapse of Napoleon's power in the Iberian Peninsula, he set up a new trading house in Cádiz, Antony Gibbs & Sons & Branscombe. Sadly, he was not to see his father again, as Antony died in 1815, worn out.

Cádiz proved to be the perfect base for William to develop the business. It had never fallen to the French, as the port had been protected by the British fleet, and this allowed him to grasp immediately the trading opportunities presented by the new peace. It was the pivotal port between Spain and her South American colonies. British manufactures, Irish linens and Newfoundland fish

The Rt Hon. Sir Vicary Gibbs (1751–1820), Attorney-General and elder brother of Antony Gibbs, by Ivan Lindle after the original by William Owen, RA, 1814.

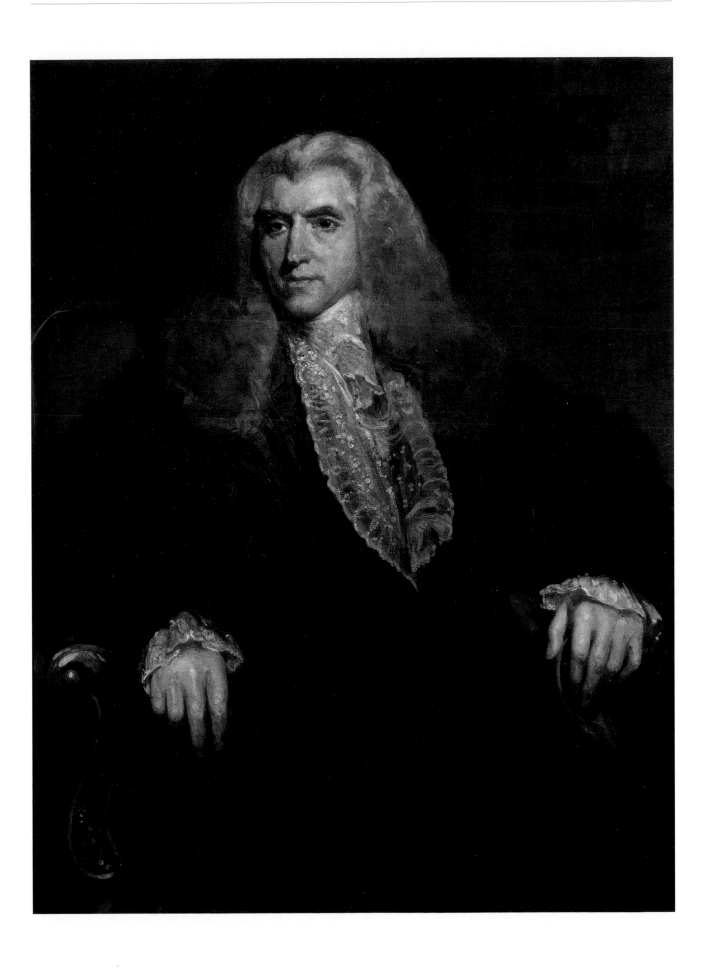

were imported by Antony Gibbs & Sons using their cousins' vessels out of Liverpool and Bristol. In 1818 William created a second trading company in Gibraltar named Gibbs, Casson & Co. Four years later he felt that the Spanish business was sufficiently well established to allow him to return to London.

William was 32 when he arrived back in London. His years in Spain had been formative ones, and he had become a highly successful and respected merchant, overseeing the company's move to trading principally in South America. He had also grown to love the country, its people, art and architecture. He was of course bilingual, and later chose to have the motto *En Dios mi amparo y esperanza* ('I place my trust in God') carved over the entrance and along the rafters of the Library of his great house, Tyntesfield. The Spanish paintings, furniture and works of art assembled there were a direct response to his love of the country of his birth.

Thirty years later, in 1853, William was to return to Spain with his nephews Henry Hucks and John Lomax, and the latter recorded another aspect of life there. The party set off driving swiftly from Pau in the south of France to Madrid: 'Uncle William was full of spirits and so were we all, but he especially. He made himself though about 70 years old, quite young – smoking his cigar with us and occasionally singing some of his old songs to us, Spanish and English We arrived in Madrid pretty fresh . . . and the same night went to the theatre hearing "El Oro y El Oropel" . . . those were very busy days – visiting all the pictures. Then on to Seville and Cádiz to warm welcome from former business acquaintances and friends. One friend in particular. There is a place near Cádiz called Chiclana where lived Doña Frasquita de la Pera, who was an old flame of Uncle William's in his youthful days in Spain. It was a case of mutual attachment but the match could not come about on account of the difference of religion Uncle William proposed that we should accompany on a visit to this lady . . . when we arrived at the house . . . my Uncle bowed but there was no recognition on her part. "No me conoce Vmd," he said, then with a puzzled look she answered "Par la voz, si – me acuerio de la voz" and then after a few moments more – with an excited voice she cried out "No Es GIBBS" and then tears on her part and embraces On our return home my Uncle sent her a beautiful Broadwood semi-grand Piano as a consolation gift!'[3] Spain left many marks and memories.

During the 1820s William and his brother Henry successfully steered the business, taking advantage of the break-up of the Spanish colonial empire. They established trading posts in Lima in 1822 and, four years later, in Santiago and Valparaíso, the three main Pacific

George Abraham Gibbs (1718–1794), Exeter surgeon and father of Antony Gibbs, by Prince Hoare, 1790.

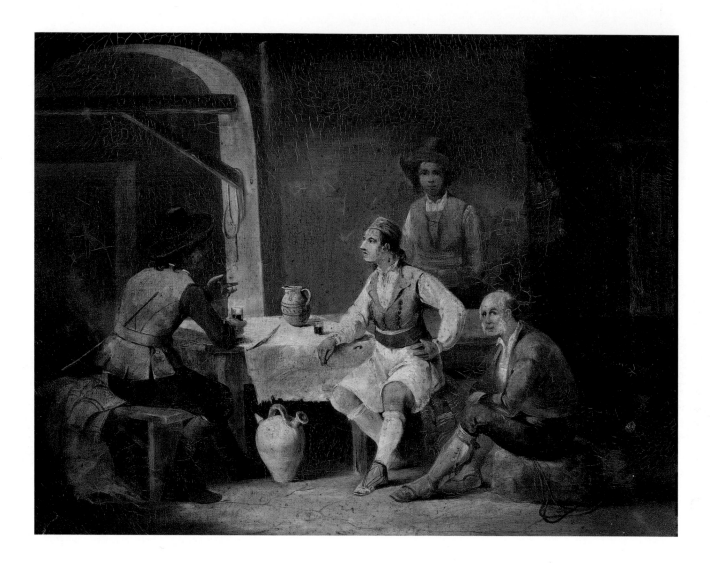

A tavern scene in Spain by Richard Bouguet, *c*.1840, probably acquired by William Gibbs on his journeys through Spain.

ports. With varying success, dealing with the shifting political complexities of Chile and Peru, the business started to prosper. By 1832 the ebb and flow of their trade ceased, and the company was consistently in profit, becoming the principal London trading house on the Pacific coast.

These successes allowed for expansion into other fields, most notably railways. From the outset the two family firms of Antony Gibbs & Sons in London and Gibbs, Bright & Co. (as it was now known) of Bristol were jointly involved in raising finance for Brunel's Great Western Railway. The first meeting of the London and Bristol committees took place at the Gibbs offices in 1833. The Great Western Railway Company was formed and, two years later, Henry was named as one of the proprietors in the Act of Incorporation. Remarkably, the enterprise took less than a decade to complete, and the first trains ran from London to Bristol in 1842.

With such a mercantile history, it is understandable why something

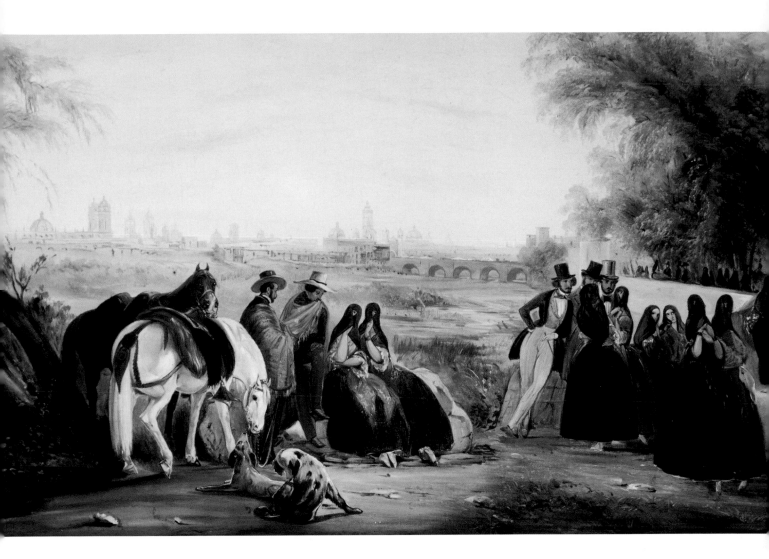

A view of Lima, Peru, by Johann Moritz Rugendas, in the mid-nineteenth century, when Antony Gibbs & Sons were trading in the city.

resembling panic stalked the offices of the Compting House in 1840. The new South American contracts were long-lasting, and the company's reputation for honouring its contracts meant that there could be no turning back. The only hope was to prepare for financial disaster. The trouble lay in the commodity: guano. This product had been tried unsuccessfully before, not only by other companies, but also by Antony Gibbs & Sons itself. Years earlier the company had imported some from a Señor Sarrata, but it was so little wanted that it never moved from the London docks and was eventually thrown into the Thames.

Guano, rich in nitrates, was well known in Chile, Peru and Bolivia as an effective natural fertiliser. Consisting of the hardened droppings of birds, the main deposits were found on the uninhabited and rainless islands off the Pacific Coast, such as the Islas de Chincha, south of Lima. For thousands of years seabirds had left droppings here, and nitrate-rich mountains of the material were there for the taking.

Guano digging on the Chincha
Islands, Peru. (An engraving from
the third quarter of the nineteenth
century.)

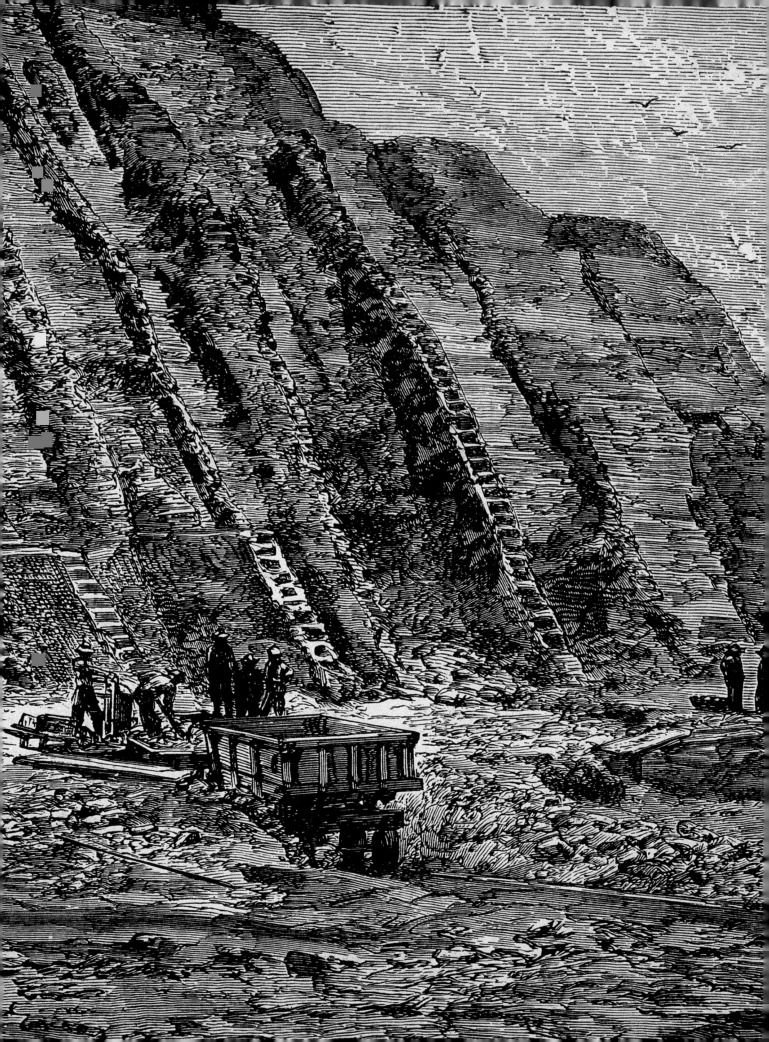

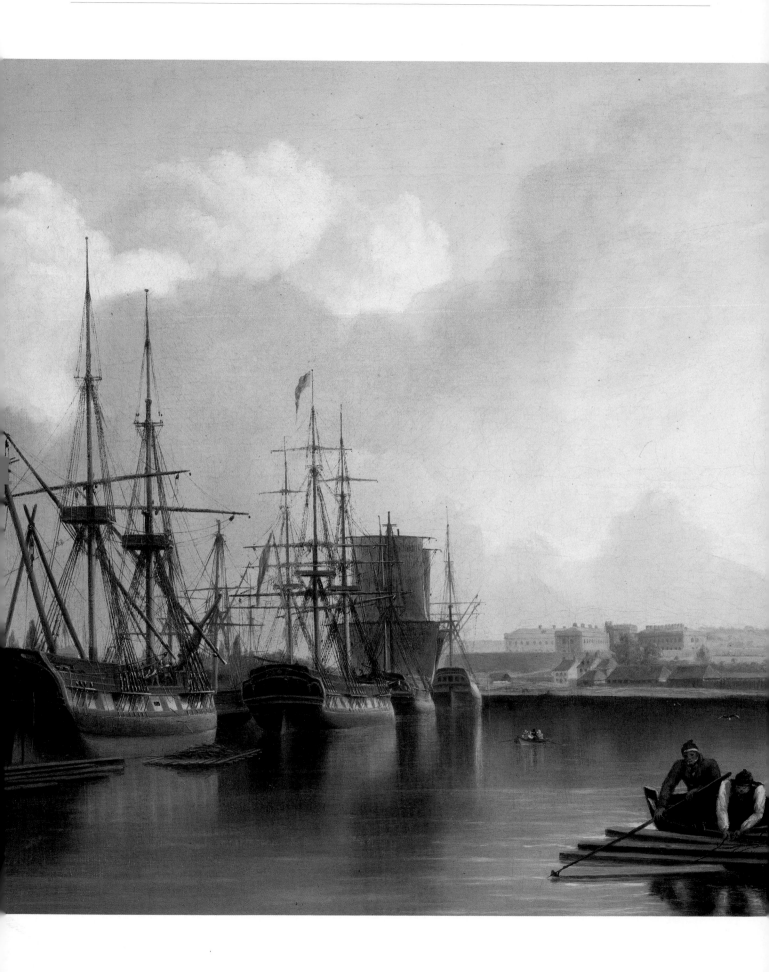

The guano was mined by the government, which had given itself a monopoly in both excavation and trade. Antony Gibbs & Sons now had to convince the progressive, yet naturally cautious British farmers. Fortunately, this time the moment could not have been more propitious. The trade depression of 1839, the bad harvests of the early 1840s, the Irish potato famine and the ever-present threat of the repeal of the Corn Laws (which finally occurred in 1846) meant that a fertiliser promising significantly to increase crop yields was exactly what the farmers were looking for.

The first shipments of guano arrived in 1842. In all, 126,900 tons were shipped from Lima to the London docks. What had been a potentially disastrous gamble turned almost overnight into an incredible success; a financial success, assured for five years, thanks to those long contracts. The British farmers were immediately persuaded by guano's potential, influenced in part by Gibbs's clever promotion. In 1843, he published a pamphlet, *Guano: Its Analysis and Effects Illustrated by the Latest Experiments*. It opened with a letter from the company: 'Sir. Being largely engaged, as Agents to the Peruvian and Bolivian Governments, in the recent introduction into Europe, from the west coast of South America, of the manure GUANO, we beg leave to lay before you the following particulars and experiments, which we trust will prove interesting and useful to you. Of the genuine article, imported by ourselves, we have deposits on sale both here and in the hands of our friends Messrs. GIBBS, BRIGHT, AND CO., of Liverpool and Bristol, deliverable from the Import Warehouses.' In the following pages came testimonial after testimonial enthusing as to guano's almost magical properties, supported by the chemical examination carried out by Dr Andrew Ure, MD, FRS, etc. Additional proof of its effectiveness was to be found in the wheat yields from George Gibbs's land at Wraxall, where it had been tested the year before. Not only was it much more productive than other natural fertilisers, it was also much cheaper, as less had to be used. Where there had been indifference to guano in the past, there was now a stampede, the new railways providing a quick and efficient means of transporting it from the ports to the inland warehouses.

The demand was such that by the end of the decade the farmers sent a delegation to the Prime Minister, Lord Palmerston, complaining of the high prices charged by Antony Gibbs & Sons. The canny Premier asked the farmers if the amount of guano they had bought had been increasing. Yes, they replied, by about 33 per cent per annum. 'Gentlemen,' he answered, 'you have the remedy in your hands. If you think the stuff too dear, do not buy it.'[4] But by then the die was cast; the Corn Laws had been repealed and such increased yields were now

Shipping off Bristol by Joseph Walter, 1834.

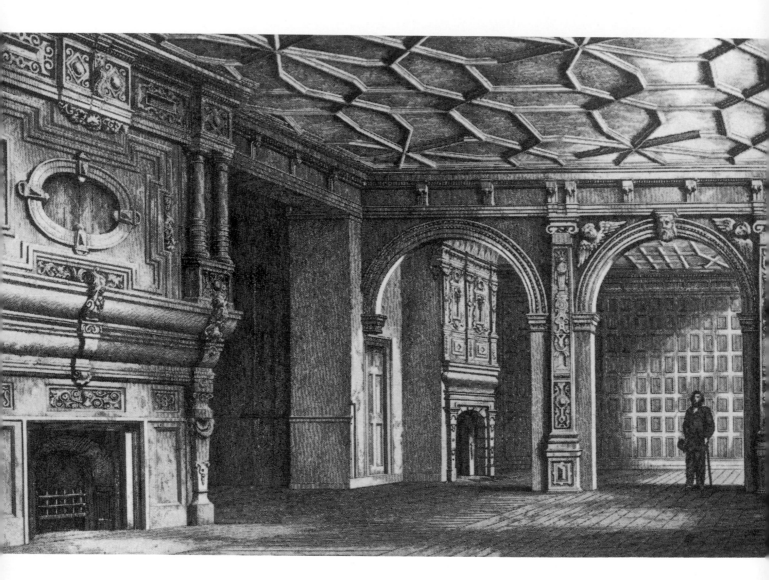

necessary; if guano cost X, then X must be paid.

Henry Gibbs died unexpectedly in 1842, and in that very year William became head of Antony Gibbs & Sons. As the sole partner, he became the chief recipient of the enormous wealth that was rapidly accruing from the guano trade. His income rose meteorically: from 1842 to 1875 the annual partners' profits could be as much as £100,000. William remained the sole partner for the five years until 1847, and thereafter he had a varying stock holding of between 50 per cent and almost 70 per cent. It is perhaps therefore not surprising that by the 1860s he had £1,500,000 of his own capital in the business, quite apart from the funds he had either spent or invested elsewhere. According to *The Times*, he was the richest commoner in England.[5]

The excavated guano lasted until the 1860s. Further contracts were signed with the governments of Peru, Bolivia and Chile in the 1840s and 1850s but the Bolivian deposits at Angamos were exhausted by

Above: The interior of 47 Lime Street, the offices of Antony Gibbs & Sons in the City of London. (Engraving, *c*.1840.)

Right: The title page of William Gibbs's pamphlet on the efficacy of guano, published in 1843.

GUANO:

ITS

ANALYSIS AND EFFECTS;

ILLUSTRATED BY THE

LATEST EXPERIMENTS.

———

LONDON:
WILLIAM CLOWES & SONS, 14, CHARING CROSS.
MDCCCXLIII.

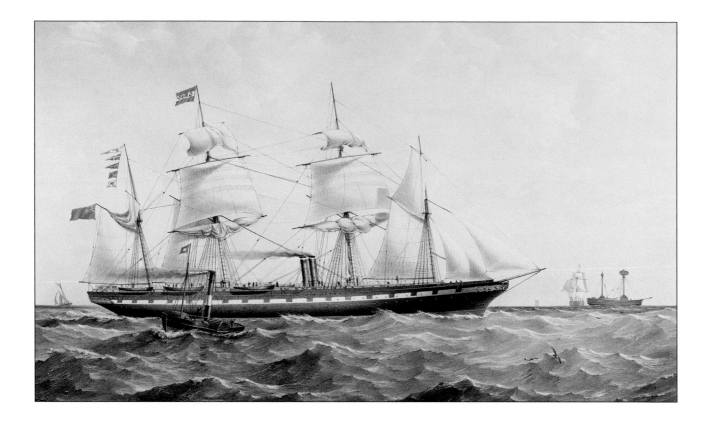

1851, and those on the Chincha Islands by 1864. Fortunately, further deposits of nitrates of soda were identified inland, especially in Tarapacá Province, and further local trading companies were established under the umbrella of the parent company Antony Gibbs & Sons. William successfully steered the company onwards, reaping further financial rewards, and diversifying trade into copper, bark, tin, silver and wool. Once the contracts were in place, William and his agents saw to it that the trade was conducted as profitably as possible. One problem was a natural enthusiasm for overloading the vessels, which then foundered and sank at sea. It was one of William's agents in 1860 who first hit on the bright idea of marking the side of a vessel when empty to show how deep it was safe for her to sit in the water once laden – an idea taken up a decade or so later by Samuel Plimsoll.

The company also began to expand globally. In 1853, they opened offices in Melbourne, and some time later they established the Blackbull Shipping Line, taking passengers and cargo to Australia. They took advantage of the Australian gold rush, and it was in this context that an association with Isambard Kingdom Brunel was rekindled. Henry Gibbs had supported the building of the Great Western Railway, but the company had sensibly eschewed the later railway craze. In 1850, however, Lawrence, Gibbs, Bright & Co. acquired the SS *Great Britain*, Brunel's mighty iron-clad 3,500-ton

The SS *Great Britain* in 1852, during the time at which the ship was owned by Gibbs, Bright & Co. She is seen here dropping her pilot off Anglesey, and flying the Gibbs, Bright flag (marked with the letters GB) from her masthead. From a painting by Joseph Walter.

vessel, and the first five-screw steamship built for the Atlantic crossing, which had run ashore in Dundrum Bay near Belfast in 1846. The company repaired the vessel and switched her to the Australia run, on which she took an estimated 66 days to arrive in Melbourne. The SS *Great Britain* continued to make the trip to Australia until 1876, when she began to ply the nitrate trade between Chile and Europe. En route to the Americas she was damaged off Cape Horn and sheltered in the Falklands, where she remained until 1970, when she was repaired and returned to Bristol where she had originally been built. William Gibbs's great-grandson, Richard Gibbs, Lord Wraxall, sat on the committee that organised this, her last voyage.

Towards the end of the century, a ditty could be heard in the City: 'Mister Gibbs made his dibbs, Selling the turds of foreign birds' – and what dibs! They enabled William not only to build Tyntesfield and create a landed estate, and to buy back the family home at Pytte and its surrounding land, but also to have funds sufficient to be one of the greatest Anglican philanthropists of his age. The two sides to his life, business and philanthropy, were never separate, though. It is no accident that as head of Antony Gibbs & Sons he was called 'the Prior', and that the company's cable addresses were Genesis, Septuagint, Sadducees, Pharisees and Epiphany.

A Country Estate

William Gibbs had married his cousin Matilda Blanche Crawley-Boevey – always known as Blanche – in 1839, creating yet another link in the close-knit Gibbs family. In 1843, three years after the first shipments of guano, the couple acquired Tyntes Place. Tyntes Place was all that they wanted. It was the ideal house for the busy head of Antony Gibbs & Sons. Recently remodelled by Robert Newton, it was in tip-top condition, and there was no need for alterations. Since their marriage, William and Blanche had already had three children: Dorothea (1840–1914), named after William's mother; Antony (1841–1907), after his father; and Alice Blanche (1843–71). In the ensuing decade four more children were born: William (1846–69), George Abraham (1848–70), Henry Martin (1850–1928) and, lastly, Albinia (1853–74). The site was perfect, with views across the vale of Nailsea, and from the top of the turret could be seen the Bristol Channel itself and the small islands of Flat Holm and Steep Holm. The gardens, with stretching lawns and meadows, lay alongside the house itself. There were woods to explore, and like-minded neighbours to visit such as the George Gibbses at Belmont and the Eltons at Clevedon.

Tyntes Place was also perfect for its newly created proximity to London. Before the advent of Brunel's Great Western Railway it took two days to travel to London. After 1842, it took but a few hours. First by carriage to Temple Meads station, and later from neighbouring Flax Bourton station, the family regularly boarded the train running to the terminus at Paddington, which was completed in the early 1850s. It became increasingly possible to travel to Tyntes Place and back in a day, although the family normally stayed for longer periods, especially during the school holidays: Antony started at Radley College in 1855 and Henry Martin at Lancing a decade later. The family's use of Tyntes Place was more akin to that of the twentieth century than the

Above: A detail of the carving of William Gibbs's initials on the Crace sideboard in the Dining Room.

Left: The Entrance Porch seen from the garden gate.

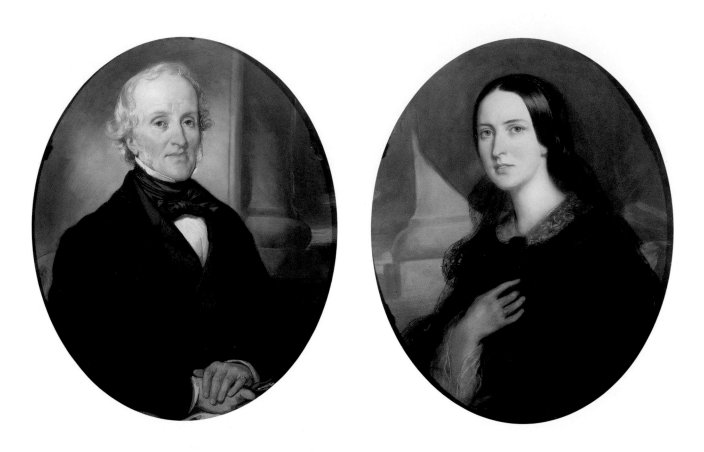

nineteenth. It was never central to the economic fortunes of the family, even though William acquired adjoining land when the price was right. Nor did it become the backdrop to either his business or his philanthropic activities, which were largely centred on London. It was a place of leisure, relaxation and entertainment. It was a place for the family and their friends – a house always full of fun and laughter, often instigated by the rich cousinship of Gibbses, Crawleys and Yonges.

Whilst Tyntesfield, as it was called by the 1850s, became a permanent country home, in London the family were constantly on the move. When he married, William left his brother's house in Bedford Square and moved to 13 Hyde Park Street. This was part of a fashionable new development of the Bishop of London's estates to the north of Hyde Park, laid out by a Mr Gutch. It was considered one of the healthiest areas to live in, far more so than the low-lying areas of Belgravia and Pimlico. In 1849 the family moved again to adjacent Gloucester Square. The new house proved too small, however, and in 1854 Gibbs's wealth was such that he could afford one of the large houses in the district – 16 Hyde Park Gardens. The house, on five floors, faced across private gardens and the Bayswater Road on to Rotten Row and Hyde Park itself. The entrance was from the rear, with stabling and staff accommodated in the mews behind. The fine

William Gibbs (1790–1875) and his wife Matilda Blanche Crawley-Boevey (1817–1887), who were married in 1839. By Eugène-François-Marie-Joseph Devéria, *c.*1850.

sequence of rooms on the first floor all enjoyed splendid views across the park towards the Serpentine and afforded a glimpse of Paxton's Crystal Palace standing high above the tree-line to the right. Like so many of his contemporaries, Gibbs and his family made many excursions to the Great Exhibition there, which had been opened by the Queen on 1 May 1851.

Fleeting images of Gibbs's life can be caught in the occasional diaries he kept from 1817 to 1850. Fortunately, after 1850 he wrote in his diary every day, a practice that remained constant until the day he died. These were not journals of reflection, but rather, as might be expected, the diaries of a businessman. They list the activities of the day. He invariably comments first on the quality of his sleep (in later years he suffered from terrible insomnia), then follows the progress of each day: breakfast, morning worship either at St John the Evangelist, Southwick Crescent, or at St Michael's, both in Paddington; business meetings; lunch; philanthropic meetings; outings to friends; concerts and dinners. Gibbs also noted his meetings with architects and artists, in particular those with his friend the painter Sir William Boxall, RA, and the decorator John Crace.

John Gregory Crace (1809–89) first appears in the diaries in 1854 when he was asked for advice over the redecoration of Hyde Park Gardens. In 1842, the firm of J. G. Crace had formed a working relationship with the most brilliant of all Gothic designers, Augustus Welby Northmore Pugin (1812–52). Pugin produced a large number of highly distinctive designs over the ensuing decade, and Crace's work during the period increasingly took on a seriousness of purpose, an appropriateness of ornament and a careful selection of materials that set the firm's Gothic work apart. Although the number of commissions in the Gothic style represented a relatively small part of the firm's output, they were some of its most important. Foremost amongst them was the decoration of the new Palace of Westminster, where Pugin was responsible for the interior decoration of Sir Charles Barry's great building.

Crace was commissioned not only to redecorate 16 Hyde Park Gardens, but also to send his team of painters, paper-hangers and decorators down to Tyntesfield to refurbish the house. The Reverend Seymour's house was presumably showing signs of wear and tear. Equally, the decoration may well have seemed old-fashioned, compared to the prevailing tastes in London. Whatever the reason, Crace left few rooms at Tyntesfield untouched. In the principal invoice he presented at the end of the first year, entitled 'Painting etc done at Tyntesfield House near Bristol'[5] he lists in full the rooms he has decorated, providing an invaluable account of layout of the house at

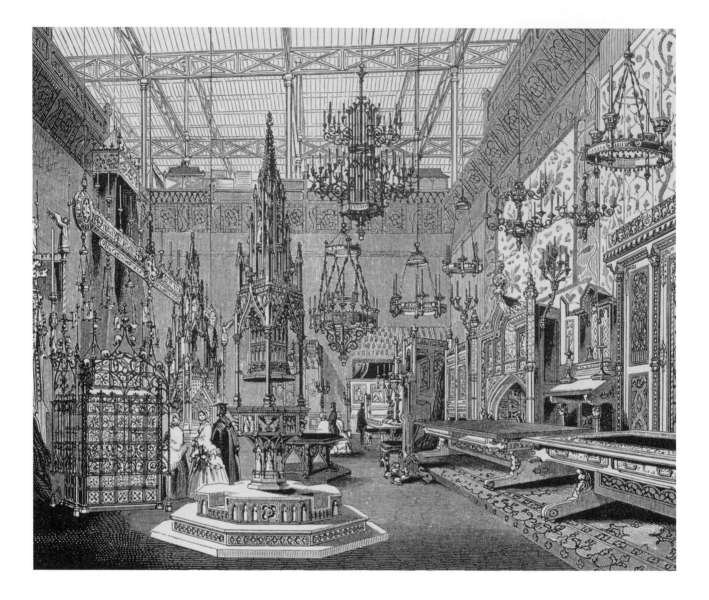

that time, from the formal rooms on the ground floor to the bedrooms of the female servants in the attic. Most of the work was painting: the ceilings were distempered, the woodwork was varnished in oil, mouldings, stencilling and grained wainscoting were added, and the old papers were cleaned with bread.

In the principal rooms some of the work was more elaborate; 32 feet 9 inches of panel and 26 feet 6 inches of ribs 'cut to gold' were supplied. The oak staircase walls were painted with lines to simulate stone. In the Drawing Room, Music Room and Library the existing paint and graining was simply washed and repaired where required. A separate account was rendered for paper-hanging. Wallpaper with flowers on a buff ground was selected for the Spare and Day Nurseries; a rose pattern for the Playroom; flowers on a white watered satin for Miss (Dorothea) Gibbs's bedroom; a brown embossed paper, rather

The Medieval Court at the Great Exhibition of 1851, displaying the Gothic craftsmanship of John G. Crace & Sons and other manufacturers. The exhibition and court were visited by William Gibbs and his family from their London home at Hyde Park Gardens nearby.

gmentrtrtortrtort A COUNTRY ESTATE 43

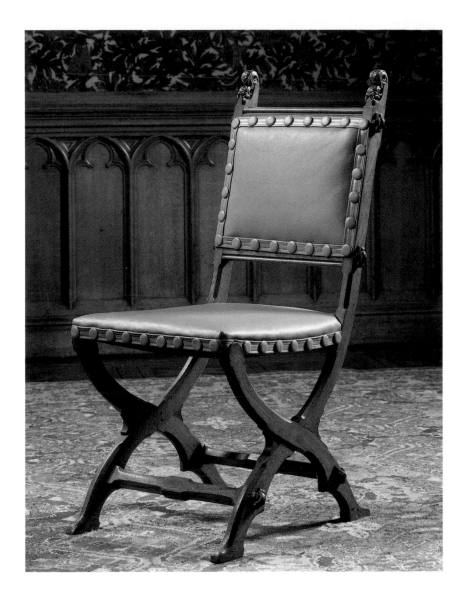

One of a set of four oak X-frame chairs supplied by John G. Crace & Sons, c.1855, and identical to those made by Crace for his own dining room at Springfield, Dulwich.

surprisingly, for the White Room; flowers on a light-green ground for the Housekeeper's Room; Siena marble paper for the bathroom; imitative wainscot paper for the water-closet; and yet more Siena marble paper for 'Water Closets in the New Building'. The invoices submitted by Crace at the end of the year fully describe the work, even down to that on the exterior of the house and the ancillary buildings. The primary activity here was repair work, although J. G. Crace also supplied a dozen ornamental hinges and a new bronze knocker, probably made by William Jeakes of 57 Great Russell Street, Bloomsbury. The team of painters took eighteen days to complete the work, and twelve days to scrape, clean, rub down and repaint the Conservatory inside and out. The Gardener's Lodge, Coach House and Harness Room were also painted and decorated. Crace's bill that year came to £816 6s 8d.

The following year Crace's team returned to complete their work, tackling the Dining Room and Dining Room Lobby, the principal stairs, and the Drawing Room ceiling. In the Drawing Room, the existing gilt decoration was simply cleaned and the ceiling washed, whilst the Entrance Hall, Gallery and principal staircase were 'tinted to imitate stone of different shades and lined in blocks'.[2] The graining in the Library was retouched. Crace was then commissioned to clean and repolish 'various Articles of Furniture', and his invoices provide an indication of how the rooms were then furnished. In the Entrance Hall there were two large tables, six chairs and a sofa. It must have been difficult to move in the Music Room with its piano, a set of extending dining-tables, six further tables, a Davenport, a whatnot, a Canterbury, eleven chairs, three music stools, four ottomans, two footstools and a prie-dieu! Equally, space must have been at a premium in Mr Gibbs's bedroom where – quite apart from the bedstead, two wardrobes and a chest of drawers – there were six tables, eleven chairs, an ottoman and a sofa, as well as innumerable other pieces of furniture. The Gillows library table recently discovered in the China Store, deep in the cellars, may well have been the same table that Crace was asked to revarnish. Similarly, the small tables with side-flaps now employed as bedside tables may have been the occasional tables in the Drawing Room. A *chaise-longue* and two armchairs, later relegated to a bedroom, were almost certainly part of this original furniture. Crace submitted a final invoice for all his work for some £1,070 19s 1d. It was paid in instalments in cash between 9 September 1854 and 3 October 1855, after Gibbs had negotiated a discount of some 7 per cent. The bill was finally settled by cheque on 5 January 1856.

Crace supplied furniture himself, which is neatly listed in one of the last invoices, '1855–6 Upholstery Work done at Tyntesfield near Bristol'.[3] He cleaned and repolished the prie-dieu in the Drawing Room, 'covering the same in Green Poplin trimmed with silk gimp and cord'. 'A richly ornamented Candelabrum gilt in mat and burnished gold with brass sockets and plate to hold Miniatures' was supplied at a cost of £33 10s. For the Saloon came 'a divan Ottoman stuffed and covered in Persian carpet, with a margin of mauve cloth, trimmed with silk gimp fringe and cord' for £17 6s. This was later moved to Norton's Drawing Room, where it was photographed by Bedford Lemere in 1878. 'The carved prie-dieu in Oak of Gothic design with a kneely cushion stuffed and covered in maroon Utrecht velvet furnished with silk gimp and gilt nails £8 14s 0d' now stands in the Library.

Crace's most lavish work was carried out in the Dining Room, and the effect of this can still be felt there today. To the right of the Entrance Hall, it was entered through a single door and at the far end

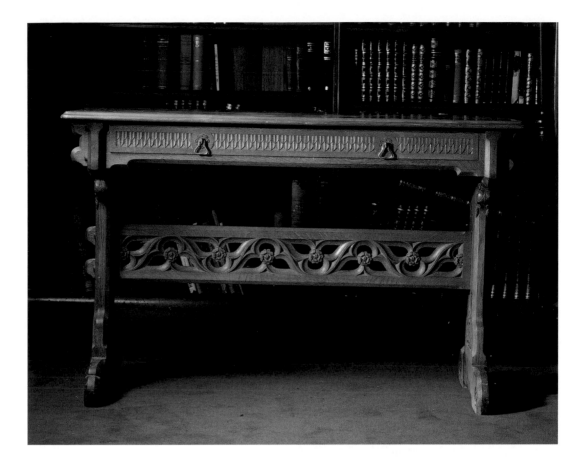

An oak table to a design by
A. W. N. Pugin, supplied by
John Crace at a cost of £16 12s.

another door led to the Kitchen. Crace supplied a large Axminster carpet, like that now in the Library, together with a Persian rug and a small maroon foot mat. The walls were probably papered or stencilled, the cornice and woodwork grained with highlights in gold leaf. To the right in the room was a single bay window. Here Crace had to adapt the original maroon curtains with 'an extra breadth of new cloth added to each curtain', together with silk gimp along the edges. A deep valance was supplied, decked out with further rosettes, tassels and a deep fringe. The curtains moved on a track, operated by pulleys. Against the windows hung six Holland blinds with matching silk tassels. Opposite the window stood the original fireplace, put in by the Reverend Seymour, with a large looking-glass above. To this Crace added a 'carved mantelpiece in Oak of Gothic design, with a carved frame over ditto, made to suit your Looking Glass' at a cost of £36 4s. This all survives, with 'the spandrels filled in with new looking glass' as specified. For the far end of the room, Crace supplied a new 'carved sideboard in Oak of Gothic design, the pedestal enclosed by carved panel doors, with Looking Glass in a carved frame attached to the back', costing £138. The pedestal base for this remains *in situ*, although the upper part was later replaced. The cupboard doors bear the

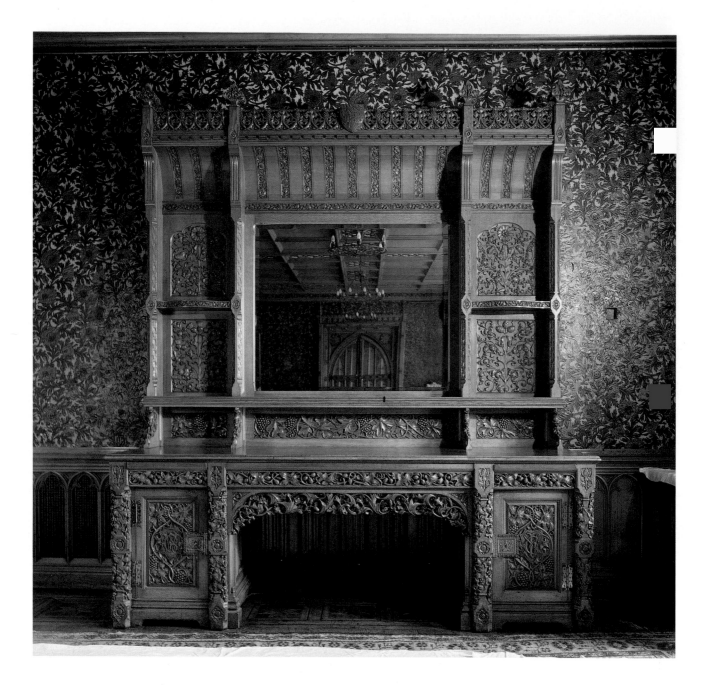

monograms of William Gibbs and Matilda Blanche Gibbs and, high above, attached to the later fretwork canopy, their armorial shield. The whole is a *tour de force* of mid-nineteenth-century English naturalistic carving. The surface is rich in ornamentation, with trailing ivies interrupted by small roses, the doors and gallery of stylised fruiting vines, whilst the drawers sport a frieze of meandering hop leaves. Even the metal lock-plates were cast with ivies and budding fleurs-de-lis. It is Crace's Gothic work at its most intricate and best.

In the centre of the room was a large dining-table surrounded by twenty chairs, which may well be those long since put away in the old

The oak sideboard in the Dining Room, supplied by John Crace in 1855 at a cost of £138, with the later upper part added by James Plucknett.

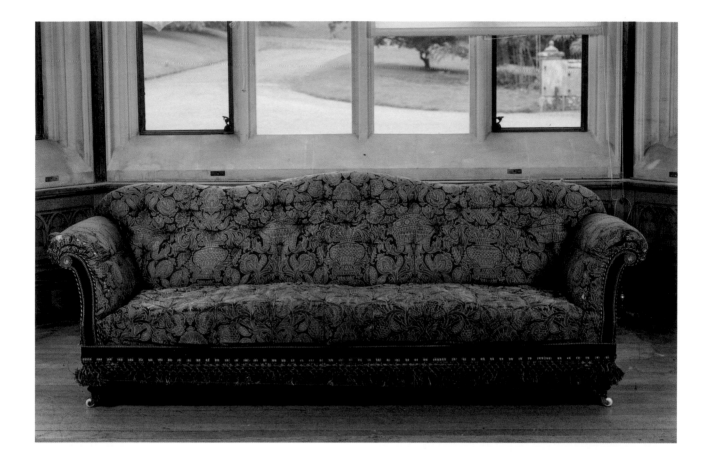

The Crace sofa, covered in its original fabric; it is now in the Library.

servants' rooms. There was a teapoy and fire-screen, and five stools near the fire, a folding screen by the far door, a dinner wagon, occasional table, and 'a carved side table in Oak of Gothic design' supplied by Crace at a cost of £16 12s. This must be the handsome oak trestle table still in the Dining Room, with a central Gothic stretcher and archaic iron handles to the drawer front. In keeping with Pugin's maxim, the construction is apparent in the design: the pegs attaching the stretchers to the legs protrude at either end. One large piece of furniture detailed on Crace's invoices is sadly not traceable – an unusual 'carved sideboard and bookcase combined' with both panelling and glass doors, and a marble shelf. This arrived in 1856 at a cost of £124. When it left the room is unknown.

As well as supplying Tyntesfield's avant-garde Gothic furniture during the 1850s, Crace also supplied comfort in the form of curtains, cushions and luxurious seat-furniture. The latter includes perhaps the most interesting pieces to have survived, as in ordinary circumstances the simple wear and tear and the changing of fashions would have taken their toll. Yet Tyntesfield is not like other houses. Lying buried under later covers, the Crace seat-furniture has now re-emerged, its sumptuous upholstery brilliant in both colour and texture. Gold

thread was used to highlight the dramatic floral designs, with leaves writhing around fecund seedpods and flowers, coloured in buff against a rich burgundy background. The pattern, held by 'margins' of maroon cloth, was itself further ornamented with rosettes and tasselled gimps. The effect is still striking and glorious; one of deep, inviting comfort, combined with undeniable luxury.

Gibbs was often horrified at what he felt were Crace's exorbitant charges. As each invoice arrived there was an almost audible sigh in his diary. On 5 January 1856 he wrote, 'Stayed at home nearly all day arranging papers and Accounts and settling with Crace his large Tyntesfield Bill.' 'Settling' meant agreeing some sort of a discount. Gibbs also expected Crace to achieve the agreed schedule, and was not best pleased when matters went awry. On 13 October the previous year he had noted in his diary, 'Thence to Crace [in Wigmore Street] to blow him up about sad delays.'[4] William anticipated that other people's businesses would share the clockwork precision of Antony Gibbs & Sons. Sadly, like many before and after, he discovered that builders and decorators often have a different approach to both time and estimates.

During the 1850s Gibbs also began to collect paintings. Crace's accounts include the installation of 77 feet ⅞ inches of picture rods and brass chains, and the hanging of the paintings. These consisted largely of English landscapes, many of which are still at Tyntesfield, including the beautiful *View of Radnorshire* by the Bristol artist William West (1801–61) that had been bequeathed to him by his brother Henry in 1842. Gibbs purchased his most important English pictures in the late 1850s and 1860s, works by Thomas Faed, John Philips and Clarkson Stanfield. The last's *Scenes off the Flemish Coast: Waiting for the Tide to Come In* was acquired through Henry Eckford, his dealer, from Christie's on 15 June 1861. Eckford also advised on another of Gibbs's purchases, even though it was bought for him by his agent William Flatou – Sir Augustus Wall Callcott's early masterpiece, *Passage and Luggage Boats*. This important picture had been exhibited at the Royal Academy in 1815, and marked a turning point in the artist's career. It was to be the first in a masterful series of marine paintings, rivalling his contemporary J. M. W. Turner, and even challenging Cuyp and the Dutch seventeenth-century painters. The picture was bought by Sir John Swinburne, one of the foremost patrons of British art, on whose death it was offered for sale.

Callcott brilliantly captured the atmosphere of the flat coastline around Southampton Water with the calm sea subtly blending into the vast expanse of the sky. The figures in the forground clambering into the boat add a sense of leisured movement. Gibbs first encountered the picture at Christie's on 29 May and, having agreed with his agent

A detail of the fabrics used by John Crace on the upholstered furniture supplied *c*.1855.

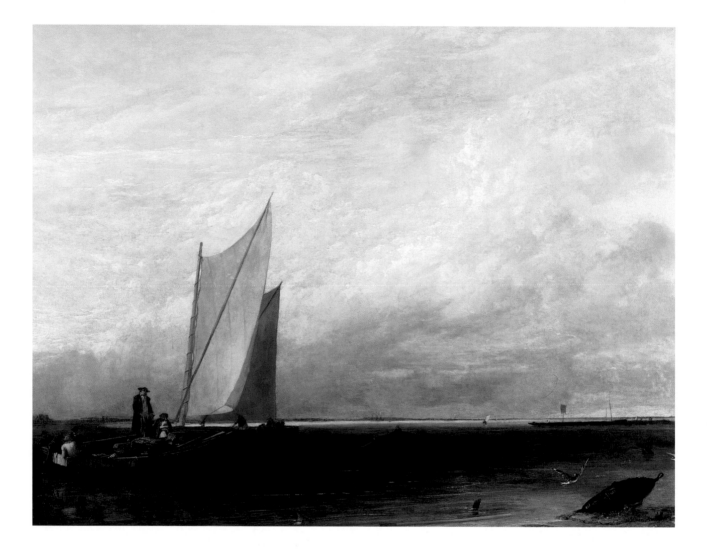

Eckford on what he would like to spend, he then visited the portrait painter Sir William Boxall 'to consult him about Calcott's [sic] Picture'. On 17 June he reports that 'found from Henry that he had bought for me the large Picture by Calcott [sic]'. Then the fun really began! The next day Gibbs 'moved bookcase from Dining Room [at 16 Hyde Park Gardens] to my room to make room for the picture'.[5] The picture was still hanging in exactly the same spot in 1883, but by 1890 it had moved to the Hall at Tyntesfield.

William's acquisition of Old Master paintings was just as exciting, although he did not always succeed, as he refused to overpay: 'went to a sale of Pictures where Guardi's St James which we bid £400 sold for 1250gns' reads one typical entry in his 1861 diary. His first foray in this field was in 1840, when he and Blanche visited Rome. He acquired a number of paintings from a Signor Luchetti in the Via Babuino, including *A Landscape with Travellers on a Path* by the Dutch artist Willem Schellinks (1627–78). It originally hung in the Hall at

Above: *Passage and Luggage Boats* by Sir Augustus Wall Callcott, 1815, puchased by William Gibbs in 1861.

Right: *St Lawrence*, attributed to Juan Luis Zambrano of Córdoba, *c.*1620, purchased by William Gibbs from Dom Romero Balmaseda of Seville in 1853.

Tyntesfield, from there moving to the Ante-room in the early part of the twentieth century.

Prolonged summer holidays abroad became an almost regular part of family life after 1844 when Gibbs's nephew Henry became a partner in the family firm. In 1853 William toured Spain and not only met his 'old flame' Doña Frasquita de la Pera, but treated himself to paintings. In Seville, he and his nephews fell in with Manuel Williams, the son of the British Consul. On 22 November Gibbs 'called on Williams who gave us a list of the Prices asked by Balmaseda for his pictures, amounting altogether to about $10,000 which Williams valued at about the half'. Later on that day, 'We called on young Williams and went with him again to see Romero de Balmaseda's pictures and took a note of about 20 which I should like to buy of them including of course the Mater Dolorosa of Murillo and two of Zurbaran of St Lawrence and St Antonio After a good deal of precious negotiation between him and Romero Balmaseda to offer $4,000 – for about 25 of his pictures – which he refused, and offered 12 of them for $2,000. His Dolorosa for $3,000 so that negotiations came to nothing.' At that point the diary leaves the matter, but further letters from Williams to Gibbs show that a deal was concluded on 14 December: '*obtiene los cuadris par 5.500 duros* [sic]' ('the paintings are acquired for 5,500 duros'). On 31 December the canvases were shipped to England by Jan Hiero of Seville, and the following year elaborately carved and gilded frames were ordered from Luigi Piaretti of Florence, coming to England via Leghorn on 24 July. The wonderful *St Lawrence*, now attributed to Zurbarán's short-lived contemporary, Juan Luis Zambrano of Córdoba (1598–before 1636), hangs on the main staircase. The saint stands wearing a chasuble of cloth of gold, holding his gridiron in his left hand; below are the flames of the torturer's fire, whilst an angel flies above his head holding a wreath and a martyr's palm. Other paintings acquired from Don de Balmaseda included *The Christ Child* by a follower of Murillo, and Miguel Alonso de Tovar's *Immaculate Conception*, which was to hang in the great Drawing Room at Tyntesfield until the room was remodelled, when the painting was moved to the Staircase Gallery.

William's purchases in Spain were not all protracted, or indeed so serious. He decided he would like to return with some souvenirs, and bought a fine painted terracotta group of a mounted picador, supplied by Datez y Salesse in Cádiz. A few days later, on 1 November, he records in his diary, 'Afterwards called at the Málaga figure shop and bought another.'[6] In fact, he ended up with three, all modelled by José Cubero Galadrón. Initially they were displayed at 16 Hyde Park Gardens, but were later brought to Tyntesfield by his eldest grandson.

The Madonna and Child with the Infant Baptist, the Magdalen and St Zacharias, purchased by William Gibbs as being by Parmigianino at Lord Northwick's sale, 1859.

Some of the Spanish furniture, including the gilded hall chest, which it is highly unusual to find in an English house, may also have been acquired by William at the same time.

In 1859, like many other picture collectors, Gibbs was drawn to the twenty-day-long sale of Lord Northwick's collection that took place at Thirlestaine House, Cheltenham. Here Northwick had assembled a magnificent group of Old Master and British paintings in a gallery built specifically for his collection (now part of Cheltenham College). Again Gibbs employed Henry Eckford to act as his agent. There was first a lively correspondence as to which paintings to bid for and, equally importantly, how much to bid. Eckford's correspondence from his hotel in Suffolk Street, Cheltenham, relayed their successes and their failures. In all, Gibbs spent £2,179 1s 6d on twenty paintings and two pairs of vases. A number of the pictures remain in the collection, including *Democritus in Mediation*, then attributed to Salvator Rosa, and based on an autograph work now in the Staten Museum for Kunst,

Copenhagen. The excited Eckford had written after that sale session: 'I have purchased for you yesterday lot 997 – 75gns.' Earlier that day they had secured *The Madonna and Child with the Infant Baptist, the Magdalen and St Zacharias*, attributed to Parmigianino. Eckford wrote to Gibbs, 'I have succeeded in purchasing for you today [lot] 584 – gns 100',[7] and followed up with a note saying complacently, 'Your Parmigianino, Sir Edward Lechmere told me he would have gone as far as 200gns for it had he been present' (rather typical comfort from a dealer). The most beautiful paintings they acquired were *The Baptism of the Ethiopian Eunuch*, then attributed to Rubens and now to his contemporary Jan Wildens, and *Tobias and the Angel*, then attributed to

Tobias and the Angel, purchased by William Gibbs as being by Rembrandt at Lord Northwick's sale, 1859.

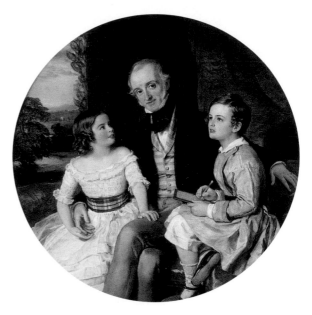

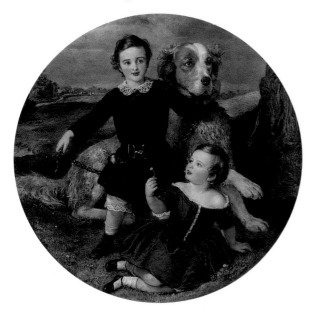

The Gibbs family –
three miniatures by
Sir William Charles Ross, RA,
1849 and 1852.

Rembrandt and now to his pupil Gerrit Willemsz Horst (*c.*1612–52).
It is a hauntingly beautiful work: the angel, dressed in white, holds
Tobias's staff, encouraging the young boy to catch the fish that will cure
his father's sight.

Gibbs also commissioned portraits that reflected the domestic life
of his family. The earliest were pastels of himself and Blanche painted
shortly after their marriage by the French artist Eugène-François-
Marie-Joseph Devéria (1805–65). He is shown smartly dressed in his
habitual black cravat and dark coat, whilst Blanche is demure in a
black dress, with her hair drawn neatly back and her hand drawn across
her dress. The most tender, though, are those by Sir William Charles

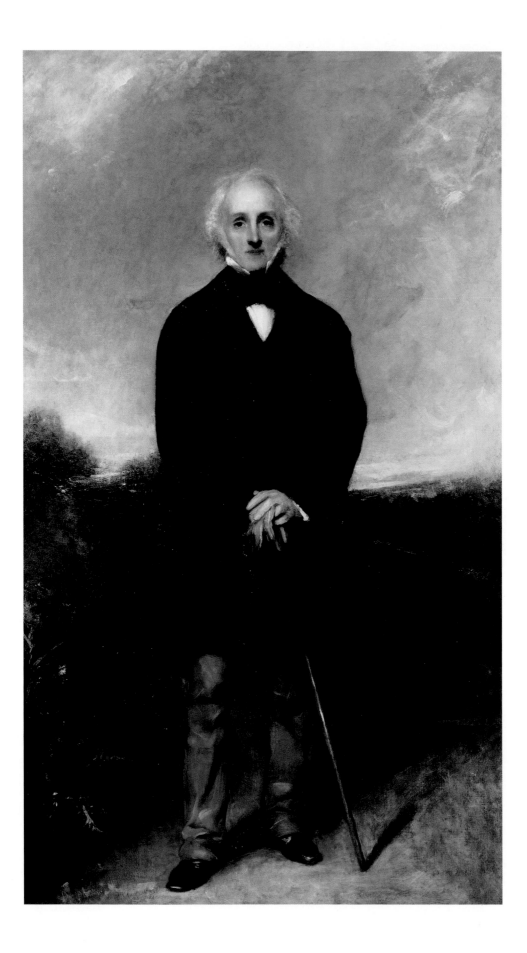

Ross, RA (1784–1864), miniature painter to Queen Victoria. Ross stayed at Tyntesfield for six weeks in 1849, and during that time he painted William with his two eldest children, Dorothea and Antony. William smiles out at the viewer, while his daughter in her flowered white dress gazes up at him. Her brother sits with pen and paper, a young businessman in the making. In the pendant, Blanche is surrounded by the younger children, William, Alice and the baby George Abraham, then just one year old. Three years later George Abraham was painted by Ross, this time with his baby brother Henry Martin, born in 1850, and the family's pet dog. These are unusually large miniatures, painted on ivory discs ten inches in diameter. They are contained in ebony cabinets to protect them, with a pair of doors that open to reveal the pictures inside, glazed and surrounded by gilt mounts delicately ornamented in the spandrels. In the recent exploration of the contents of Tyntesfield, the portraits were found, carefully put away in the Drawing Room cupboard, the doors of the ebony cabinets firmly closed. Opening them opened a window on Gibbs's young family – a warm and friendly family, certainly not flaunting their wealth, and with a hovering sense of seriousness of purpose.

Further portraits followed. In 1859 William and Blanche sat for Sir William Boxall. The first picture of Mrs Gibbs is more of a sketch, left unfinished, its rapid strokes producing a rather dynamic painting of her, in contrast to her normal placid appearance. It may well have been painted at the same time as the charming portrait of Albinia, aged about six, when Mrs Gibbs probably accompanied her daughter to the artist's studio. Boxall also made a small portrait study of Gibbs himself before attempting his full-length portrait, which initially hung in the Morning Room until moved to the Staircase Hall in about 1910. The finished portrait shows Gibbs in familiar guise, dressed in black and holding his walking stick. The walking stick is a masterstroke of characterisation – Gibbs walked everywhere, from Tyntesfield to Belmont, from Hyde Park Gardens to Lime Street in the City. It is the portrait of an active man who had built up a highly successful business and owned two beautiful houses decorated by the celebrated Mr Crace. It is also a portrait of a man in his seventies, and it comes as a surprise to realise that even at this advanced age the sitter was shortly to embark on the rebuilding of his country house, and that his greatest works of philanthropy were yet to come.

William Gibbs by Sir William Boxall, RA, 1859. The artist was a close friend of the sitter and his family.

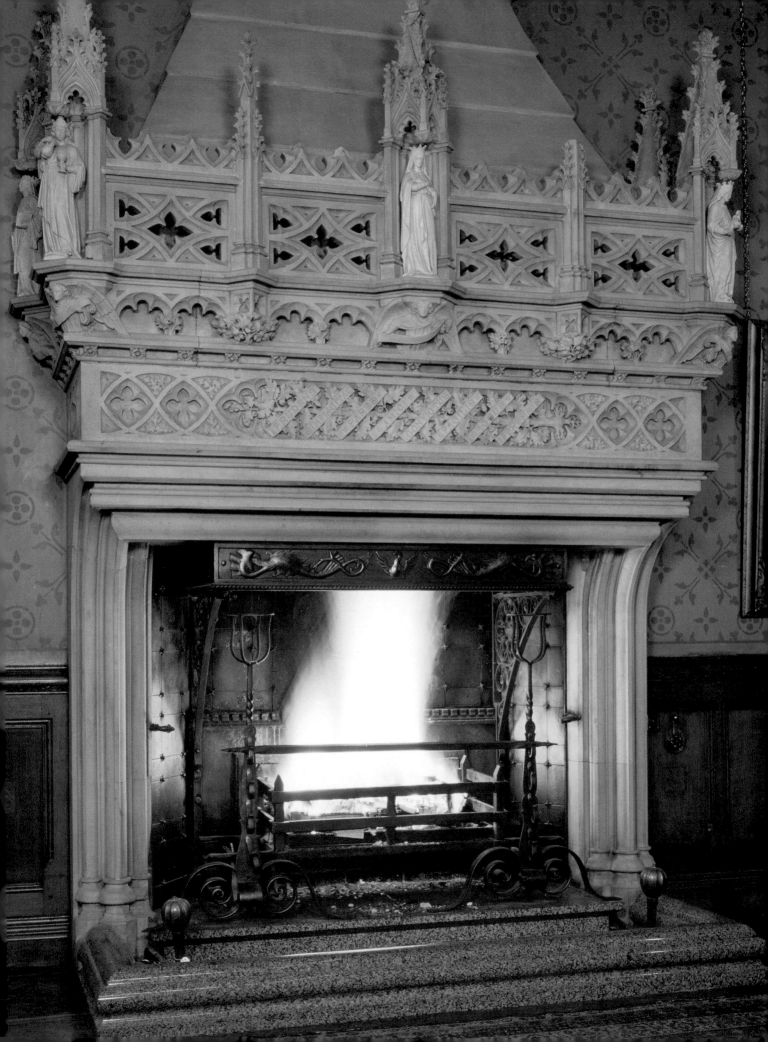

Tyntesfield Rebuilt

'Hawkins arrived at 1.20 and after lunch we went over the whole house with him, with most of which he seemed most pleased. He said that it did Norton great credit. Generally he thought the chimney pieces heavy but admired that in the drawing room. He did not consider the outside as too much ornamented which I was glad to hear him say.'[1]

The 74-year-old William Gibbs entrusted these words to his diary on the evening of 14 December 1865. The relief is almost palpable. The rebuilding of Tyntesfield had taken nearly two years to plan and three to execute. That it was a triumph of planning and execution Gibbs needed no reassurance, but its architectural qualities were so original in both design and ornament that he was glad to have the approval of his old friend, the architect Major Rhode Hawkins. It is true that there had been moments of frustration. On 2 November 1865 he had written that Tyntesfield was 'still in a most unfurnished state and full of workmen',[2] but on the whole the building work had proceeded well. John Norton, the architect, and George Plucknett of William Cubitt & Co., the builders, had managed to accommodate the late changes to the plan and bring the project to a close on time, and almost within the £70,000 budget. This is all the more remarkable given the transformation that they had wrought.

When the last pile of stones was cleared away and the final section of scaffolding was taken down, a glistening Gothic giant of a house was revealed. The charming but cautiously picturesque outline of the Reverend Seymour's Tyntes Place had been superseded by the powerful, bristling Gothic of Mr Gibbs's Tyntesfield. It was not just that the house had doubled in size, nor that it soared upwards, taking in another storey and then rising even higher; it was that every part of the building, both inside and out, had been considered as an independent work of art that Norton had brilliantly orchestrated into a dynamic whole. Towers, gables, pinnacles, tourelles and crenellations articulated

Above: A detail of the carpet supplied by John Crace, in the Library.

Left: The monumental Gothic fireplace in Mansfield stone, designed by John Norton for the Staircase Hall, with statues symbolising Fortitude, Temperance, Justice and Prudence.

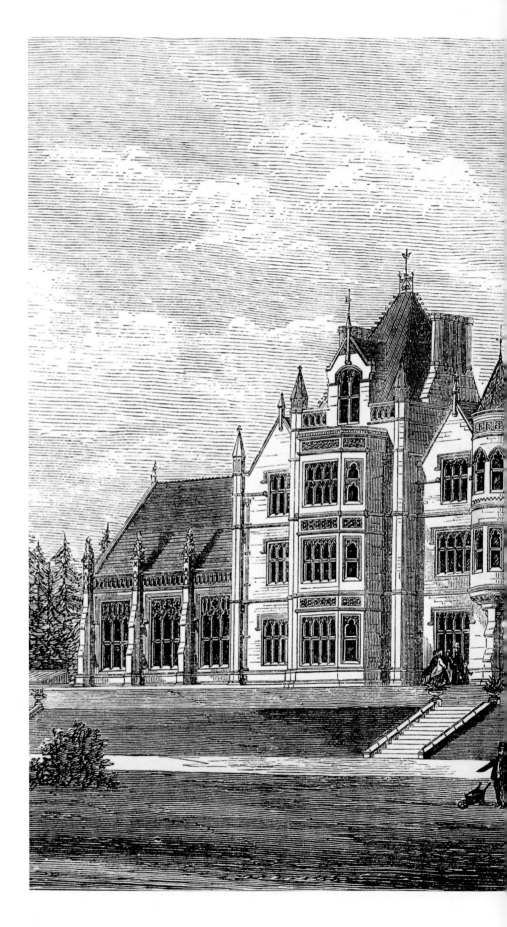

Tyntesfield as remodelled by John
Norton, taken from the article in
The Builder, February 1866, p.101.

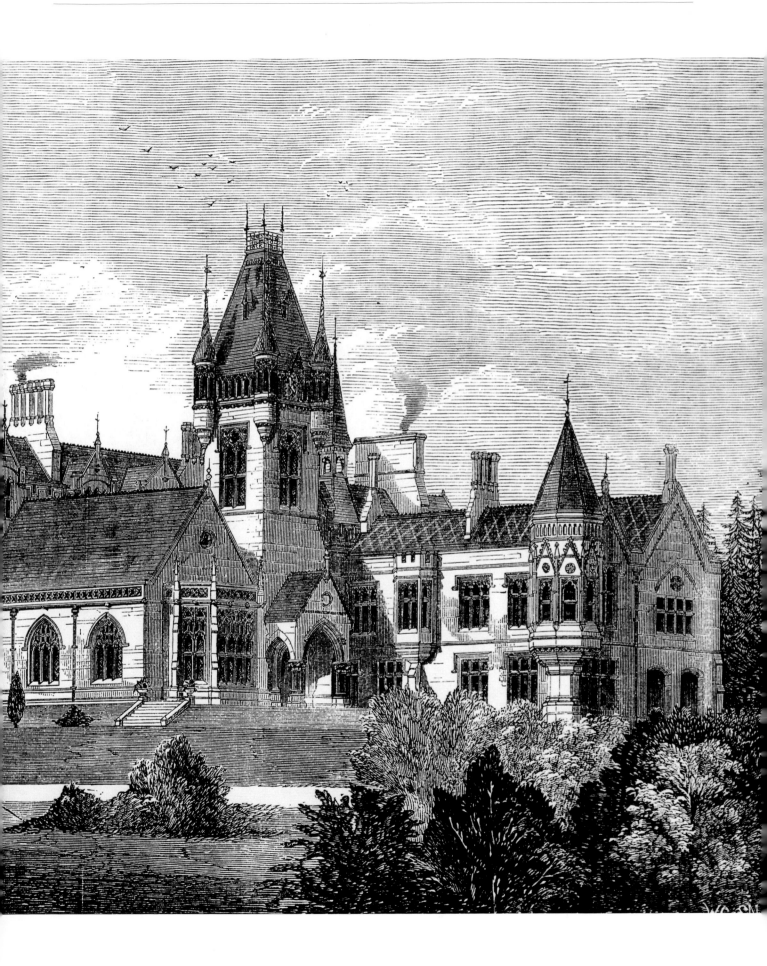

the roof like a rhythmic fugue; the windows were equally varied, with leaded lights, sheets of plain glass, bronze ornamental bars and stained glass. Some walls were left aggressively plain whilst others were richly ornamented with supremely confident Gothic and naturalistic carvings. On the east side new wings sailed out to form a noble entrance court; the south front took full advantage of its terraced position; the west front was the most varied, with the apsidal end of the new double-height Drawing Room balanced by a crystal palace of a Conservatory. The house had been transformed from a comfortable ensemble into a resounding paean of domestic Gothic architecture.

The architect of this transformation was John Norton (1823–1904), who had built up a reputation as a 'Goth' in the 1850s. He had been born and educated in Bristol before becoming a pupil of Benjamin Ferrey (1801–80), friend and biographer of Augustus Pugin, whose credo and style the young Norton absorbed. Ferrey himself had established a domestic and ecclesiastical practice in the West Country with his appointment as honorary architect to the diocese of Bath and Wells. Norton retained strong connections with the West Country. His principal office was in London, but he kept up a subsidiary one in Bristol and it was from here that he designed a host of West Country churches between 1855 and 1870.[3] These churches shared an architectural language derived from fifteenth-century English buildings, and by the early 1860s Norton had acquired an impressive fluency in his approach to design. It was this experience he brought to his country-house work.

In 1859 Norton had his first opportunity to build a large Gothic house, Nutley Priory, near Redhill in Surrey, for the banker E. H. Gurney. This was highly successful, but sadly the demise of the building was sealed only ten years later when a new owner decided he needed an even larger mansion and demolished Norton's edifice. However, by then Norton had built his enduring Gothic masterpiece, Tyntesfield, heralded by two other West Country commissions: Brent Knoll for G. S. Poole and the remodelling of Chewton Magna Manor for W. Adlam.

Norton's name first appeared in Gibbs's diary on 21 August 1860: 'Norton came up [to Tyntesfield] & dined with us and spent the evening.'[4] A professional friendship developed, a friendship that may have introduced Gibbs to Cubitt the builder, although it was his ecclesiastical architect, Rhode Hawkins, who was present at their first meeting on 13 March 1861: 'I drove with him [Hawkins] to Cubitts in the Grays Inn Road & was very much interested in going over their works where we were joined by [his] Partner, Mr Plucknett with whom we have a long talk about New Church Seats, different stones etc &

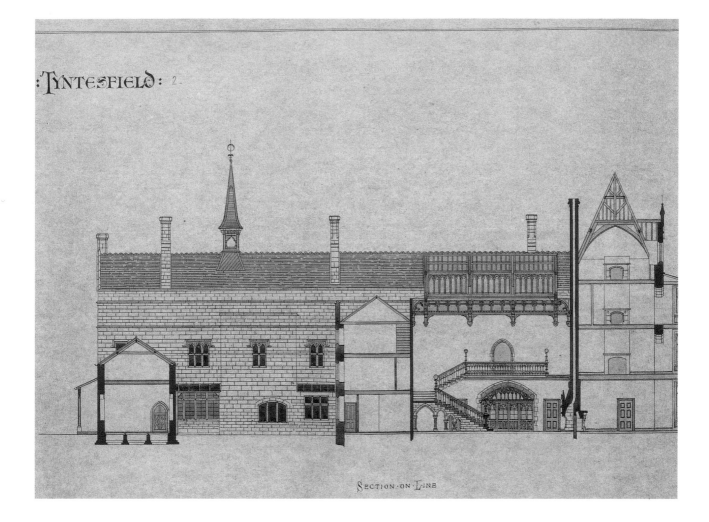

A cross-section drawing by John Norton, *c.*1862, showing the Staircase Hall.

I was very much pleased with him.'⁵ Norton completed his initial designs in 1863 after visits to the house – recorded in William's diaries – in March, April, October and November. His drawings showed how he could graft his new building on to the existing house, colouring the new walls on his plans in a vibrant pink wash. Work then commenced and the first payment was made to William Cubitt & Co. on 7 October. Cubitt's was the natural choice. The company had been founded by Thomas Cubitt earlier in the century and subsequently managed by Sir William Cubitt. Its premises at 47 Gray's Inn Road were second to none and the firm had established a pre-eminent reputation for its ability to carry out all manner of work. It had also won royal approval, having built Osborne on the Isle of Wight for Queen Victoria, to Prince Albert's design. Both brothers were also involved with building churches and schools, and supporting many charitable causes that would have endeared them to Gibbs. Sir William's partner, George Plucknett, was to be given the overall responsibility for the building work at Tyntesfield.

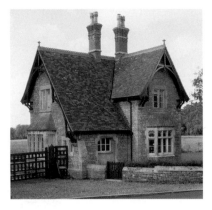

One of the entrance lodges designed by John Norton, *c*.1865.

When work started in earnest, the family vacated the house. When events necessitated a visit, William stayed at Belmont with his sister Harriett, now widow of George Henry Gibbs, who had died in 1842. Otherwise they were in London or in Devon. William's nephew John Lomax Gibbs noted in his 'Reminiscences' in 1862, 'The Tyntesfield family were living at Mamhead at that time. The beautiful place near Dawlish which they had taken for two years during the alteration of their own home.'[6] Norton and Plucknett adhered to Gibbs's tight deadline and two years later, in the autumn of 1865, the family were able to move back to the transformed house. The following February, public recognition of the great undertaking was given in *The Builder*: 'TYNTESFIELD, NEAR BRISTOL, SOMERSET. This very complete and costly mansion [has] just [been] completed, from the designs of Mr John Norton.'[7] It was an enormous achievement on the part of both the architect and the builder. It had not been without its disagreements and worries, particularly over the use of ornament, which Gibbs held as unnecessary and costly, but he had been brought round. In June 1864 he had written in his diary, 'Walked out to Tyntesfield [from Belmont] where Norton arrived late at 12 & we went over many pending matters & had additional reason to disapprove his immense show of ornament & outward features.'[8] But by December 1865 everyone seemed to have been pleased with what had been accomplished, even though work was still in progress. 'Plucknett made his appearance & came down no doubt to hurry on the work in consequences of having said that I would pay nothing more till the work was finished.' Not surprisingly, after they had moved in, William and Blanche were visited by streams of relations and friends anxious to see the new Tyntesfield – the diaries are full of such visits, some for the day and others much more prolonged. It is hardly surprising that Gibbs, writing towards the end of the summer, noted, 'Painful talk to Blanchey who seems so dreadfully depressed and tired for having people in the house that I shall be afraid to ask anyone here.'[9] The mood passed and friends were less demanding, but still they came.

A visitor's first intimation of the estate would have been one of Norton's new lodges built of deliberately rough-hewn pink-grey stone from Blanche's native Forest of Dean, with finely cut Bath ashlar around the windows and arched doors. Irregular in their outline, mildly Gothic in their detail, with whimsically shaped bargeboarding beneath their low eaves, these buildings were the homes of the lodge keepers. Typically of Norton's technical ingenuity, winches were installed in the small entrance hall for opening the gates, a highly practical device, especially in foul weather.

Three independent drives led to the house. The one for Belmont

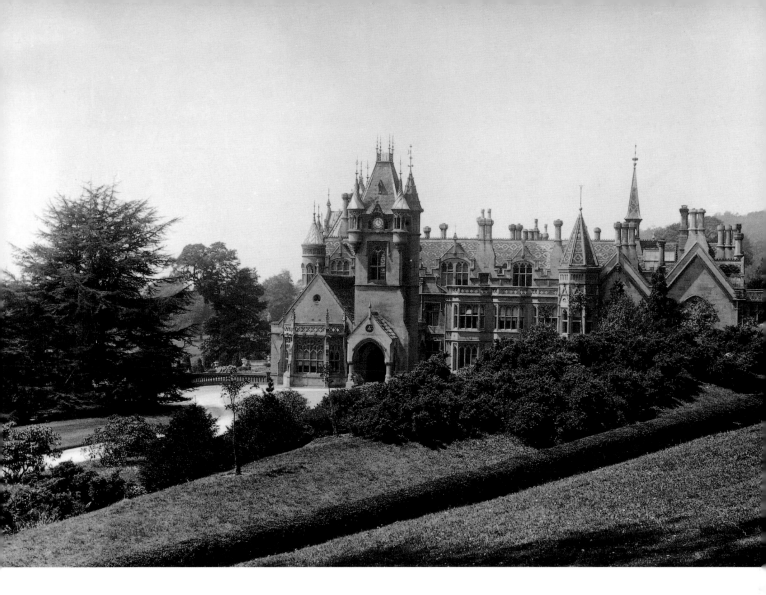

The Entrance Front showing the
Clock Tower above the new
Entrance Porch, *c*.1865.

passed through the woods that hugged the hillside. The southern drive, extending from the road between Flax Bourton and Wraxall, led up through a fine, curved avenue providing glimpses of the house beyond. The northern drive passed gently down through open parkland, its way marked by clipped yews, before curving and dipping, offering views over the spiky new skyline of the house. The drives came together before opening out into a grand courtyard in front of the east façade of the house.

Alighting from a carriage, or the family omnibus which collected visitors from the station at Flax Bourton, the visitor would be struck by the unusual Cloister entrance seen through the entrance porch, surmounted by a 'lofty great tower, with high pitched roof and cornered angle tourelles, topped by conical lead roof terminating in elaborate finials, and linked by an open Gothic arcade'.[10] Centrally placed between the front tourelles was a chiming clock by the principal London maker, Dent, which was illuminated by gaslight at night, making it visible across the park. This mighty tower was the highest part of the entire building. Its Gothic style was continental

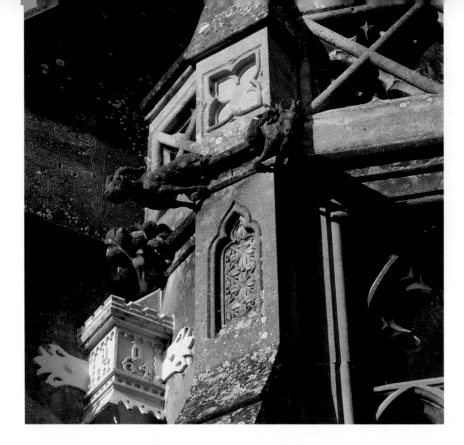

rather than English, reminiscent of the famous tower over the Danube Bridge in Prague, but its immediate architectural antecedents were much closer. Its sharply pitched roof echoes that on the Oxford Museum, completed in 1860 to the designs of Deane and Woodward, which would have been familiar to William and his eldest son Antony, who had gone up to Exeter College that year. To the right of the court stood a new wing, its roof ornamented with patterns of coloured tiles reminiscent of Burgundian churches. At its end, on the first floor, was a further, larger tourelle, similarly tiled and richly decorated with Gothic blind arches and columns. On the left was a simpler, quieter Gothic building, single-storeyed and monastic in feeling, although ending in an applied window richly ornamented with pinnacles, arcades and tracery. The brilliance of Norton's conception was immediately apparent. It lay not only in its delicious Gothic irregularity, but also in achieving a sense that the building had grown organically over a long period of time.

On closer inspection the visitor would have become aware of the ingenuity of the ornamental carving. Its use was brilliantly orchestrated, again giving a sense of the different elements having been conceived at different times. Whilst the right-hand wing relied simply on architectural details, arcades, roundels and heavy lintels, the plainer building to the left is alive with crisply executed naturalistic carvings, as described in *The Builder*: 'The chief carver was Mr Beates, who has repeated in stone the beautiful forms found in the woods.'[11] Beates and his team created the most delightful stone vignettes: a weasel scurrying

A detail of the flamboyant and naturalistic carving carried out by Mr Beates.

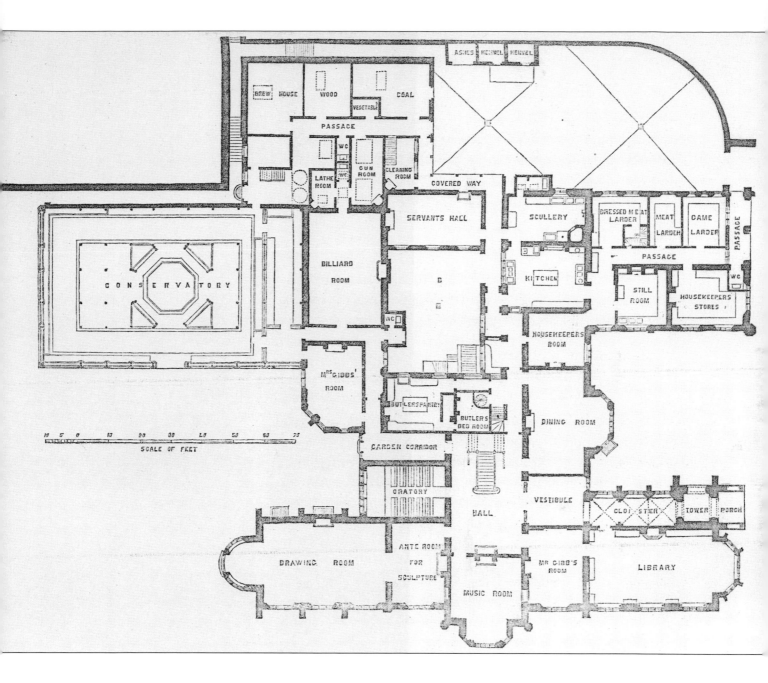

The ground plan published in
The Builder, February 1866.

into bracken and a startled bird taking flight from a branch. The gargoyles above are more fantastic. Here, as elsewhere, there is delight in transforming moments of nature into works of art. The balance between architecture and ornament was nowhere better achieved than on the entrance porch itself. Here the naturalistic carving was restricted, in minute detail, to the capitals, where lizards, a dormouse and even dragonflies interweave amongst ferns. The contemporary influence of John Ruskin's precepts are strongly felt here: 'all art employed in decoration should be informative, conveying truthful statements about natural facts'.[12] Above the entrance, beneath the apex of the roof, the

wall is left very plain. Incised into it, and not dominantly superimposed, were the family arms with small lettering for their Spanish motto, *En dios mi amparo y esperanza* ('I place my trust in God'). More overt is the proclamation, deeply carved above the arch itself, *Pax intrantibus salus exeuntibus* ('Peace to those who enter, farewell to those who depart').

Passing beneath the arch, the visitor would have walked beneath the tower towards a pair of Gothic doors, with open lancet windows to their right, ornamented with Gothic metalwork. The bronze hinges and handles on the doors, also in the Gothic manner, created ornamental patterns across the massive oak frames. Beyond was a further three-bay Cloister corridor with a vaulted ceiling with corbels carved with cobnuts, holly and mistletoe, primroses and other local flowers, reminiscent of the O'Shea brothers' unfinished work on the Oxford Museum. The floors were covered in colourful encaustic tiles made by John Minton, the lively designs and bright tones – especially of the border tiles – influenced by Pugin's intensive study of medieval originals in the 1830s and 1840s. At the corners of each Cloister bay are slender shafts of native carboniferous limestone, again reflecting the influences of the Oxford Museum, where the columns supporting the internal cloisters were all constructed of British rock, each labelled, and ranging from carboniferous limestone from the Hot Wells in Bristol (a darkish grey) to Devonian limestone (a pink-grey), and serpentine from the Lizard in Cornwall (a rich, dark green-black). Nearly thirty different natural stones were used. The variety incorporated into Norton's decorative scheme at Tyntesfield falls only slightly short of this. Passing through double Gothic doors at the end of the Cloister corridor, the visitor would enter a Vestibule 'paved with a mosaic of marble and tiles', for which Crace designed a handsome Gothic oak cloak-stand. The ceiling retained (and still retains) Crace's original grained ribbing and ornamental cornice leading down to stencilled walls. On the far side was an elaborately glazed Gothic screen, reminiscent of a rood screen, with a central door which in turn opened into the Staircase Hall. Norton's creation was quite extraordinary. He had combined the Gothic beauty of holiness with a reverence for nature. He created a domestic architecture based on the recent collegiate buildings in Oxford. Suddenly, too, the tenets of Ruskin and Pugin have become transfixed in stone.

Before arriving at the Vestibule, a visitor might well have turned left through a smaller Gothic door, in the third bay of the stone Cloister. Its bronzed Gothic hinges were inscribed *Litera scripta manet* and *Verba locuta volant* ('The written word remains'; 'Spoken words fly away'). This door opened to reveal, obliquely, a high and light room

The Cloister corridor showing the Minton tiles and the carving on the arch and bosses.

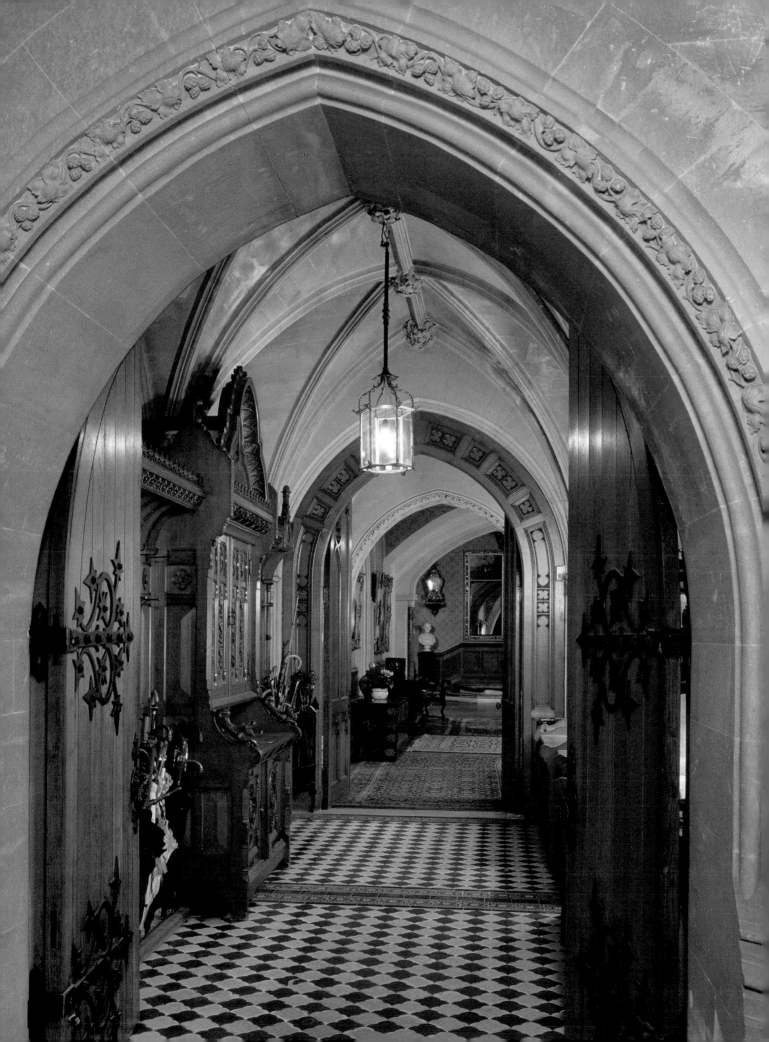

dedicated, as the inscription would suggest, to the world of books. The walls were lined with polished oak bookcases with outlines reminiscent of a trailing Gothic script, and whose tops were in two heights with mild running crenellations. Their golden colour was enhanced by the gilt leather dust-flaps, and the bindings of the books contrasted with the darker tones of Norton's decidedly plain wooden panelling. At cornice level the mighty ribs of the open wooden ceiling are similarly covered with further tongue-and-groove panelling. Again Oxford is evoked, though here not the Museum, but Giles Gilbert Scott's new library at Exeter College, which had been completed in 1860. Here, as at Tyntesfield, the walls and beams are striking in their plainness. Norton lightened his design with Gothic ornament to the beams and the cornice, incorporating in a running italic script the family's Spanish motto.

The room, with its preponderance of wood, might have seemed heavy and even gloomy, but Norton flooded it with light and brought colour and life to all the ornamental details. Along the far wall, opposite the door, are three wide stone windows with Gothic stone tracery in the upper register and tripartite windows beneath, filled with clear glass opening to the view of the valley below. As if that were not enough, at the far end of the room a large bay with three taller Gothic windows, full of clear glass, look out across the entrance court. The ceiling of the bay was made of a large opaque glass panel flooding yet more light on to Beates's exquisite carvings set into the span of the arches. Norton introduced colour with Minton tiles that edge the stone windowpanes. This delicate polychromy was taken up and vastly expanded by the first of his hugely idiosyncratic fireplaces. Its massive Gothic frame is carved in cut Bath stone, inset with a galaxy of brightly coloured native polished stones, some as flat panels, some as applied hemispheres. The sides are held by twin pairs of twisted,

Above: One of the inscribed Gothic hinges on the Library door.

Right: The Library, designed by John Norton and influenced by the upper library at Exeter College, Oxford, showing Crace's sofa and his magnificent carpet.

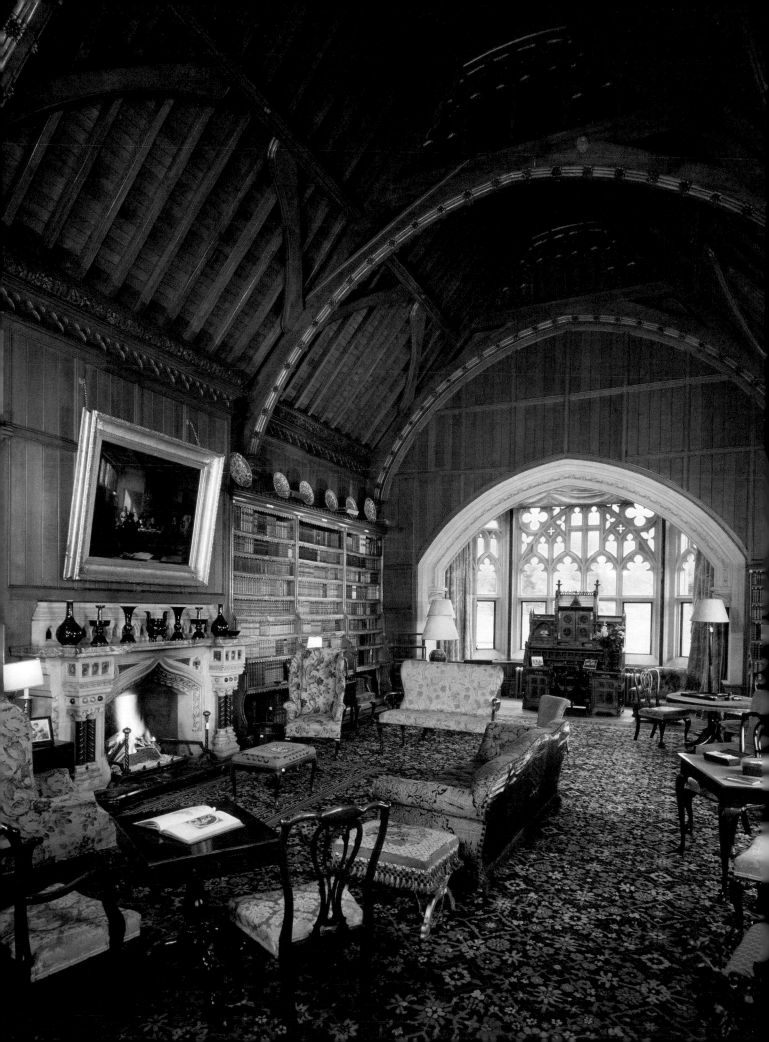

Matilda Blanche in the Morning Room, wearing Court dress and standing by her harp.

dark-red Cornish serpentine columns. The central opening is an ogee arch expressively carved with bands of leaves. Yet further colour came from the magnificent carpet supplied by Crace and woven by Blackmore on the old Axminster looms which, since the 1830s, had been installed at Wilton. The time and cost involved in the making of such carpets had meant that it had had to be commissioned. Gibbs may well have first come across such spectacular weaving at the Great Exhibition in 1851, where five carpets specifically woven for Windsor Castle were shown. Crace also supplied curtains (now gone) and the set of three parcel-gilt and polychrome oak curtain poles with their beaded collars, foliate Gothic roundels and fleur-de-lis terminals, which remain.

Crace's bookcases are now full of books bought over many generations, but those originally owned by William are still much in evidence. He was a regular buyer of books, and invoices relating to various transactions survive. On 9 March 1859 he called on Bernard Quaritch, buying Spanish books, and on 21 March on James Nisbet & Co.: some twenty years later he was acquiring books from Francis Edwards and Rivington & Co.[13] The room contained a large number of contemporary theological volumes as well as rows of contemporary novels, travel books, lexicons and a wealth of contemporary books on art and architecture. The Library, though, was not just for reading and working; it was also, from the start, a family room. Less than a month after they had moved back into Tyntesfield, amateur dramatics were taking place there, the capacious bay of the end window presumably providing the perfect proscenium arch.

From the Library a door through the bookcase led straight into William's study. This and the adjacent Music Room were largely left unaltered by Norton: the former retained its original early nineteenth-century Gothic fireplace, although the latter received a spectacular new one. This time the ogee arch is further decorated with a running pattern of smaller arches, above which are panels of pale-pink and pale-green Connemara marble. The room was to become Blanche's sitting room, and it was here she was later to be photographed working and playing her harp. Both rooms also benefited from Norton's innovative heating system. 'Three separate boilers in the basement provide the means of warming the halls, corridors, principal rooms and conservatory,' wrote the contributor to *The Builder*.[14] The ducting pipes, which open halfway up the walls, are still in place in the Morning Room, and were adjusted by turning a small tap in the form of a miniature hand.

The alterations to the adjacent Saloon were more significant, transforming it into an Ante-room to the new Drawing Room beyond. Norton's great alabaster fireplace here is richly set with pink, grey-green

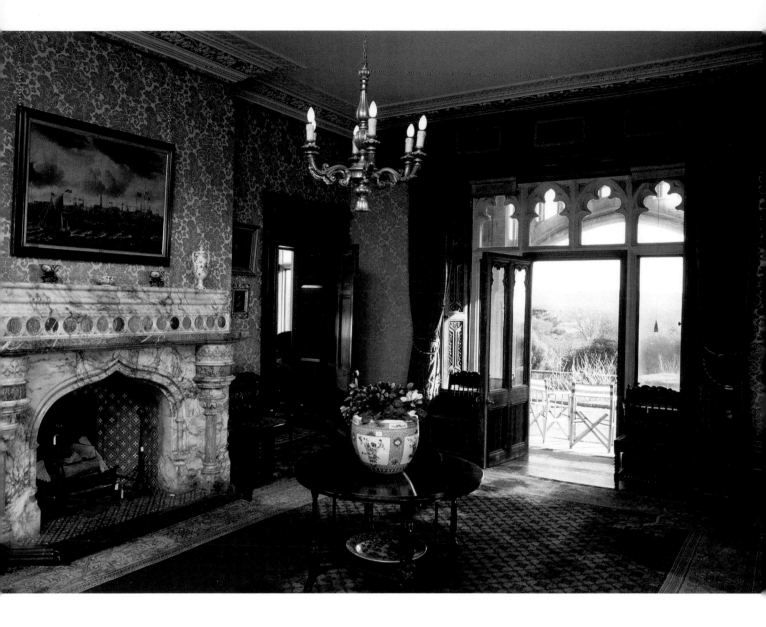

The Ante-room created by John Norton, where William Gibbs's collection of contemporary sculpture was originally displayed.

and dull-red polished limestone, and decorated internally with Minton tiles filling the eastern wall. On the floor is a further specially woven Axminster carpet, designed and supplied by Crace, and incorporating William's monogram in the corners. This room was soon used to display his growing collection of contemporary British sculpture. In 1861 he had acquired from M. M. Holloway of 25 Bedford Square in London a pair of white marble idealised heads for £57 15s. These were by Richard James Wyatt (1795–1850) who, having studied under both Canova and Thorvaldsen, spent the rest of his life working in Rome. Later the same year Gibbs and his family made their first journey to Italy. They stayed in Rome for four months and commissioned a pair of busts of themselves as well as a full-length marble of their daughter Albinia by Lawrence Macdonald (1799–1878). The busts were

executed the same year and the full-length statue was completed in the following. Macdonald was the foremost portrait sculptor in the city. In 1850 a critic commented that his studio was like 'the peerage done into marble, a plaster galaxy of rank and fortune, row after row in room after room of noble and illustrious persons'. His busts of Gibbs and his wife were sensitively executed and the statue of their sweet daughter, Albinia, whom Gibbs always referred to as his 'little maid',[15] is incredibly touching as she stands carefully holding a flower and a small bird. The statue is on a revolving base so that when standing in the Ante-room it could be gently turned. The same is also true of the marble of Albinia's older sister, Alice Blanche, later Mrs Gurney, commissioned from Macdonald's rival Benjamin Edward Spence (1822–66).

Spence had been born in Liverpool but had arrived in Rome in the 1840s, where he trained with Richard James Wyatt and John Gibson. In 1852 he carved the first version of *The Highland Mary* for Charles Meigh of Grove House, Shelton. It represented Mary Morison, Robbie Burns's unattainable lover. Spence showed her at the moment after they had met for the last time and sworn eternal faithfulness, evoking

Albinia Gibbs by Lawrence Macdonald, 1864. The statue, formerly in the Ante-room, now stands in the Entrance Hall.

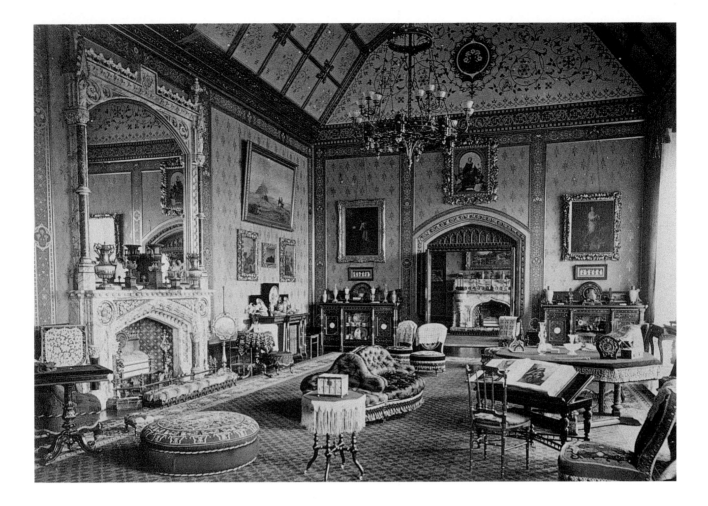

The Drawing Room in 1878.
This photograph by Bedford Lemere
shows the painted decoration
devised by John Crace and the
great Gothic fireplace, later moved
into store.

Burns's lines: 'Ye banks & braes, and streams around the castle of Montgomerie / Green be your woods and fair your flowers. Your waters never drunke / Their summer first unfaulds her robes. And there she longest tarries / For there I took my last Farewell, of my sweet Highland Mary'. The work was immensely popular and Spence made a number of subsequent versions, including one for the Prince Consort as a present for Queen Victoria. Gibbs left a similar commission with Spence before the family left Rome. The only difference was that the head of *The Highland Mary* was to be based on that of Alice Blanche who, according to William's diary, sat at least eight times for the sculptor.

Quitting these white marble statues, the visitor to Tyntesfield then passes into the new Drawing Room. This is Norton's next masterstroke. Placed on the furthest side of the house from the Library, it is also a new building, over 40 feet long and rising through two storeys, but here the similarities end. Here Norton had designed a room even loftier than the Library, lit by even larger windows, and entered through massive carved double doors on an axis. Whereas the

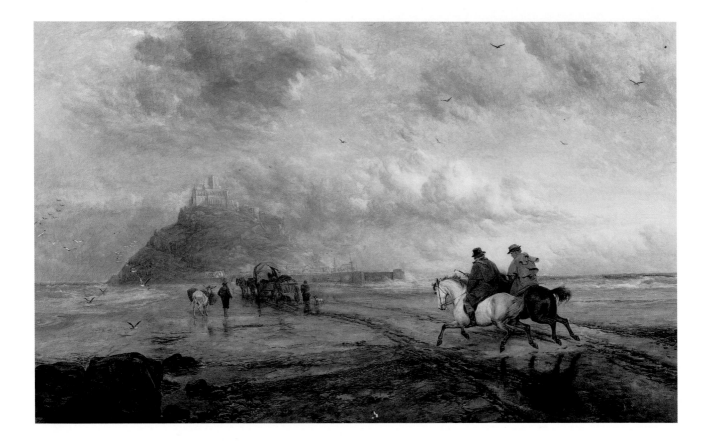

Library was richly honeyed in tone, the Drawing Room was conceived
in light, bright polychromy. A photograph by Bedford Lemere shows
how it looked by 1878. A huge Gothic fireplace, executed in coloured
marbles, lined with Minton tiles and surmounted by a vast looking-
glass, with side columns supporting statues, fills the left-hand wall. The
walls themselves were richly stencilled by Crace, who called to see Mrs
Gibbs in May and July 1865 to discuss the decoration of the house and
arrangement of the furniture. Gilt fillets framed the stencilling,
between which ran further panels of stencilled flowers. The pitched
ceiling, divided into panels of *carton-pierre*, was decorated with freer
patterns executed in lighter colours that emphasised the height of the
room. Again the influence of Oxford hovered here. The treatment is a
similar but more sophisticated version of the ceiling of the debating
room at the Oxford Union. Crace supplied the richly tasselled curtains
and another diaper-patterned, richly coloured Axminster carpet, with
its stylised flower border again incorporating William Gibbs's initials at
the corners.

The paintings hung on the far wall included *Tobias and the Angel*
by Horst, which had been purchased from the Northwick Collection,
The Immaculate Conception bought from Romero de Balmaseda, and,
above the door, *The Virgin Appearing to St Bruno* after Perugino. Gibbs

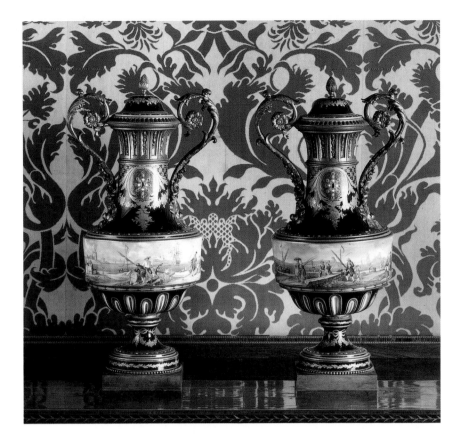

A pair of gilt-metal mounted 'Sèvres' vases, c.1850, acquired by William Gibbs from the Great Exhibition in 1851 and visible in Bedford Lemere's 1878 photograph of the Drawing Room.

had so admired the original, which he saw in Munich on 5 October 1861 that he ordered a copy of it. To the right of the fireplace hung the large *Breezy Day on the English Coast, St Michael's Mount, Cornwall* by Thomas Creswick, RA (1811–69) in association with Richard Ansdell, RA (1815–86), who painted the figures. The painting had originally been exhibited at the Royal Academy in 1866 and so is almost contemporary with Norton's room.

The chairs, sofas, stools and ottomans to be seen in Lemere's photograph were those supplied by Crace in the 1850s, augmented by a pair of glazed ebonised cabinets and a variety of mid-nineteenth-century ornaments and ceramics. On the mantelpiece stand a pair of gilt mounted Sèvres vases with central sections painted with harbour scenes and set against a jewelled and gilt blue ground, which had been purchased at the Great Exhibition. A delicate brass chandelier, probably made by Hardman & Co. and supplied by Crace, hangs from the ceiling in the centre of the room, in the Gothic style of Pugin and Crace's 'Medieval Court' at the Great Exhibition. Delicacy and variety of ornament were even to be found in the window shutters. Like the doors, these were carved in oak with panels of local flowers. The windows at the far end of the room were designed as a bay, but again they outdid those of the Library, with floor-to-ceiling fenestration

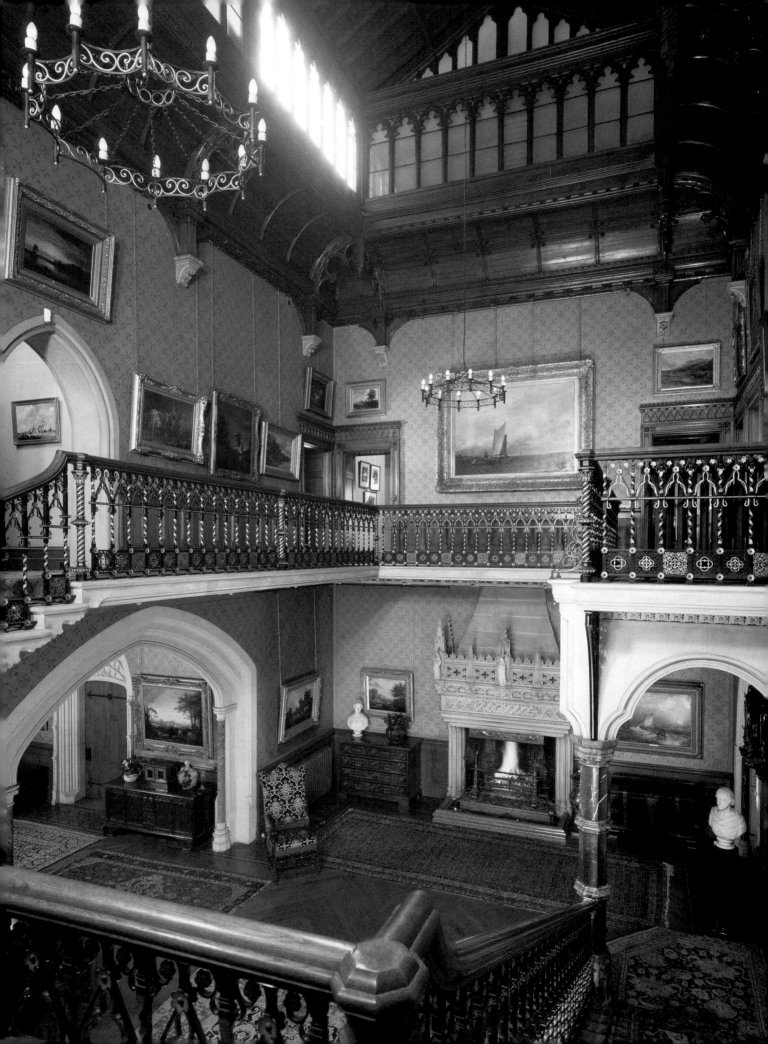

containing large panes of specially made curved glass. From there a door led on to a formal terraced garden.

Returning via the Ante-room to the centre of the house, the remodelling of the Reverend Mr Seymour's Staircase Hall gave Norton the opportunity to create another spectacular room. It rose to the very roofline of the building, some 43 feet through three storeys, enabling him to create a glazed Gothic lantern that rests delicately on beams of English oak that spring from the cornice. A brilliant interpretation of a hammerbeam roof allows light from the cusped lancet clerestory windows to thread its way down first to the gallery walls on this first floor, then to the ground floor beneath. The walls were stencilled by Crace in floral geometric patterns in tones of green. The imperial staircase itself, of Portland stone, sprang from the centre of the Hall, rose to a half-landing supported by Gothic arches, and then divided, joining again on a first-floor balcony that gave access to the bedrooms. The newel posts were formed of *griotte* and green Irish marble, ophicalcite from County Galway, also to be found at the Oxford Museum. The balustrade was of gilded wrought iron originally painted to imitate bronze, its Gothic pattern owing much to the gilded grille that surrounds the organ pipes in the chapel at Exeter College, Oxford. At night the room was lit by a pair of 'wrought and jewelled gasoliers'[16] placed on the newels and by decorated gas 'standard lamps' rising from the rails at the corners of the balcony. The gasometer for the lighting, supplied by Messrs J. T. B. Porter & Company of Lincoln, was concealed in a plantation to the north of the house. It also supplied gas for the offices, stables and even extended as far as the lodges. In case of fire, fire hydrants were supplied for every floor, fitted in specially made wall cupboards.

The detailing of the great space was brilliant in its execution, from the naturalistic carvings of the stone brackets to the huge Burgundian-style fireplace of Mansfield stone with its statues of Fortitude, Temperance, Justice and Prudence carved in pale Maltese stone and standing beneath their Gothic canopies carrying legends. This was the very centre of the house: a Gothic archway led to the Ante-room; another, beneath the stairs, to the Kitchen. The Gothic screen led to the Vestibule and three further doors to Mr Gibbs's Study, the Music Room and the Garden Hall. A final small Gothic door led west to the Oratory. Here prayers were said morning and night, led by the Reverend Hardie, the chaplain, for both family and household. From the simple oak stalls on either side of a central aisle, the congregation looked towards a lectern and litany desk and windows containing grisailled glass. Crace supplied further furnishings, including an oratory cross, which he and Gibbs first discussed in May 1867. The

The great Staircase Hall showing Norton's redesigned roof.

Leaving the Staircase Hall by the garden-passage door, a visitor would pass down a further stencilled corridor to the new Billiard Room. This is the third of Norton's double-height rooms. Here he brilliantly constructed another highly unusual ceiling, partly fashioned out of elements devised for the Staircase Hall and Library ceilings. Oak hammerbeams spring out above the cornice to support a tent-like roof of tongue-and-groove boards, while the beams themselves support open timber lancets matched by dormer windows that puncture the intervening walls. Light flooded down on to the billiard table beneath. Beyond this room are further male preserves, including a Lathe Room, created for William's son Antony, who became proficient at turning ivories, and a large Gunroom. At the end of a short corridor was a water-closet, tiled in an alternating pattern of white and a striking mid-blue, supplied again by Mr Minton.

The ground-floor window of the Billiard Room looked straight into the Orchid House, part of the Conservatory. The whole structure

The Organ Room (formerly the Oratory) showing Crace's stencil decoration, the Elizabethan table supplied by Gillows surrounded by chairs designed by James Plucknett, and the Cox & Co. cabinet.

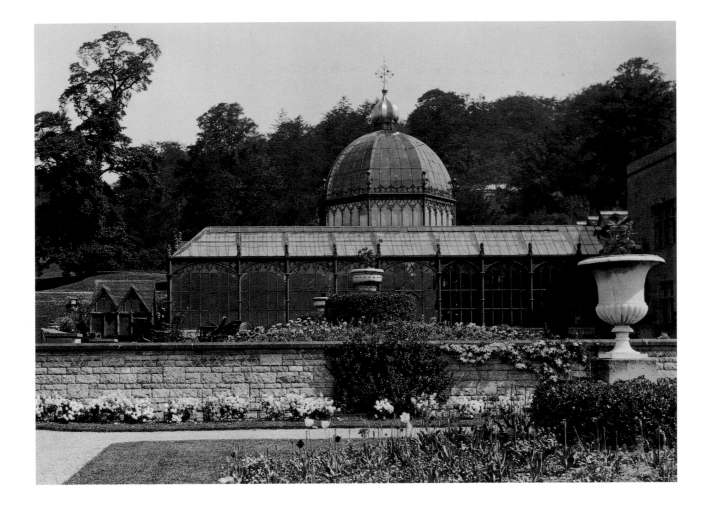

The Conservatory with its dome, modelled on that of the Cathedral of San Marco in Venice.

was 80 feet long and 50 feet wide, almost double the size of the Drawing Room. The anonymous contributor to *The Builder* was suitably impressed: 'Octagonal columns, with moulded caps, annuletes, and bases – the former encrusted with conventional flowers, rose, lily and fern – divide the plan into nave and aisles: the great central feature is an octagon rising into a pear-shaped dome, with a gilt-copper cupola, after the model of S. Marco at Venice and 50 feet in height All the framing, girders, roof, etc are of rich ironwork, resting on a dwarf wall of Bath stone. The glass is of a pale green tint, from a recipe of the late Sir W. Hooker, made especially for the Palm House at Kew; the floor is laced with Minton's tiles, and the beds and stands are ranged to permit of the house being used for promenades on occasions of receptions.'[17]

On the first floor Norton exercised considerable restraint in the main bedrooms. The corridor's oak doors were treated with simplified Gothic patterns incorporating distinctive varnished mouldings; inside the bedrooms the early nineteenth-century frames were largely retained. The majority of the fireplaces were also kept, though some

bedrooms were given simplified stone versions of those that had appeared on the ground floor. One exception was Mrs Gibbs's bedroom (now the Charlton Room), where another elaborate fireplace with coloured stone was installed. Norton's main contribution to the first-floor arrangements was the new east wing, which refashioned and doubled the size of the old service wing. Here he contributed two spectacular double-height rooms, now the Flaxley and Turret Rooms. Again, it was his treatment of the ceiling in the former that was so idiosyncratic, with plain oak beams running up from a deep oak cornice, creating a pattern of large squares. The effect was stark, strong and uncompromising. The Turret Room, with another distinctive fireplace, became William's bedroom in later life. A lighter feeling is found in this adjacent corridor, which linked the old wing to the new. In the remodelling it lost its original windows, so Norton provided a brilliant *coup de théâtre* to overcome this potential problem. Light was filtered down from skylights in the ceiling of the floor above, through

The Chapel corridor with its Gothic arched ceiling set with opaque glass.

special thick glass floor panels. The light was then diffused through a series of curved glass panels set in a Gothic framework. This top-lit Gothic corridor led back to an internal hall with another elaborate fireplace containing a mirror, which was used to reflect the light further. Beyond, a simplified, painted version of the Gothic ceiling led to the oak service stairs, behind another glazed Gothic screen.

Apart from the original Tower Room, the second floor was entirely Norton's design. A small staircase led from the first-floor balcony up to an inner corridor, off which ran a sequence of children's bedrooms. Here Norton was obliged to re-use fireplaces that had been preserved from the earlier house, but otherwise the eight bedrooms were designed with his now familiar stained beams creating geometrical patterns on the ceilings. In the Louvre Room, at the top of the Terrace Tower, the sharply pitched walls are intersected by much larger internal beams supporting the roof. By 1878, this had become a den for Henry Martin Gibbs, the youngest son.

Norton was responsible for the extensive remodelling of the Kitchen, offices and servants' quarters essential for the running of the house. Beyond the Staircase Hall, mimicking the corridor to the new wing above, a passage led to the domestic area presided over by the butler and housekeeper. The butler's rooms (two rooms preserved from the earlier house) were immediately behind the main stairs. The Butler's Pantry was fitted with cupboards and a special wood-lined sink for washing precious objects that might be damaged against stone or porcelain. Adjacent to this room was his bedroom, with access only from his Pantry. This was his domain.

Further along, the corridor, with its range of hanging bells (each connected by wires to a particular room), ran through a series of turns into the Kitchen. The turns helped to deflect smells drifting into the adjacent Dining Room. The Kitchen was divided into two main areas: the first for cooking, with a large range and gas ovens, a central table and huge dresser. Beyond was the Scullery with a small storeroom for preparation. Both rooms were given fireproof ceilings. Off the Kitchen ran a further passage leading to the Dressed Meat Larder, Meat Larder, Game Larder, Housekeeper's Store (with built-in cupboards) and the Still Room. It also led to a large Housekeeper's Room with its own window on to the exterior courtyard, fireplace and small slip door into the corridor adjacent to the Dining Room. From here the housekeeper could observe and run the daily activity of the house.

Across a covered way stood the large Servants' Hall lit by three large windows that looked on to the internal courtyard. At its far end stood a large fireplace for warmth in winter, surmounted by a carving of the family's armorials, dated 1864. Beyond this, a covered way led to the

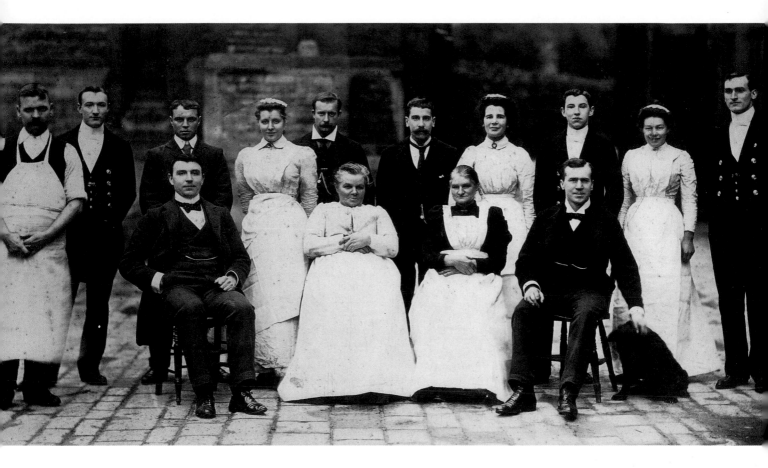

Above: The household staff at Tyntesfield in the late nineteenth century. Seated by the dog is Hemmings, who remained in service at Tyntesfield until the 1940s.

Left: One of the wooden sinks with lead surrounds in the Butler's Pantry.

Cleaning Room, and separate internal rooms for coal and wood, a dark store for vegetables, and a Brew House for making the house beer. In the large courtyard at the rear, with its impressive retaining wall standing high against the hillside, were the kennels and an ash dump. Commercial carts could be brought here by a small separate drive, to unload. A rear passage led from behind the Brew House building to the rear of the Conservatory and out into the garden beyond, so that the gardeners could easily visit the Kitchen area when necessary.

The accommodation for the servants was equally carefully thought out and appointed. The male servants were all housed above the Servants' Hall in a series of well-lit rooms, each with its own coal-fed fireplace. The female servants slept on the second floor of the new wing, high above the Kitchen area. Access was by the oak stairs that led to a corridor, along which were the Washroom for clothes, with a lift to bring the dirty washing from the different floors, and an extensive internal Drying Room, which was well heated and ventilated. Beyond that the corridor led to a series of brightly lit bedrooms, each with a fireplace, and with a second row of bells for night use.

Another corridor at the top of the oak stairs led to two more servants' rooms expressly designed for visiting servants, and an

The Drying Room on the top floor, adjacent to the servants' rooms.

independent staircase down to the guest rooms below. On both the first and second floors were a series of well-placed small rooms where hot and cold water could be obtained for the jugs that had to be filled each morning for washing. There were independent bathrooms, a spectacular shower room in the new wing, and water-closets. On the ground floor one water-closet was situated off the garden corridor and another off the Billiard Room, and there were two for the servants, one at the end of the Kitchen passage and the other opposite the wood store. The enlargement of the house meant that the water supply had had to be increased. The River Land Yeo drove pumps that drew water from deep wells and then along two miles of pipes to a reservoir on the hillside some way above the house. The water was held here in a large, half-buried water tank lined with white tiles from where it was gravity-fed to the entire estate, including a network of tanks placed high up in the roof, containing 180,000 gallons of water. A further

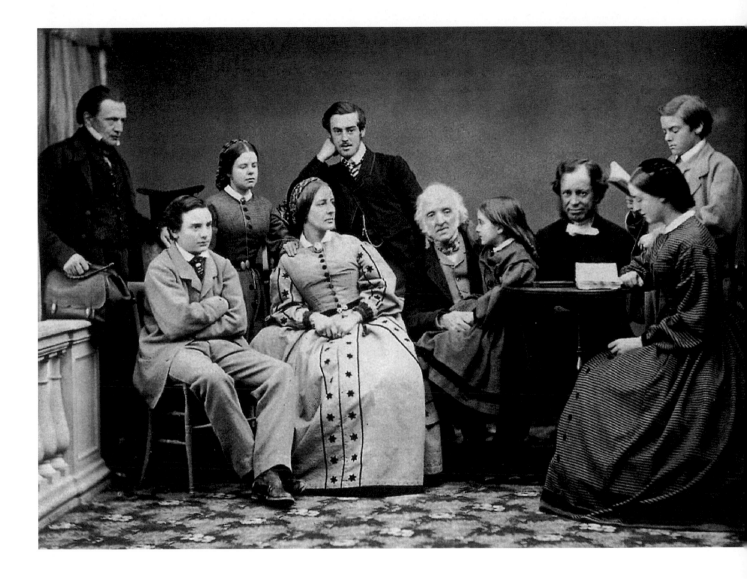

William and Matilda Blanche with their family and the Reverend Mr Hardie, photographed shortly after the completion of Norton's remodelling of the house.
From left to right: William, Henry Martin, Dorothea Harriett, Matilda Blanche, Antony, William, Albinia, the Reverend Mr Hardie, Alice Blanche and George Abraham.

special soft-water tank beneath the Orchid House collected rainwater falling on the roofs for use in the Conservatory.

William's concerns when he visited the almost completed building were largely directed towards the ornamental decoration. He was perhaps overly fearful that he had allowed enthusiasm to get the better of his judgement and that he had failed to remember 'that English taste among the superior orders is averse to rich and sumptuous effects. Excessive ornament is almost invariably vulgar'.[18] His concerns were unfounded. Even the late addition of the Entrance Tower was a masterstroke, giving vertical emphasis just where needed, and claiming for itself the varied Gothic languages of the entire building. Gibbs, Norton and Cubitt had built a masterpiece: one that fully reflected the serious architectural aspirations of the period and created a highly original and friendly house.

SAVL·WHY·PERSECVTES T·THOV·ME + SAINT · PAVL NOTHING · SHALL · HVRT·YOV

The Philanthropist at Work

The rebuilding of Tyntesfield was William Gibbs's response to the needs of his growing family, a reflection of his increased wealth and of a desire to establish the family once more amongst the landowning classes. Yet it was also more. In its form and character, it spoke of a deeper motive. At Tyntesfield, he built a Christian house, serving a Christian household. Tyntesfield was the domestic reflection of a wider response to the faith that was central to the lives of both William and Blanche. When William married Blanche, he married an ardent supporter of the Tractarian Movement, and from that time forward he became increasingly involved in the Movement's work. This work, fostered by the faith, was the foundation of their life together.

The Gibbses had originally been Dissenters, but by the late eighteenth century they had begun to conform to the Established Church. William's formative years in Spain had left him with a wide religious tolerance, and a particular love of ceremonial. When he returned to Seville in 1853, he attended a service in the cathedral. His sentiments on the occasion were not those of a narrow-minded Protestant, rather of someone who has a sympathy for the Catholic Church, and who is inspired by the 'beauty of holiness'. Such a person would be likely to become a supporter of the objectives of the Oxford, or Tractarian, Movement.

The Movement had begun in Oxford during the 1830s amongst a group of religious thinkers including John Keble, Edward Bouverie Pusey and John Henry Newman. It was the latter who in 1833 first published his series of sermons at St Mary's the Virgin, the university church, under the title *The Tracts for the Times*, which gave the Movement its name. The young reformers argued that the Church of England, although it had lost its way, was the only true Catholic Church, the descendant of the Church created by Christ and entrusted to St Peter and his successors. Whilst at the Reformation the

Above: The alms dish designed by Hart and Peard and set with semi-precious stones, *c.*1878.

Left: The mosaic panels by Salviati in the apse of the Chapel.

Church of England had broken with the corrupt Church of Rome, it had not itself been corrupted by Protestantism. Rather, it had maintained true catholic worship, albeit later diminished by the intrusion of political expedients. It was the mission of Newman, Keble, Pusey and their followers to restore the Church of England and rekindle in it a passion for its Catholic antecedents. The clergy would have to believe in all the Thirty-Nine Articles, and their churches would become hallowed with the full practice of ancient Catholic ceremonial. They argued forcibly for the revival of ancient rites and rituals; the separation of the altar to the east end; the draping of it with rich cloths. The use of candles, crosses and Gothic-inspired church plate was to be encouraged, as were vestments, stained glass, processional crosses and lecterns. Services were to include hymns, sung to organs, led by surpliced choirs. Many of the clergy were not persuaded, however, and sides were taken, the battleground quickly spreading from Oxford across the whole country.

William and Blanche were persuaded, and their lives were devoted to supporting the Movement. Their personal beliefs are reflected in their collection of theological books in the Library at Tyntesfield. Here, volumes published by the Camden Society brush against works by John Henry Newman and John Keble, of whom Gibbs wrote that 'a more sincere, humble-minded and devoted Christian cannot possibly be imagined'. His copy of Jeremy Taylor's *The Rule and Exercise of Holy Living and Dying* lies adjacent to J. M. Neale's *History of the Holy Easter Church* (1850) and Henry Hart Milman's *Latin Christianity* (1857). Neale and Milman are perhaps best remembered for the hymns most strongly associated with the Movement, which appeared in *Hymns Ancient and Modern*, first published in 1861. Neale provided a substantial number of the hymns whilst Milman wrote the famous Passiontide hymn 'Ride on, Ride on in Majesty', and their friend John S. B. Monsell penned the most apposite of all their hymns, 'O Worship the Lord in the Beauty of Holiness'.

The aspirations of the Tractarians were inextricably linked with those of Pugin, whose desire to re-establish proper Gothic architecture as the national style struck an answering chord. His works, including *Contrasts* (1841) and *Specimens of Gothic Architecture*, were also in Gibbs's library, as too are Thomas Rickman's *An Attempt to Discriminate the Styles of Architecture*, G. E. Street's *Brick and Marble of the Middle Ages* and Henry Shaw's *Dress and Decoration of the Middle Ages*. Not far removed are Gibbs's copies of the seminal works of John Ruskin, *The Seven Lamps of Architecture* and *The Stones of Venice*.

In many ways it was the involvement of Blanche's family with the Tractarian Movement that brought the newly married William firmly

A page of *Les Arts du Moyen Age*, by Simon Nicolas Alexandre du Sommerard, 1838–46, from William Gibbs's Library, showing some of its illustrations of medieval costumes, This was one of the greatest books on the Middle Ages to be published in the mid-nineteenth century.

Chromolith. de J. Engelmann à Paris.

XV.º Siècle. Étoffes: 1.re planche d'après le dessin fait à Berne, de divers trophées conservés dans la Cathédrale de cette ville, sous le titre d'antiquités bourguignonnes comme ayant été trouvés par les Suisses, le 3 Mars 1476 après la victoire de Grandson dans la tente de Charles le téméraire. Étendart et Étoffes aux armes du Duc de Bourgogne, tabars de hérauts d'armes de ce prince.

into their ambit. The Crawley-Boeveys were staunch members of the Church of England and had been for generations. They quietly ministered to the needs of their congregations in Gloucestershire, and more especially in west Northamptonshire, where they were the incumbents at Heyford, Holdenby and Stowe IX Churches. The Reverend Charles Crawley (1756–1849), uncle to both William and Blanche, was rector there for 60 years. His son Charles (1788–1871) had originally joined Antony Gibbs & Sons, but retired from the business in the early 1840s, going to live at Littlemore outside Oxford to be near John Henry Newman.

William's nephew John Lomax Gibbs (1832–1914), the son of his brother Henry and his wife Caroline Crawley, became inspired by the Movement while studying at Oxford. He was very aware of the tightrope that had to be walked between the Tractarian Church of England and the often magnetic blandishments of Rome. He visited the Eternal City in 1852 shortly after Newman and Manning had 'gone over', and the precariousness of his position was later revealed in John Lomax's 'Reminiscences'. 'At Rome we had a very pleasant time . . . West [his companion] knew some who had in the late crisis . . . gone over to Rome – amongst them Manning [late Archdeacon of Chichester], Pollen of Magdalen [Oxford], Bastard, and Monsignor Talbot. They gave us facilities for seeing many ceremonies e.g. on Xmas Eve we went (in evening dress) to the Sistine Chapel – when Pio Nono celebrated Mass – and 20 Cardinals were present.'[1] Later on, West's acquaintance with the converts led to an attempt to induce John Lomax to 'go over'. So persistent were they that he had hurriedly to leave Rome: 'there was every effort being made to convert English visitors – special sermons were preached by Manning with this intent, and with his eloquence and persuasive manner and inviting appearance, they had great effect'.

William and Blanche demonstrated their own support for the aims of the Movement by building churches, schools, institutions and colleges. This was not simply a matter of giving money, as they played a prominent part in their design and in their subsequent activities. The experience they gained here was to influence the design of Tyntesfield, and the work at Tyntesfield itself certainly influenced their later architectural patronage. Just as the refurbishment of the house in the 1850s had brought them into contact with Crace and Pugin, their ecclesiastical patronage introduced them to the leading architects and designers of the day: George Gilbert Scott, William Butterfield, George Edmund Street, Jes Barkentin, Carl Christopher Krall, John Hardman and Arthur Blomfield. The first two churches were both family affairs: St Michael and All Angels at nearby Clifton Hampden,

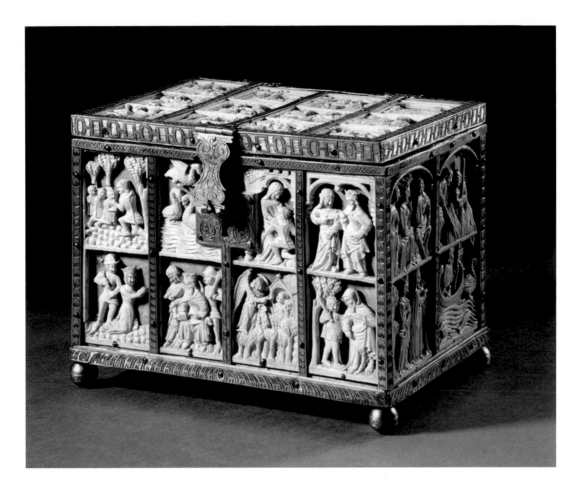

The Flaxley Casket, given to William Gibbs by his father-in-law, and decorated with ivory panels depicting *The Romance of the Knight of the Swan*. The casket stood in pride of place in the Drawing Room.

where William's brother Joseph was rector, and St Mary's at Flaxley, where William had married Blanche. In both cases, George Gilbert Scott was the architect, vesting the churches with Gothic dressing, complete with a spire, chancel, altar and choir-stalls, stained-glass windows and encaustic tiles. Blanche's family appears to have given William the famous Flaxley Casket, decorated with ivory panels of scenes from *The Romance of the Knight of the Swan*, as a token of their thanks. This casket, one of the great treasures of Flaxley, had first been recorded by the antiquarian and herald Ralph Bigland in the mid-eighteenth century, and was later published by his son in *Historical Monuments and Genealogical Collections Relative to the County of Gloucester 1791–2*. By 1876 it stood in pride of place in the Tyntesfield Drawing Room.

As might be expected, William Gibbs took a lively interest in the running of the churches in the villages near Tyntesfield. In the 1850s he paid for the restoration of All Saints at Wraxall and for a new north aisle for St Mary's at Flax Bourton. He was equally keen to support Tractarian worship, and encouraged his nephew John Lomax to help. The latter wrote, 'I had already begun to get into work to some extent

Keble Oak.

This Tree was planted by
William Gibbs, of Tyntesfield.
on the xxxi day of October mdccclxxii
to commemorate the visit of his friends
the Right Hon^ble
Sir John Taylor Coleridge,
the Rev: Edward Talbot
Warden of Keble College.
Henry Hucks Gibbs, Esquire.
the Rev: John Hardie,
and William Butterfield, Esquire,
Architect.

who met at Tyntesfield, by his desire.
on the v. day of September mdccclxxii
to give him their counsel respecting
ye Chapel which he proposes to build
at Keble College, Oxford.

whilst at Tyntesfield – for I assisted the chaplain at Flax Bourton Workhouse Chapel occasionally – and took the duty several times at Flax Bourton Parish Church.'[2] The quality of the worship – both the ritual and the intellectual rigour of the sermon – was of the utmost importance to his uncle.

When in London, William and Blanche worshipped daily at St John the Evangelist, Hyde Park Crescent. This fine Commissioners' Gothic church by Charles Fowler, close to 16 Hyde Park Gardens, had a congregation drawn from the surrounding wealthy neighbourhood. Gibbs and the vicar were concerned, though, that the warren of poorer streets in the shadow of St Mary's Hospital and Paddington Station to the north of the parish were not adequately ministered to. Gibbs therefore undertook to build a sister church, St Michael's, between Star Street and what would become St Michael's Street. This was designed in 1861 by Rhode Hawkins, who built a remarkable brick church with a tall brick steeple that could be seen from Star Street (sadly, it was damaged during the Second World War). In his native Devon, William paid for the rebuilding of the parish church at Clyst St George, where his forebear and namesake had been incumbent in 1543. The rector in 1854 was the Reverend H. T. Ellacombe, a friend of Newman at Oriel College, another Tractarian and a frequent correspondent in *The Ecclesiologist*. He was also a distinguished campanologist and wrote a book on the subject.

William also supported the poor in Exeter, building in 1862 the Exeter Free Cottages, a cluster of almshouses in Tudor style and arranged in four rows on a bluff above the River Exe at Exwick, adjacent to his new church of St Michael and All Angels, again designed by Rhode Hawkins and built in 1865–8. This was a huge undertaking – the church was very impressive, with a long nave and chancel. The spire, based on that at Salisbury Cathedral, soared some 220 feet into the sky. The west front was decorated with sculptural angels surrounding a rose window. There was no sense here or elsewhere that it was simply sufficient to build an 'adequate' place of worship for the poor. These were Gothic churches of the highest quality, where the daily rituals of the Church of England would be enacted by clergy dressed in vestments, surrounded by stencilled decorations, carvings and stained glass and lit by flickering candlelight. Such churches slowly came to represent the norm for the renewed Church of England, inspiring faith and ministry through their architecture.

During the last twenty years of his life (1855–75), William's philanthropy became his principal occupation, to which he brought the same practical application as he had to the running of Antony Gibbs & Sons. In Exeter he built St Leonard's, Cowley, 1867–8, again

The engraved plaque recording the planting of the Keble Oak at Tyntesfield in 1872.

to designs by Rhode Hawkins, and he dramatically extended St Andrew's in Exwick, 1873–5, to designs by Hayward & Sons; and as the reform of the Tractarian Movement came increasingly to be accepted, larger and more public projects were undertaken. William again committed funds for the restoration by Sir George Gilbert Scott of Exeter Cathedral, 1870–8, and for that of Bristol Cathedral by George Edmund Street. In all, he was said to have built, restored or contributed to over nineteen churches, as well as to a large number of almshouses, schools, institutions and hospitals.

The culmination of his public philanthropy was his decision to pay the entire cost of the chapel at the newly founded Keble College, Oxford. The death of the Reverend John Keble in 1866 gave impetus to the founding of a new Oxford college (the most recent previous foundation being Wadham, in 1610). Keble had had a brilliant university career, obtaining a double first at the age of eighteen. He had then been elected a Fellow of Oriel, and whilst there had published his famous verses, *The Christian Year*, a meditation on readings for Sundays and holy days. He was elected Professor of Poetry at the University in 1831, and two years later preached the University Sermon, which was regarded by Newman as the first salvo of the

The chapel at Keble College, Oxford, designed by William Butterfield and financed by William Gibbs, seen in a contemporary engraving.

Oxford Movement. Keble's life and work were to be celebrated in the new college: it was also to be a monument to the success of the Tractarian Movement.

Within days of Keble's death an appeal went out to sympathisers for money. Donations poured in, land to the north of the city was purchased from St John's College, and the foundation stone for the new college was laid on 25 April 1868. However, the money that was pledged was quickly absorbed and there were no funds for the chapel, which was to have been the centrepiece for the Tractarian college. William Gibbs was applied to, and he agreed to pay the entire amount.

The Master and committee had engaged William Butterfield to design the whole college. He was dogmatic and opinionated, and courted controversy in his building style and decoration. His chapel, like the rest of his college, was built of polychrome brickwork. It was a colossus, one of the largest college chapels ever built, its interior incorporating stained-glass windows and more unusual mosaics, illustrating scenes from the Old and New Testaments. These were the first large-scale mosaics to be produced in England, and Butterfield had to send to Venice to obtain the necessary expertise for their installation. Whilst William was not involved in their technology, he was drawn into the heated debate over their placing. The resulting correspondence was later tied up with ribbon and entitled 'The Keble Controversy'. Butterfield wanted a mosaic of Christ Pantocrator to be set above the altar, as in Eastern churches, whereas the Oxford authorities thought the scene of the Crucifixion would be more appropriate. Butterfield appealed to William as patron, and William backed Butterfield. The stunning mosaic of Christ Pantocrator is still there today, and so too is the name of Gibbs, high above the north transept on a large alabaster tablet recording the names of the benefactors. Beneath the words *Aeterna fac cum sanctus tuis gloria numerati* can be read first 'William Gibbs of Tyntesfield', then 'Matilda Blanche'. The project was also commemorated at Tyntesfield, where in 1872 the Keble Oak was planted on an axis with William's study, below the Terrace Garden, in a ceremony attended by Sir John Coleridge, the Reverend Edward Talbot (first Warden of Keble), William Butterfield, Gibbs and the Reverend Hardie. The beautiful silver trowel made by Thomas Peard to Butterfield's design and used at the laying of the Keble foundation stone was also sent to Tyntesfield, whilst at Keble itself William's portrait by William Blake Richmond was proudly hung in the college.

Gibbs was in his eighties when the Keble Oak was planted, and was increasingly infirm, suffering from insomnia and bad legs that forced him to rely on a Bath chair. However, he continued to improve

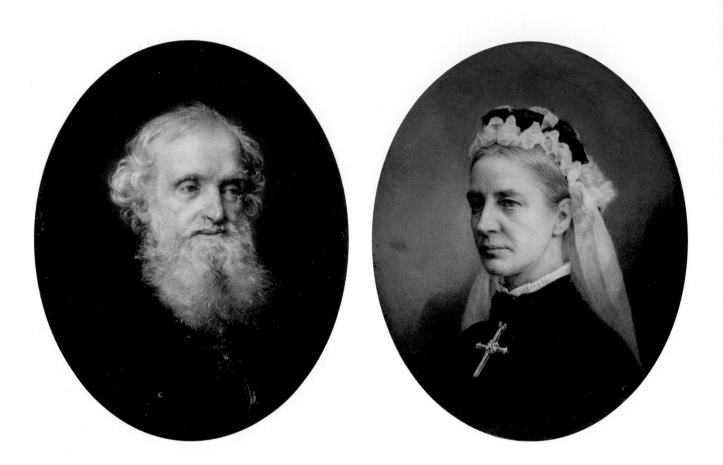

William and Matilda Blanche Gibbs in old age. A pair of miniatures by Antonio Tomasich Haro.

Tyntesfield and enlarge the estate. He often chose to forgo land rather than allow his long-held business principles to be undermined, but in 1866 the estate of Nailsea Court was acquired. In all, the Tyntesfield estate grew from the few hundred acres bought with Tyntes Place to some 3,000 acres. A model farm was built off the North Drive, with a stockman's house and technologically advanced milking parlours and cattle barns. Also along the North Drive a Clergy House was built, lived in first by the Reverend Hardie and later by the Reverend Medley.

The later years were clouded by the deaths of four of William and Blanche's seven children. William, their second son, had to leave Dublin University because of ill health, and died at Tyntesfield in 1869 aged 23. His brother George Abraham, who was to join Antony Gibbs & Sons, contracted yellow fever on his return from South America and died in Kingston, Jamaica, in 1870. Alice Blanche – who in 1866 had married the Reverend Alfred Gurney, curate of the most advanced Tractarian London church, St Barnabas in Pimlico – died in 1871. Finally, Albinia succumbed to tuberculosis in 1874, aged just 21. William, like Job, remained stoical in the face of adversity, finding succour in his faith. The novelist Charlotte M. Yonge, Keble's friend and Gibbs's cousin, stayed regularly at Tyntesfield during these years and wrote: 'That beautiful house was like a church in spirit, I used to

think so when going up and down the great stairs like a Y. At the bottom, after prayers, Mr Gibbs in his wheelchair used to wish everyone good night, always keeping his last kiss for "his little maid" Albinia, with her brown eyes and rich shining hair.'[3]

Life in the house revolved around Gibbs's daily routine. He would still rise early and take breakfast in the Dining Room, followed by prayers for the family, guests and servants in the Oratory, led by the Reverend Hardie, and accompanied on the organ by Antony when he was staying. Gibbs would then retire to his Study adjacent to the Library. After lunch there were the gardens to see, or friends to visit, including the Brights at Abbots Leigh and the Eltons at Clevedon Court, whose daughter Laura had married William's nephew George in 1864. Dinner was taken early, followed by a short service in the Oratory, and then he would retire to his great bed in the Turret Bedroom. On Sundays the family would attend church for morning prayers or Communion, and then evensong at either Wraxall or Flax Bourton church. William's diaries reveal a patriarchal, Christian household, one full of warmth and concern for people's wellbeing.

In 1870, Gibbs had sat for his portrait by Edward Opie, and two years later he was persuaded again to sit for the miniaturist Antonio Tomasich Haro (1820–90), who worked so slowly that he occasioned some uncharacteristic comments in William's diary. On 14 June 1872 he wrote, 'Gave Tomasich another and I hope the last sitting of 1½ hours and he gave me hopes that he would tell Henry on Monday that the miniatures were finished.'[4] But unfortunately Tomasich made another appearance four days later: 'Tomasich came again and I gave him an 11th sitting of 1¾ hours but it really is terribly tiresome work in this broiling heat and I am heartily sick of it.' Gibbs has one's sympathy – the miniature measures only 2¾ by 2 inches. And he was not the only one to suffer these sittings; his diary also records regular sittings by Blanche and Albinia between 17 June and 11 July. Tomasich seems to have happily spun out his stay at Tyntesfield for at least a month.

Following hard on Tomasich's departure was the arrival of the architect Arthur Blomfield, son of the Bishop of London. Gibbs records in his diary on 15 July 1872, 'About ½ past 6 Mr Blomfield arrived and we had some talk before dinner about the Chapel.' The following day the discussions continued: 'Had a long talk and consulted Blomfield about his plans.'[5] The plans were well advanced. Since 1870 there had been a suggestion that, as at Keble College, a chapel might be added to Tyntesfield. The architect's reputation for being extremely businesslike would have appealed to Gibbs, but what had not been anticipated was the sheer splendour of the building, which would

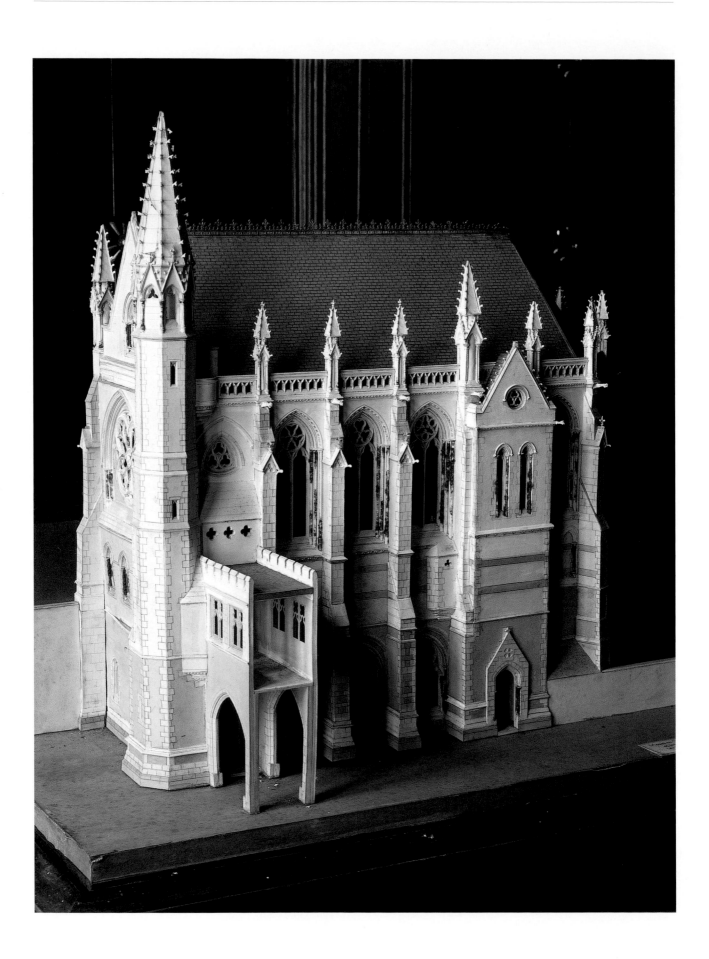

make it one of the finest country-house chapels ever constructed. It is remarkable that the building was somehow constructed in only three years, and that it came in at the agreed budget of £15,000. Gibbs continued to keep a tight rein on whatever he built for himself.

The Chapel was conceived, like the Oratory, as central to the life of the house. All members of the household could easily gain access: estate staff from the north porch, servants from the courtyard, and the family from the first-floor corridor, crossing a covered bridge spanning the carriage drive. It was built for the daily worship of the household. At morning prayer its beauty was revealed through its stained-glass windows, and at evensong through the flickering gas and candlelight on the sumptuous mosaics. It was also intended as a burial place for the family; for the sons and daughters who had died, for William and Blanche, and for generations to come. Provision was made for this in the crypt below. It was to be the personal summation of William and Blanche's faith, and their eternal resting place.

By late 1872 everything seemed to be in place. Blomfield was confirmed as the architect and George Plucknett of Cubitt's was appointed to supervise the building. In his confirming letter to Gibbs, Blomfield recommended a model: 'I was at Eaton [Eaton Hall, in Cheshire] yesterday with the Marquess of Westminster who is almost rebuilding the place – amongst other things he is going to have a chapel and I see that Waterhouse has had a small model made for him. It struck me that you might perhaps like this, as giving a more correct idea of the building than any drawing can.'[6] Gibbs's response was revealing: 'Mr G. leaves Blomfield to arrange with Cubitts & Co. for execution of the work. Prices to be sanctioned by B. before work begins . . . sufficient provision to be made for light coming through coloured glass. Crypt for burial . . . Model to be made.' The model, by O. N. Thwaite of the Commercial Road in Peckham, has survived, and shows at a glance Blomfield's indebtedness to the medieval Sainte-Chapelle in Paris. That soaring Gothic building inspired a number of contemporary English architects such as Gilbert Scott, whose chapel at Exeter College, Oxford, would have been well known to William and his son Antony. However, there was a significant difference between the interpretation by Scott and that of Blomfield. Whereas the college chapel is dark and rich, the Chapel at Tyntesfield sparkles and glistens; whereas the mood of Exeter is one of prayerful humility, that at Tyntesfield is of joyous exultation. The words of Robert Grant's near-contemporary hymn seem particularly appropriate – the Chapel at Tyntesfield seems indeed 'pavilioned in splendour and girded with praise'.[7]

Whilst the building went to plan, although Cubitt's were later

The model of the Chapel made by O. N. Thwaite to a design by Arthur Blomfield, 1872.

replaced by G. W. Booth as the builders, the consecration did not. A row broke out, gentlemanly in its conduct but distressing in its consequences, and now recalled in a bundle of correspondence, this one tied with purple ribbon, entitled 'The Chapel Controversy'. Mr Vaughan, the patron of the local church at Wraxall, was extremely unhappy. He did not want a rival church to be built near the village. He feared a split in congregation and, undoubtedly, a diminution of his influence. He complained to the Bishop of Bath and Wells, the Right Reverend Arthur Charles Hervey, brother of the 2nd Marquess of Bristol, who then wrote to Gibbs, withholding the building's consecration. The octogenarian Gibbs was understandably alarmed: the building was going up fast, the money was spent, and what had been started as an act of faith was beginning to look vainglorious. Eventually a compromise was achieved. The Chapel was consecrated, but regular parochial services might not take place there, nor could anyone be buried. The crypt would remain empty and memorials to the dead could only be placed discreetly along the walls in the nave.

Fortunately, the building work showed no signs of this dispute. It

Above: The Clergy House, designed by John Norton, and home first to the Reverend Mr Hardie and then to the Reverend Mr Medley.

Top right: The interior of the Chapel soon after its completion; a contemporary photograph.

Bottom right: The Chapel seen from the Entrance Front. This contemporary photograph also shows the pinnacled roof of the oriel window of William Gibbs's bedroom, which was subsequently removed.

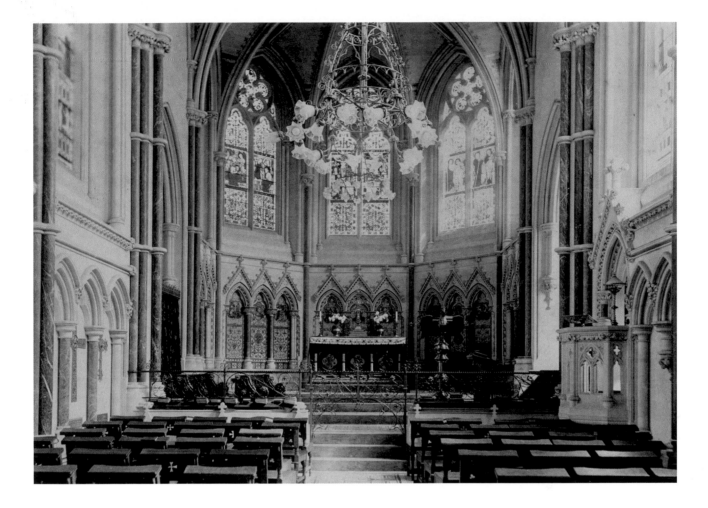

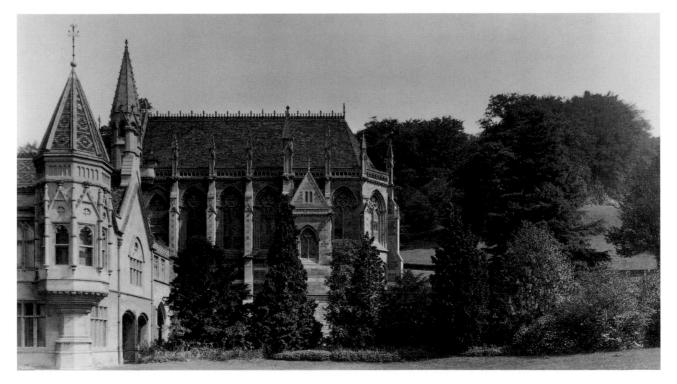

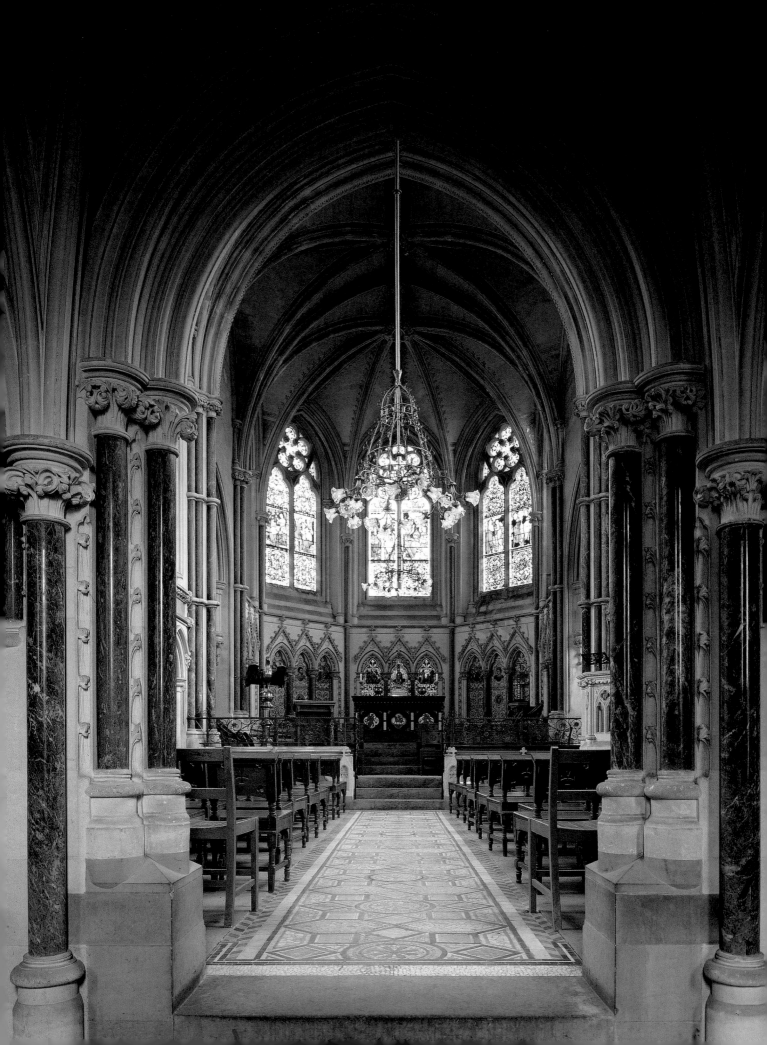

proceeded according to plan, Plucknett and his men first building massive foundations to secure the construction, which straddled the hillside. At the east end the great space of the crypt rose first, followed at floor level by the nave and elevated apse. The building soared upwards, firmly buttressed on the south side, and topped with crockets and pinnacles. At the west end the servants' spiral staircase rose to an open arcade topped by a short spire. The whole is in contrast to Norton's building of the house, which seems somewhat austere in comparison with the exuberance of the Chapel's architecture. This contrast is even more apparent inside, where Blomfield assembled a formidable array of talent to create a jewelled casket dedicated to worship.

The series of lancet windows were filled with bright, light stained glass, the nave windows to designs by Henry Ellis Wooldridge (1845–1917) and made by James Powell & Sons of Whitefriars, London. They depict a procession of apostles and prophets standing above beautiful base panels containing scenes of their lives. The floor is spangled with colour, designed by Blomfield and again created by Powell & Sons. The encaustic Minton tiles of the house have given way to intricate marble mosaics, reflecting those of early Christian churches. In the chancel they become yet more elaborate, with pieces of pale-blue faience, honey-coloured Mexican onyx and squares of bluejohn. They seem to echo the words of Bishop Heber's famous hymn, 'Holy Holy Holy / All the saints adore thee / Casting down their golden crowns / Around the glassy sea.' The altar, with its slender shafts of ivory intersected with carvings, was made by James Forsyth to a design by Blomfield, who was also responsible for the designs of the wooden lectern, tripartite screen and the chairs, made by G. W. Booth. At the chancel steps the delicate metal communion rail was made by James Laver of Maidenhead, who was also responsible for the brass eagle lectern and the four brass gas chandeliers. The brass altar furnishings, cross, table-lectern and a gem-encrusted alms dish were made by Hart and Peard.

The series of mosaics behind the altar (made by Salviati & Co., Venice), reflecting Butterfield's work at Keble, contain the lives of Saints Paul, Peter, John and James the Great. In the centre, *Christ Pantocrator*, flanked by the *Road to Calvary* and *Our Lord's Appearance to the Magdalene*, hover above the altar. Gibbs's old friend Sir William Boxall, who had painted a number of family portraits, also designed a separate mosaic in *opus sectile* of the *Head of Christ* to be placed in the south transept. This, too, was made by Salviati, and based on a detail from Leonardo da Vinci's *Last Supper*. In the gallery, at the west end, beyond the screen and above the narthex, stood the organ. It was

The interior of the Chapel.

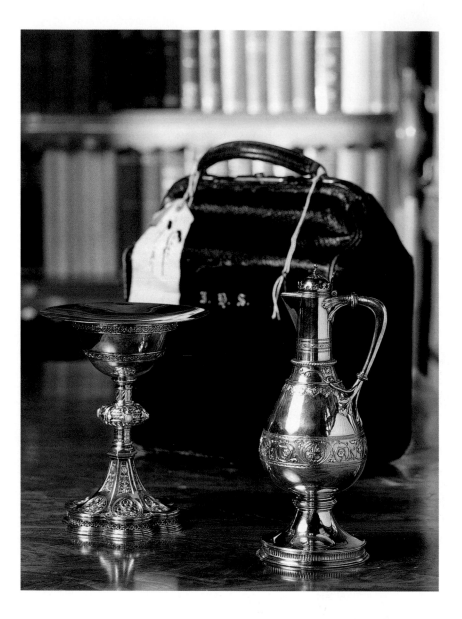

designed by William Hills & Sons of London, and Gibbs had met Mr Hills himself on 19 December 1872: 'Hill [sic] the Organ builder came and saw the model.'[8] The instrument was designed so that the pipes were graduated to follow the shape of the rose window behind. Gibbs would have been pleased that his model of the Chapel had found a practical application.

Towards the end of the project, William Butterfield was appointed to work alongside Blomfield. At the same time, he appears to have designed the beautiful silver communion plate: a chalice set with rubies, sapphires, opals and emeralds, and an accompanying ewer with bands of decoration and an intricate flowing handle. This was made by Jes Barkentin (*c*.1800–81), known as the Danish Cellini, who with his partner Carl Christopher Krall produced some of the most

Above: The Chapel plate designed by William Butterfield and executed by Barkentin and Krall, *c*.1876.

Right: The monument to William Gibbs at the church of St Michael and All Angels in Exeter, sculpted by H. H. Armstead.

outstanding Gothic Revival silverwork of the nineteenth century.

Shortly after the consecration of the Chapel, William Gibbs died. He was 84. His friend and close neighbour Sir Arthur Elton of Clevedon Court wrote in his diary on 3 April 1875, 'The good old man – holy and devout – Wm. Gibbs died today.'[9] The Bishop's strictures were adhered to, and William's coffin was carried by relays of estate workers to All Saints, Wraxall, some two miles away, where he was buried. Later a beautifully wrought cross, worked in enamels, gold thread, rock crystal and precious stones was made by Barkentin and Krall, and set up in the nave of the Chapel. Its inscription read, 'In Loving Memory of William Gibbs. "The Hoary Head is a Crown of Glory if it be found in the Way of Righteousness" ', a wonderfully appropriate and rare quotation from the Book of Proverbs.[10]

In his native Devon, in his church of St Michael and All Angels in Exeter, a yet more impressive monument was raised by his family. Here, under a Gothic canopy, lies William Gibbs, sculpted in white marble by H. H. Armstead, lying at peace on the north side of the sanctuary he had built. His had been a remarkable life: an enormous fortune had been made by diligence and foresight, and the same virtues had informed the quiet dispersal of his money for the betterment of his family, the building of a great house and, above all, for the promotion of the Kingdom of God.

Tyntesfield Remodelled

Above: A detail of the carved fruitwood panels in Lord Wraxall's Study.

Left: The Orangery in the walled garden designed by Walter Cave (1863–1939).

William Gibbs did not bequeath Tyntesfield to his eldest son Antony. Instead, he left it to Blanche with the provision that she could, if she wished, sell the house and estate. A surprising thought, perhaps, but the previous few years had seen the deaths of four of their seven children, and had been further clouded by the controversy over the Chapel. Blanche, though, had no intention of selling. She was extremely capable and knew her own mind, and wished to continue her husband's philanthropic activities. She built almshouses, a village club, a cottage convalescent home and a temperance (not a teetotal) inn, the Battle-Axes, in Wraxall, and St Michael's Home for Consumptives at Axbridge, a memorial to both William and their daughter, Albinia. In Exeter she oversaw William's monument in St Michael and All Angels, and at Exwick 'improvements were made [to the church], chiefly at the expense of our kind and good Aunt Blanche who took the same interest . . . as Uncle William in his lifetime took'.[1] She was continually supported by the family, the Reverend Hardie and close friends, including Charlotte Yonge. The latter wrote shortly after William's death to her friend Miss Barnett: '. . . dear Blanche did revive wonderfully throwing herself into all her good works and making the house such a place of rest and refreshment'.

Blanche also continued the building work at Tyntesfield. The Chapel was completed in 1876–7 and some time afterwards she commissioned the architect Henry Woodyer to design a veranda for the south front. It was conceived as a short cloister entered through a Gothic arch. Like Norton's cloistered Entrance Hall it was paved with encaustic tiles, and the cluster columns were of local pink granite. The upper part of the arcade wall was pierced and the roof glazed to allow the maximum sunlight to pass from the veranda into the adjacent Drawing Room. Like all Blanche's work, it was practical and true in style to the Gothic idiom of the house.

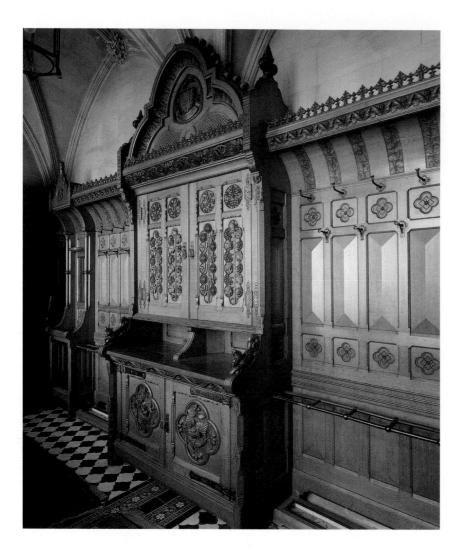

In 1878 Blanche either commissioned, or was given by Antony, a magnificent, but again highly practical, addition to the internal Hall – probably the most sumptuous Gothic coat-stand ever made. It was conceived like a reredos with a central section, two wings and gabled ends. The centre was formed by two cupboards, separated by a deep shelf, and surmounted by a broken quatrefoil arch edged with crockets. The two panelled wings stretched out, incorporating hooks and drip-pans for umbrellas, with coved panelling above decorated with a running pattern of fleurs-de-lis. At either end stood small gabled tabernacles with deep stands. It was executed in native oak to the design of James Plucknett. His company's label was attached to the backboard, reading: 'COLLIER & PLUCKNETT, CABINET MAKERS AND UPHOLSTERERS, WARWICK & LEAMINGTON'. As well as in the originality of its design, the cabinet was also a masterpiece of carving. Plucknett responded to the consistent theme of naturalistic carving found throughout the house. The upper panelled doors were crisply executed

The elaborate Gothic coat-stand devised and executed by James Plucknett for Matilda Blanche Gibbs in 1878.

with intricate patterns of ivies, hops and roses whilst the lower doors had large quatrefoil panels with deeply carved animals and birds. Along the upper frieze, and through the coving, were further tightly conceived panels of roses and other flowers, contrasting with the plain grain of the wood. The central gable contains the family's coat of arms whilst Blanche's cipher (MBG) is carved over one end-gable and the date 1878 above the other. It is a *tour de force*, in which Plucknett rose magnificently to the Gothic challenge of the building.

His other contribution, equally practical and equally original, was the refitting of Blanche's bedroom, bathroom and water-closet. The bedroom was on the south side of the house, where Plucknett created an oak safe and a pair of oak and parquetry cabinets. In the adjacent bathroom he panelled the newly installed bath, provided a new surround for the fireplace, surmounted by a looking-glass, and a further wall safe. The cabinets retain their original trade label, again reading Collier & Plucknett, which dates the work before 1880, when that partnership was dissolved. The oak cabinets, with their crenellated cavetto cornices and carved flower-heads, have similarities with the

The South Front showing the veranda built for Matilda Blanche Gibbs.

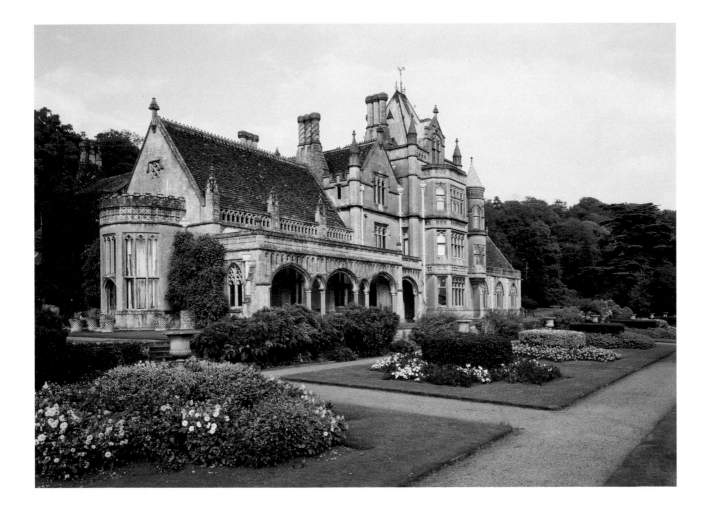

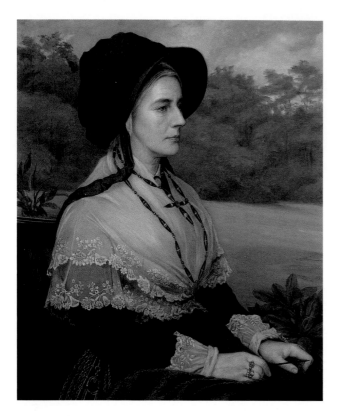

coat-stand, but are more domestic in feel. Plucknett also incorporated a favourite device, ebonised collared columns. The new bathroom was the height of technology, with flowing hot and cold water and a flushing lavatory. No maids would now have to scurry to Blanche's bedroom first thing in the morning carrying steaming Minton jugs of hot water.

Whilst Blanche seems to have purchased little in the way of works of art and only a few paintings, she probably commissioned the portrait of her friend Charlotte M. Yonge. Whilst born in 1823 at Otterbourne in Hampshire, Charlotte Yonge was really a Devonian. The family had been settled for generations at Puslinch, north of Plymouth, and were, like the Crawleys, multiple cousins of the Gibbses. Early in life Charlotte had come under the influence of John Keble, who had encouraged her to express her religious beliefs through writing. She quickly became a successful and influential author whose lively portrayal of Victorian family life proved very popular. She wrote over two hundred novels including *The Heir of Redclyffe* (1853), *The Daisy Chain* (1856) and *The Trial* (1895). In 1882, to commemorate their friendship, Blanche commissioned a portrait of her by John Henry Lorimer. Blanche herself sat in 1881 to Edmund Havell, a particularly adroit pastellist who had earlier painted the Reverend Mr Charles Kingsley, author of *The Water Babies*, and to Edward Clifford. A copy of Clifford's portrait by Horsley now hangs in the Vestibule.

Above left: Matilda Blanche Gibbs by Horsley, after a portrait by Edward Clifford, *c*.1882.

Above right: Charlotte M. Yonge, the celebrated Victorian novelist and friend of the Gibbs family, by John Henry Lorimer, 1882.

A final, typical, if sad glimpse of Blanche is also caught in John Lomax Gibbs's 'Reminiscences'. He wrote that on 21 June 1887 'she was present with me and others in Westminster Abbey when the wonderful commemoration [of the Queen's Golden Jubilee] took place. She was eager and full of anxiety to see and hear all that went on – just as if she had no bodily trouble to distress her. It was a long service and there was long waiting before it began – but she forgot all her troubles in the pleasure of seeing and hearing it all.' Later he records that Blanche 'paid us a visit at Clyst St George on her return from a trip to the S. of France which she had made with Mr Hardie and whilst she was with us told my dear wife she was suffering from an incurable complaint . . . She was wonderfully calm and brave, submitting herself entirely to God's will There was never anyone so thoughtful of others She was laid to rest in the family vault in Wraxall Churchyard with uncle William and Alice Gurney & two of the sons George & Willy.'[2]

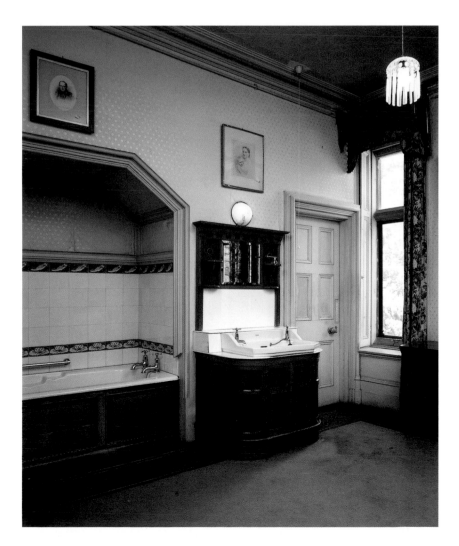

Matilda Blanche Gibbs's new bathroom.

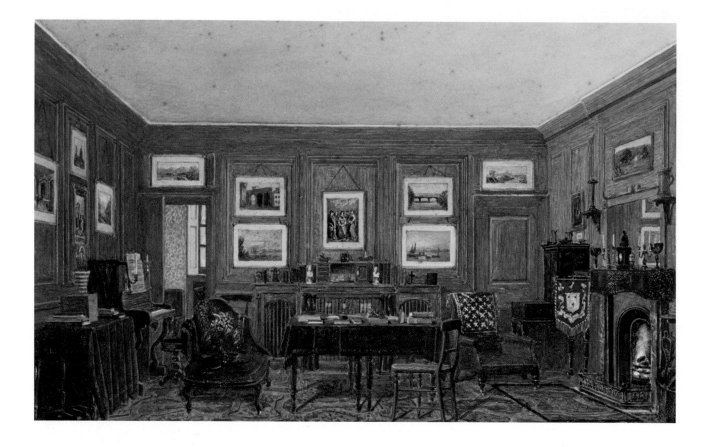

At 47, Antony inherited Tyntesfield, assuming the family role of landowner and philanthropist, but not of businessman. His father had discouraged him from joining Antony Gibbs & Sons as he had felt that his son showed too little natural aptitude for the life. He tried to teach him accounts, but this was not a success. Antony wrote, 'all this morning my father has been cramming my head with instruction . . . until he has driven me nearly wild, and I had half a mind to be rebellious and tell him I was going to invent a plan of my own'.[3] William's test had been to ask him to add up four columns of figures simultaneously. Apparently Antony continued to muff this, and as a result he was encouraged to enjoy the life of a country gentleman rather than that of a businessman. He had been educated privately by the Reverend Hardie before going to Radley College near Oxford in 1855. Radley had been established only eight years earlier and its quirky brick buildings, in an odd, austere Gothic style, were still being built. The school was an obvious choice, founded on Tractarian values and within easy distance of his cousins' home at Clifton Hampden, a few miles away across the River Thames. After Radley, Antony went up to Exeter College, Oxford.

Exeter was the college of William Morris and Edward Burne-Jones, and art, architecture and religion were part of daily discourse. This had

Antony Gibbs's room at Exeter College; a watercolour by George Pyne, *c.*1862.

A pair of turned ivory and ebony candlesticks worked by Antony Gibbs.

a profound effect on Antony, broadening his world both intellectually and socially. Like many undergraduates he commissioned George Pyne (1800–84) to paint a watercolour of his room, which now hangs at Tyntesfield. It is the room of a budding, if rather tidy, aesthete. Above the mantelpiece hangs the small oil painting of Tyntes Place, which by 1912 hung in the Billiard Room passage. Painted in 1851, it shows the new buttressed terraces with recently planted yews. The watercolour shows, on the far wall, arranged around a print after Raphael, two engravings of Florence and two Neapolitan gouaches that may have been acquired in Italy in the winter of 1861–2. The mahogany furniture is contemporary and good. A pole-screen (which emerged from a chest in the chapel passage in 2003) stood adjacent to the fire, proudly displaying the family arms done in beadwork.

Life in Oxford must have been exhilarating: debates on Tractarian and Ruskinian ideas to the sound of builders at work on new Gothic architecture. Antony's college had not only a new chapel, but also a new wing and library by Gilbert Scott. The new debating chamber at the Union had just been completed, as had the Oxford Museum over the fields in the Parks. It is not surprising that Antony's interest and enthusiasm should have informed Norton's contemporary rebuilding at Tyntesfield. It also gave Antony the confidence to apply himself to his particular artistic talent: turning ivories and carving wood. It was a skill he was rightly proud of and, years later, when wooing his bride, he wrote telling her, 'I turned you yesterday the tops of what I think even you will say is a very pretty ring stand.'[4] The collection still retains a number of bowls, candlesticks and stands showing the mastery Antony acquired in this field. His lathe, which formerly stood in its room off the Billiard Room, was later retired to the stable yard.

After Oxford, Antony attended the Middle Temple, studying law, but this failed to engage his interest and, like his parents and cousins before him, he began to tour Europe, visiting Russia, Germany, Denmark and Sweden in early 1868 before spending his summer on the Italian Riviera at San Remo. The following year he was in France. In Somerset he was beginning to establish himself at Charlton, which was to be his home for the next twenty years. The Charlton estate lay to the north-west of Tyntesfield, on the other side of Portbury Hill. At its centre was a substantial sixteenth-century house, sheltered in a small combe, which William acquired in 1855. In 1869 he noted in his diary that Antony had gone to Bath with his mother expressly to purchase furniture for Charlton. It was not for three more years that the remodelling of the house commenced in earnest. Then it was to put it in readiness for his bride, Janet Merivale.

The Merivales, like the Gibbses, came from Devon where, in the

eighteenth century, they had been both merchants and Dissenting ministers, although they too exchanged Dissent for Tractarianism. Janet Merivale's father, John Louis, lived in London, however, where he was the senior registrar at the Court of Chancery. The couple were married on 22 June 1872 at St Michael's Church, Paddington, by her uncle, the Dean of Ely. After their honeymoon the couple settled at Charlton, where the quietly beautiful Janet took on the responsibility of the household and their expanding family.

Antony, Janet and their nine children (a tenth died in infancy) lived at Charlton for the next seventeen years. It was here that Antony's early interest in art had its initial expression, and the paintings, furniture and works of art he collected for this house would eventually enrich the interiors of Tyntesfield. Likewise, his architectural sensibilities would be honed during the rebuilding and extending of Charlton, a process he entrusted to Henry Woodyer. Woodyer had all the hallmarks of a Gibbs architect: high church, Gothic, original, experienced and professional. He responded well to the house, making improvements to the central block and adding a new wing to the south, providing three new reception rooms, a new staircase and bedrooms. It was all expertly ornamented, reflecting the original Jacobean decoration to be found elsewhere in the house. In the park, adjacent to the farmstead, he also designed a charming model dairy for Janet, complete with diaper windows, tiled walls in Turkish taste, and an alabaster fountain for cooling the milk.

Fortunately, Antony's house and collection were captured in a series of photographs taken in 1885. In the Drawing Room hung James Archer's beautiful portrait of Janet above a great ebonised bookcase on which is arranged the enamelled glass by that technical wizard Philippe-Joseph Brocard (1831–96), which Antony had acquired at the first London International Exhibition in 1871. The adjacent Hall was full of part of his collection of ancient and contemporary antiquarian furniture. To the right of the fire stands an extraordinary metal chair, supplied in 1877 by Barkentin and Krall who had earlier provided the fitments for the Tyntesfield Chapel. The chair was so unusual that Antony's eldest son later decided to write to the company asking what it was. In a letter to George Gibbs dated 1913, Carl Christopher Krall explained that the chair was made of solid bronze, with rock-crystal lion finials to the ends of each arm. Its design had been chosen by Antony from an engraving that he had come across in the famous French Gothic Revivalist Eugène Viollet-le-Duc's *Dictionnaire raisonné du mobilier français de l'époque carolingienne à la Renaissance*.

In the same photograph is a group of distinctive ebony chairs, now

Antony Gibbs with his wife Janet Merivale (on the right) and her sister Sophy.

also at Tyntesfield. When acquired by Antony they were thought to be Tudor, and thus highly appropriate for Charlton. In reality they date from the end of the seventeenth century and were made in India. The misconception had arisen in the mid-eighteenth century when Horace Walpole placed a set of them in his Holbein Chamber at Strawberry Hill. Like so many of Antony's purchases they show a keen sense of style, history and workmanship.

This can also be said for his patronage of contemporary designers, principally James Plucknett (*c.*1836–1905). Plucknett's early work at Tyntesfield is hard to identify. He must have been a kinsman of George Plucknett, Cubitt's manager, who oversaw Norton's rebuilding, and he may have contributed to the ornamental woodwork, possibly the carvings on the shutters and doors of the Drawing Room, which are close to his later work. He was certainly living locally, for whilst he had been born and trained in Devon, he had moved to Bath by the early 1860s. Later that decade he moved to Leamington in Warwickshire, joining Frederick John Collier as a partner in 'Collier & Plucknett . . . Upholsterers, cabinet makers and decorators by appointment to Her Majesty, and Manufacturers of rich carved furniture in the peculiar style particular to the Gothic, Tudor and Elizabethan ages'.[5]

It is highly likely that the first piece of Plucknett's furniture commissioned by Antony was the great Gothic desk that relates to a cabinet exhibited by the firm at the second London International Exhibition in 1872. A photograph taken in 1884 of the desk at

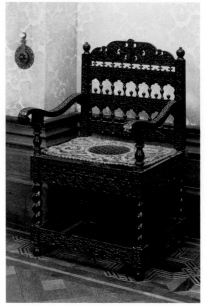

Charlton shows that it originally had no central tambour section, but that the superstructure stood at the back of a flat-topped desk. It must have been altered by Plucknett some ten years later when the applied motto *Sit meae sedes ultinam senectae* ('Let there be a seat for my old age', from Horace's *Odes,* Book II, Ode 6) would then have been more appropriate. Its genesis takes away nothing from its spectacular effect. It was conceived like a piece of architecture. At the top, along a 'tiled' roofline, are a series of crockets, leaf crestings and finials, cut into by a gabled dormer containing the Gibbs crest of an armoured fist holding a battle-axe. Below are a pair of doors with roundels exquisitely carved to depict crafts – weaving and pottery, masonry and carpentry. The quality of this carving is matched in the lower part where the doors and drawers contain panels of flowering plants. The whole is watched over by sentinel owls, symbols of wisdom, whilst lizards emerge at the sides. True to its Gothic character, it is executed in oak, with the addition of burr-oak veneers. The dowels, both real and ornamental, were made more pronounced by their ebonised highlights, and ebony was further used on the drawers. It is one of the most elaborate pieces of Gothic architectural furniture of the mid-nineteenth century, and its re-emergence before the public eye places Plucknett alongside the designer William Burges as one of the supreme masters of the Gothic idiom.

In the early 1880s Plucknett formed a new partnership with a Mr P. Stevens and the new firm made a highly idiosyncratic set of library chairs and a set of metamorphic library steps, again for the Library at Charlton and now found at Tyntesfield. Plucknett also responded to Antony's interest in the designs of Viollet-le-Duc, making an extraordinary

Above left: A child's bed made by James Plucknett, adapted from Viollet-le-Duc's *Dictionnaire raisonné du mobilier français*, 1872–75.

Above: An ebony 'Tudor' chair that originally stood in the entrance hall at Charlton.

Right: The great Gothic writing-desk supplied to Antony Gibbs by James Plucknett.

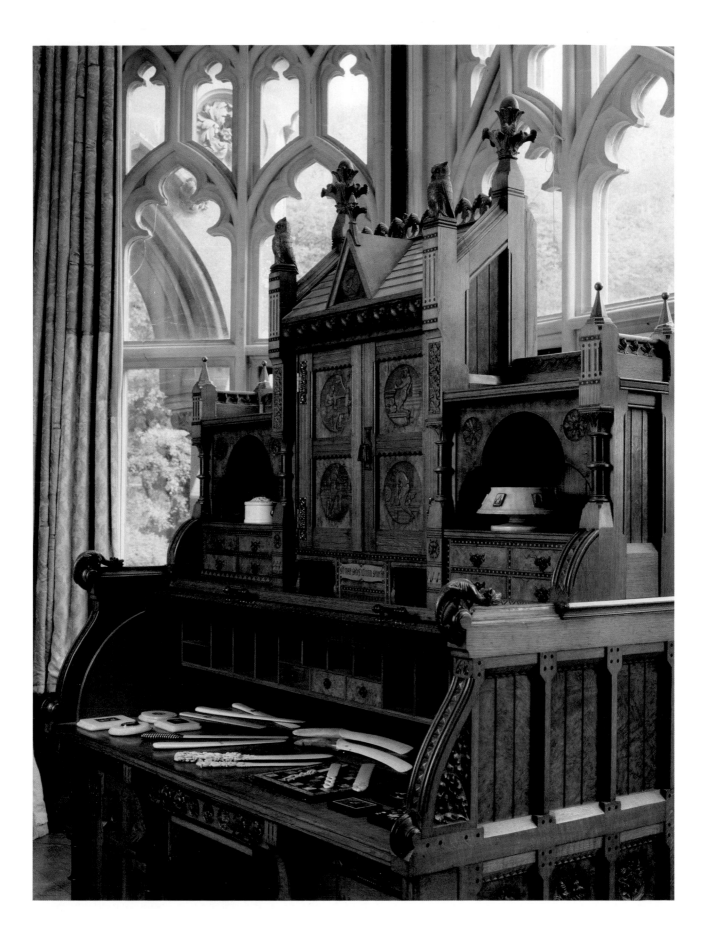

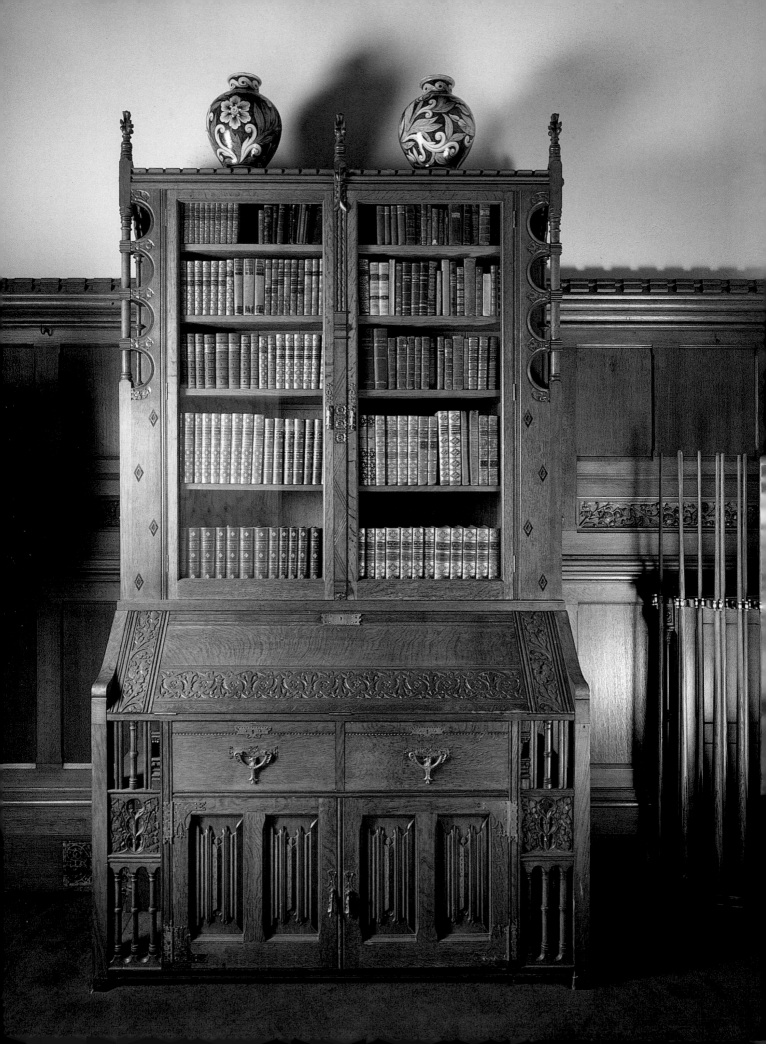

oak 'bed' to another design from the *Dictionnaire raisonné du mobilier français*, entitled *Lit de dames*. In the engraving, a surprisingly comfortable lady, complete with high wimple, is shown resting delicately in one. Antony cleverly asked Plucknett to transpose the design, making it into a child's bed. It was first used by his son George, and later by George's daughter Doreen. Plucknett may well also have made the most archaic of all the furniture at Tyntesfield based on Viollet-le-Duc's *Dictionnaire*, the oak cupboard that stands in the ambulatory of the Chapel, its austerity elevated only by strapwork hinges.

Plucknett was not the only contemporary craftsman to be patronised by Gibbs. In 1872, when he was visiting the London International Exhibition, he must also have noticed Cox & Co.'s display. This included a highly advanced aesthetic bureau-bookcase fashioned in oak and walnut to a design by Samuel Joseph Nicholls. The cabinet was also featured in their *Illustrated Catalogue of the Gothic and other Aesthetic Domestic Furniture, Decoration, Upholstery and Metalwork*, and was illustrated in *Building News* of May the same year. Antony was clearly taken with it and acquired a similar cabinet, with remarkable silvered handles in the form of mythical birds. The company also supplied the oak tester bed and night tables in the Turret Bedroom. Distinctive furniture was also made for the nine children, including wardrobes which – to clarify whose clothes were whose – were incised with their initials, appropriately in a Gothic script.

Not surprisingly, as a keen turner of ivories, Antony had a discerning eye for works of art, both early and contemporary. His father had acquired ivory cups, tankards and Dieppe spoons, perhaps encouraged by his son, and the latter added ivory figures and Limoges enamel from the sales of the Napier Collection and Hollingworth Magniac's Collection. These joined a varied group of works of art, including Viennese enamel *tazze*, rock-crystal boxes and candlesticks, silver-mounted coconut cups, Russian enamelled beakers, early bronze mortars (one from the Bardini Collection), early English silver, and majolica (from the Fountaine Collection). Of the contemporary objects, perhaps the most curious is the enamel and lapis lazuli table clock, surmounted by a delicate Indian jade bowl. This was commissioned from Le Roy et Fils, 221 Regent Street, in 1878. The polygonal base contains the clock's mechanism, and its face is set into a series of Limoges-style enamels. In the upper section are enamels of the gods, with oval enamels depicting the life of Venus below, and along the lower edge are the signs of the zodiac set into lapis lazuli panels. A cherub points to the time of day, leaning out from beneath the beautiful jade bowl. The bowl itself is mounted in Renaissance taste, its enamelled gold handles in the form of winged figures, whilst its gold stem is set with further

The aesthetic oak bureau-bookcase acquired by Antony Gibbs from Cox & Co., *c*.1875.

enamels and gems. It is highly likely that this is the work of the famous Parisian goldsmiths Jean-Valentin Morel and Charles Duron.

In 1874 Antony visited Italy with his brother Henry Martin, where they acquired further Renaissance-style objects. The most beautiful piece is the elaborate intaglio cabinet made by Nicodemo Ferri (1835–99) in partnership with Carlo Bertolozzi (1835–1922). They had established their workshop in Siena in 1860 and were famed for the intricacies of their inlays. The Tyntesfield box reveals their brilliance: the sliding top is inlaid with grotesques, whilst the front has classical figures in roundels. The back is completed with the Gibbs family coat of arms and motto.

A consequence of Antony's habitual foreign tours was his growing collection of continental watercolours that now fills the bedrooms at Tyntesfield, including works by Ten Kate, Decamps, Berchère, Roussoff and Xylander. He was a keen amateur watercolourist himself, and also acquired native works by Myles Birket Forster, William Wyld, Richard Beavis and Herbert Menzies Marshall, among others, often from the annual exhibitions of the Royal Society of Painters in Watercolour. His collection of English oil paintings was influenced by his love of watercolours, and included works by Richard Wilson,

Above left: The enamel and lapis-lazuli table clock commissioned by Antony Gibbs in 1878 from Le Roy et Fils.

Above: The Zaehnsdorf binding on Henry Hucks Gibbs's *The Game of Ombre*, 1878, presented to his cousin Antony Gibbs.

David Cox, George Vincent, Clarkson Stanfield and J. M. W. Turner. In the 1870s he made his most expensive purchase in this field, acquiring Turner's *Temple of Jupiter at Aegina Restored* from the artist and dealer James Orrock. Although the Turner was later sold, the wonderfully atmospheric *The New Houses of Parliament* by his follower Henry Dawson (1811–78) remains in the Dining Room. It could not be more appropriate – a painting by an artist praised by Ruskin, depicting one of Pugin's greatest achievements. More unusual is the hauntingly beautiful triptych by Charles Fairfax Murray of *The Garland Makers*, which Antony acquired from the first exhibition of the Grosvenor Gallery in London in 1879. The languorous figures betray the painter's debt to his mentor, Burne-Jones, and the landscape background his love of Italy, where he lived during the 1870s.

Old Master paintings were also regularly bought, often from distinguished collections. The *Winter Landscape with Skaters and Koff Players* by Aert van der Neer came from Albert Levy's sale, and the meticulously painted *Israelites Gathering around Joseph's Sarcophagus after the Crossing of the Red Sea* by Frans Francken the Younger (1581–1642) from Blenheim Palace. When the Francken came up for sale at Christie's in 1881, Antony bought it for £58 16s. Although other versions are known in Hamburg and Brunswick, this is a particularly fine example of Francken's mature style.

In 1883 Antony prepared and had privately printed the first *Inventory of the Pictures at Tyntesfield and 16 Hyde Park Gardens*, providing information on the artists and on the acquisitions. Shortly after, he commissioned the Reverend Hardie's successor as house chaplain, J. B. Medley, to catalogue the Library, which he was busily expanding. Antony was clearly influenced in his choice of rare books by his cousin Henry Hucks Gibbs, who created the famous library at Aldenham in Hertfordshire. One of Henry's own works, *The Game of Ombre*, which he had privately printed in 1878, was amongst the books, beautifully bound in the French mid-sixteenth-century style by the bookbinder Zaehnsdorf, who also bound many of his other books, including the sets of Browning, Keats, Shakespeare and Shelley. One of the most beautiful volumes is Montausier's *La Guirlande de Julie*, published in Paris in 1784, one of only six copies to be printed on vellum, and illustrated with fine flower paintings by Mary Lawrence. Antony acquired it from the niece of Captain Marryat, author of *The Children of the New Forest*, in May 1878. His stunning copy of Sir Thomas Malory's *Morte D'Arthur* was bought some time later. It, too, was specially printed on handmade Dutch paper, perfect for Aubrey Beardsley's large woodcut illustrations.

By the time this volume was acquired, Antony and his family had

Above left: *The New Houses of Parliament, Westminster*, by Henry Dawson, 1875. Antony Gibbs also acquired *St Paul's at Sunset* and *A Quay on the Mersey* by the same artist.

Above: *The Submission of Gothrum from the History of King Alfred*, a Royal Windsor tapestry designed by Herbert Bone in 1887, commissioned by Antony to commemorate his parents.

moved into Tyntesfield. His mother had died in 1887 and was commemorated in the Chapel with another jewelled and enamelled cross by Barkentin and Krall. At Keble an inscription was raised to her memory, and at Flaxley her children presented the church with a new organ. In the house Antony commemorated his parents' life in a fine pair of tapestries specially commissioned from the Windsor Tapestry Company. The company had been established in 1876 by Marcel Brignolas and Henri Henry, with workers brought to England from Aubusson. In 1882 a special tapestry hall, with cottages for the workmen, was built at Windsor under the patronage of Prince Leopold, Queen Victoria's fourth son. At that time Antony bought three tapestries, representing St Agnes, Savonarola and Vittoria Colonna, to the designs of Dr Salviati, who had earlier provided the mosaics in the Chapel. The company did not thrive and, after Prince Leopold's death in 1884, it looked as though it would close. The Prince of Wales appealed for support in the City and as a result Henry Hucks Gibbs commissioned a set of tapestries for Aldenham. He must have encouraged Antony to acquire the Alfred Tapestries for Tyntesfield, specially emblazoned with the armorial badges of both his parents. Their complex iconography was explained in a privately printed catalogue published in 1882, which is to be found in the Library. Sadly, such commissions were not enough to save the Windsor Tapestry Company. The high cost of its work and the migration of workers back to France led to its collapse on Christmas Eve 1890.

In December 1887, Antony, Janet and their children were gathered together to celebrate their first Christmas at Tyntesfield. The house had been in turmoil since Antony's mother had died. On 23 November 1887, just two months after her death, he had summoned

The Garland Makers by Charles Fairfax Murray, acquired from the Grosvenor Gallery, London, by Antony Gibbs in 1879.

Overleaf: The Staircase Hall showing the alterations carried out by Antony Gibbs following the designs of Henry Woodyer, and photographed before acquisition by the National Trust. To the right is the gong by Laverton's of Bristol, based on the rose window at St Mary's Redcliffe.

Woodyer. He had radical plans for the building and Woodyer, now tried and tested at Charlton, was to be his architect. Antony did not want to disturb unduly his father's creation, but he did want to improve it and to bring it technologically up to date. It would take three years to achieve his vision. Again, the house was to be magnificently transformed for the third time in half a century.

Antony's principal requirement was to integrate Norton's Entrance Hall, Library, Vestibule and Oak Study into the main body of the house. To achieve this, the screen at the end of the Vestibule was removed, opening up a spacious vista into the Staircase Hall. New Gothic doorways, facing each other, were made into the Oak Study and Dining Room. They were ornamented with flamboyant Gothic decorative stonework, the date 1889 carved above the former, and Antony and Janet's coats of arms above the latter. Plucknett's coat-stand was altered and removed to the Cloister entrance where it was joined by the new cabinets, similarly designed by Laverton & Co. The company, based at the Bristol Steam Cabinet Works, 36 and 37 Mary-le-Port Street, also made the spectacular pair of glazed Gothic wall cabinets, the side panels replete with 'AG's, to house Antony's collection of majolica. The alterations made to the Staircase Hall were even more dramatic. Here the entire staircase was reconfigured both to open up more space and to alter the character of the room, which in Antony's mind was linked to the sight of his mother ascending and descending the stairs. The imperial first flight was cleverly re-sited to the side wall, running up to the half-landing. One of the upper flights was removed altogether and, to take the weight of the landing, the original granite newel posts were stood end on end, linking the floor to a new supporting arch. New parquet floors were laid throughout, and panelling raised to

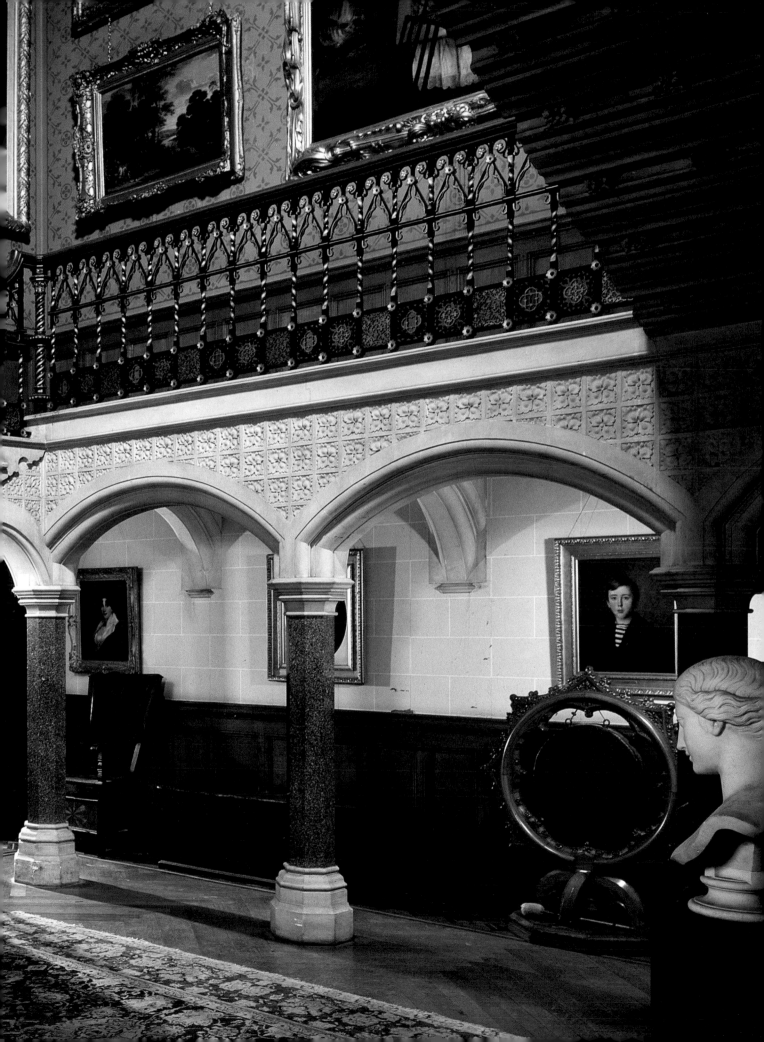

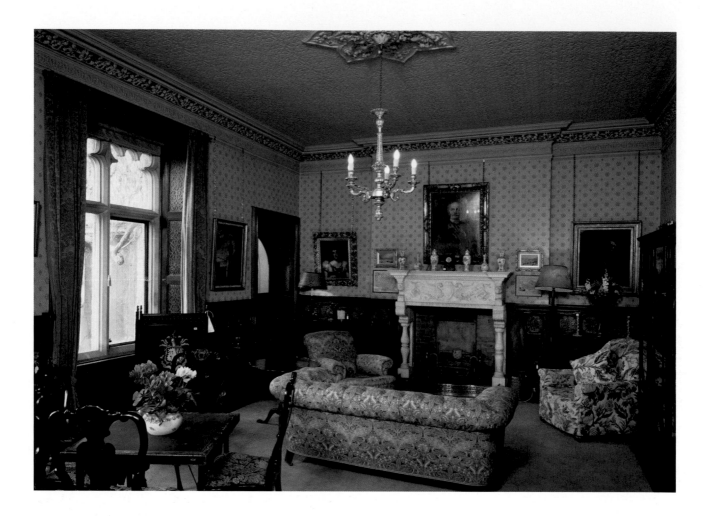

the level of the dado. A richly patterned Agra carpet, of a type Antony might well have seen at the Glasgow International Exhibition in 1888, was purchased for the Hall, and further carpets were hung on the walls either side of the fireplace, whilst a stair- and landing-carpet with a sumptuous burnt-orange field decorated with stylised flower heads was specially ordered.

The Oak Room was panelled throughout by James Plucknett. The old door to the Staircase Hall was blocked, providing a glazed cupboard to display Antony's works of art. This matched a false cupboard on the far side of the fireplace, which led through to the Morning Room, where a new carpet, woven with Antony's initials, was laid. A new door gave access to the Ante-room. Antony's own major contribution came in his mother's sitting room, which now became his Study. Here he created continuous dado panelling with a series of exquisite fruitwood panels depicting plants and flowers, which he apparently carved himself. In the Billiard Room, Woodyer, architect of the south-front veranda, provided a deep inglenook fireplace that Plucknett surrounded with carved panelling. In the middle of the

Above: Lord Wraxall's Study, with its carved fruitwood panels set on to the dado, attributed to Antony Gibbs.

room Plucknett created yet another *tour de force*: the grandest of billiard tables. The baize field rested on a steel-block vacuum cushion that was heated by hot-water pipes below. The scoring was controlled by electrically activated buttons around the cushion that linked to the scoreboard on the wall. The whole was encased in oak, incorporating twelve panels carved with traditional British sports and pastimes.

The Oratory, which had largely been redundant since the building of the Chapel, was transformed into an Organ Room. The small Gothic doorway into the Staircase Hall had been blocked and instead, two sets of double doors were made into the Ante-room, presumably for sound-proofing when Antony was in full flood. Another door was made into the garden corridor. The organ was supplied by Messrs Brindley at a cost of £729 18s:[6] its stool, with leather padded seat, still stands in the room (parts of its casing are in the cellar below). Here, as in the Oak Room, new wool curtains were supplied, which also survive.

The transformation of the Dining Room was even more dramatic. Norton had left Crace's room of the 1850s largely untouched, save for one of his fireplaces, which had been incorporated beneath the original superstructure. Woodyer was asked to enlarge the whole room, incorporating half the Housekeeper's Room and creating three capacious window bays into the entrance courtyard. It was a spectacular success. Entered through double doors, the room appears both large and intimate. Light floods in through the fifteen lancet windows, enlivening the rich panelling and the embossed gilt wallpaper, designed to imitate Spanish leather. Two granite columns support the ceiling, again topped by linked 'AG's. At the far end Crace's sideboard was given a new upper section by Plucknett, richly carved with flowering plants, its mirrored centre reflecting the Gothic carved door-case at the far end. Crace's carpet was replaced by one specially woven to fit the bays, and Crace's maroon curtains by woollen ones. Laverton's supplied the new dining-table, a Gothic oak side-table that was influenced by Crace's sideboard, and a gong based on the rose window in St Mary's Redcliffe, Bristol.

These changes to the principal rooms had repercussions elsewhere. The housekeeper was given a new room in what had been a storeroom, and a passage was made behind the Dining Room, allowing the staff to reach the larders without passing through the Kitchen every time. Likewise, the Butler's Pantry was given a new door to the garden corridor, enabling quicker access to the Billiard Room. Upstairs the bedrooms looking on to the entrance court all gained deep bay windows matching those of the Dining Room below. On the top floor some of the bedrooms were refurbished to accommodate the influx of the

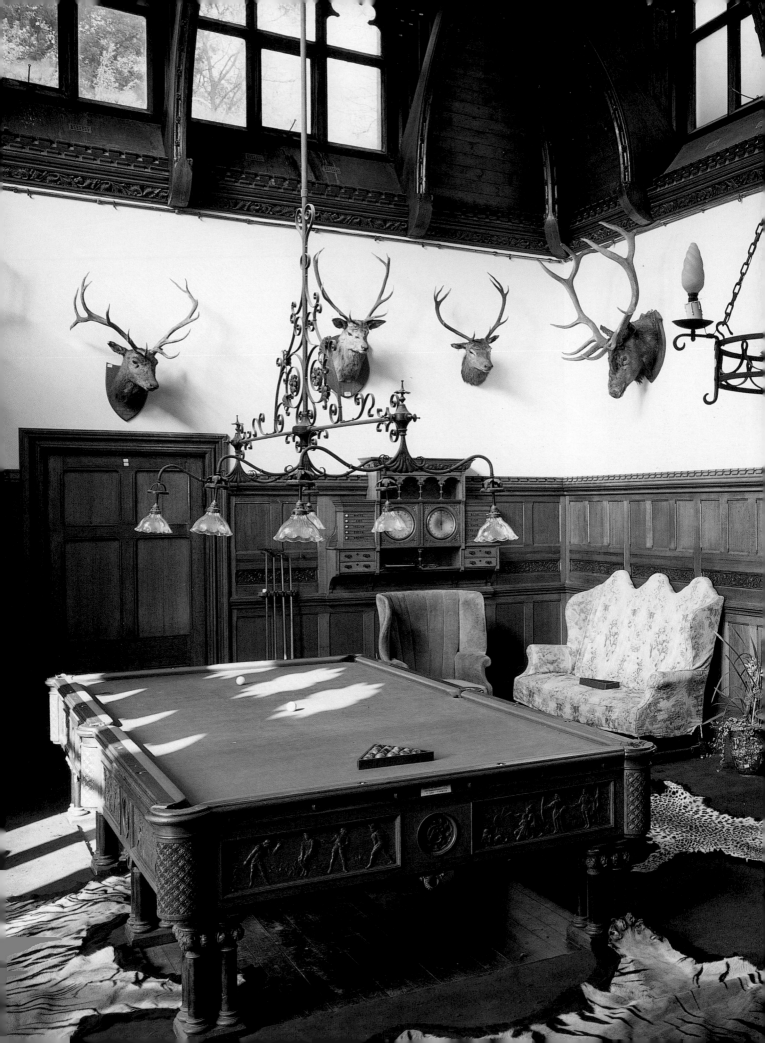

The Billiard Room designed by John Norton, with Henry Woodyer's later inglenook fireplace and the billiard table by James Plucknett.

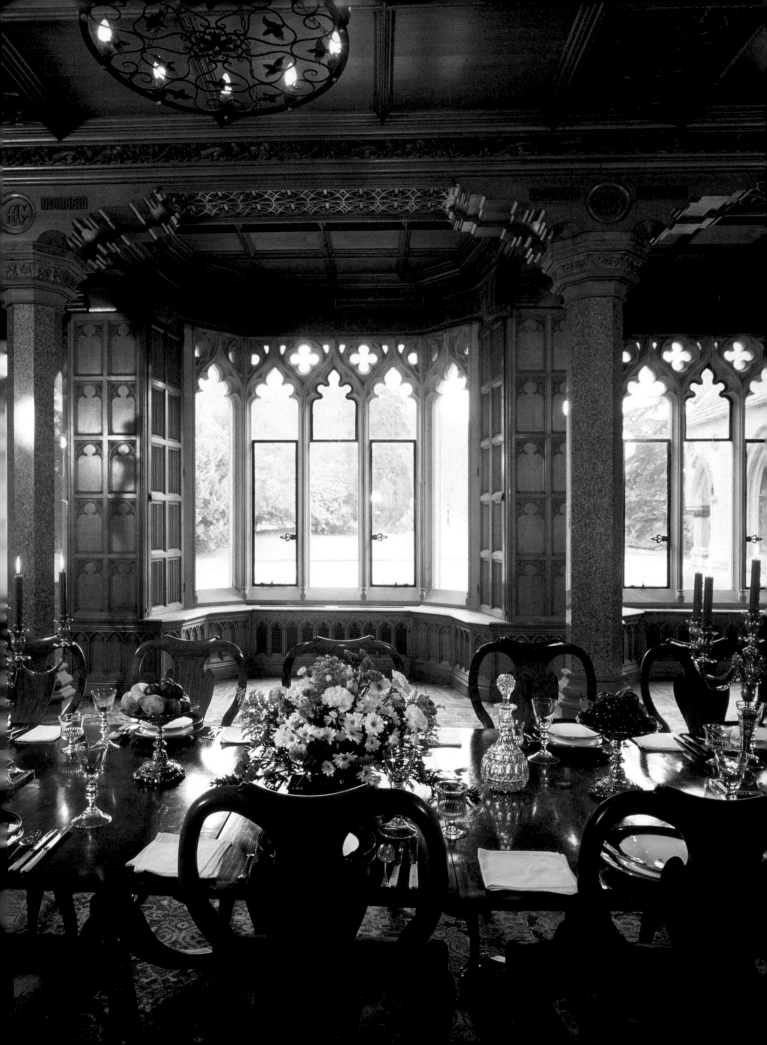

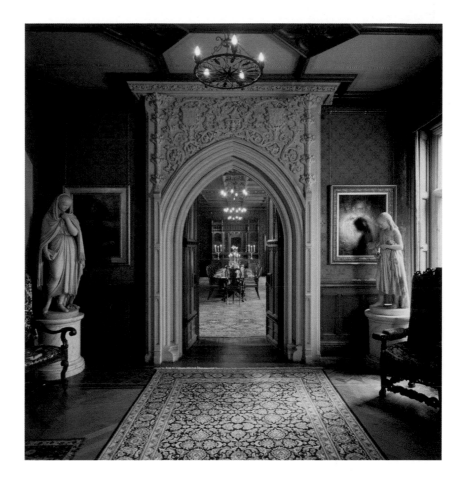

Left: The Dining Room as extended by Henry Woodyer for Antony Gibbs.

Above: The doorway to the Dining Room with the elaborate carved decorations devised by Henry Woodyer. The statues of the *Highland Mary* (by Benjamin Spence) and the *Little Maid* (by Lawrence Macdonald) stand at left and right.

children. The principal technological changes were a new heating system and, even more revolutionary, electric lighting. Very few country houses had taken advantage of this; Lord Armstrong's Cragside in Northumberland and Tyntesfield were among the exceptions. The electrical system was installed by Mr Bowles of Hardman's, and was powered by a generator housed near the timber yard. On 30 May 1890 Antony recorded that he spent an entire night in the house alone testing 'all the new fangled electric lights'.[7] The light-bulbs were either attached to the ceiling, as in the bays in the Dining Room, or they simply dangled from circular chandeliers, with no shades to obscure their technical brilliance.

Woodyer's work continued outside, where he designed new stables and motor houses built by the local builders, Newton's, at an additional cost of £6,726 4s.[8] A fine new drinking fountain in the Renaissance manner was placed in the centre of the first courtyard. Further work was carried out in the gardens, extending the original terraces, paths and formal beds, which had been laid out in the 1840s and 1850s. The slope had been adjusted to allow three terraces beneath the house: the upper terrace was reserved for bedding out, the second

The Terrace Walk with the interplanting of yuccas and yews.

had eight hexagonal beds with small cut hollies growing around marble campana vases, and the third an alley of alternating yuccas and Irish yews – surely a unique combination on such a scale. From near the Conservatory a holly walk led to the plantations known as Paradise, filled with specimen trees probably supplied by Veitch of Exeter. To the right was the formal rose garden with its pair of thatched summer-houses, probably designed by Norton and lined with beautiful Minton tiles.

Ever since William Gibbs had first lived at Tyntesfield, the plants and specimen trees had thrived, almost certainly aided by applications of guano. Grapes grew in his hot-houses, supplied by Henry Ormison of King's Road, London. They were remarked on approvingly by Charles Curtis, editor of the *Gardener's Magazine*, who visited the gardens in 1873.

As with the house, Antony felt his father's gardens should be improved and extended. As a memorial to Queen Victoria's Diamond Jubilee he extended the kitchen garden, adding an Orangery, a lily pond, box-edged beds for gladioli, pentstemons and snapdragons, and

The Terrace Stairs leading down to the Keble Oak.

a formal entrance that passed through a wrought-iron gateway into a walled herb garden, through an arcade and into an open court with glasshouses. Ormison's earlier hot-houses were replaced by new hot-houses for vines, carnations and delicate plants, erected by W. G. Smith of Ipswich, using Beard's patent system. In 1878, G. Beard & Sons of Ipswich had patented a new method of attaching the glass panes with metal caps rather than putty, which tended to weather. This system was installed by the technically minded Antony, and has withstood the test of time. Close by was a long brick building in the 'Wrenaissance' style, like the Orangery. This was the first building at Tyntesfield not in the Gothic style, and is almost shocking with its pediments, pilasters and columns. It was designed by Walter Cave, a pupil of Sir Arthur Blomfield and the son of the Bristol banker Sir Charles Cave.

Antony's work was celebrated in an article on the house published in *Country Life* in May 1902. The writer comments that 'Mr Gibbs may well be proud of the perfection in which his house and grounds are kept. In this matter they are not excelled in the West Country. It is

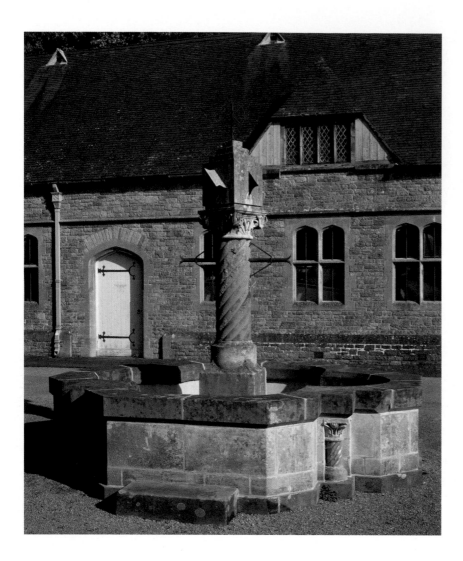

a beautiful and attractive estate, well managed and abundantly cultivated with farms, dairies and orchards as fruitful as we would wish to see', and further, 'Tyntesfield is a lustrous example of the manner in which judgement and good sense work out an excellent result, and we are glad to number it among the most interesting mansions in that very charming and attractive shire.'

If the house and estate had become accepted as part of the rich pattern of English country life so, too, had the family. In *Somersetshire Lives*, also published in 1902, the writer notes of Antony Gibbs, Esq., MA, CA, JP: 'a gentleman of solid substance, dignity and position, Mr Gibbs illustrates in his person and training the qualities and traits which are typical of our county families It is not money alone that effects, or could possibly effect this result.'[9] The money still being made by Antony Gibbs & Sons, run by Antony's cousin Henry Hucks Gibbs, by this time Lord Aldenham, underpinned the whole, however. Like his father, Antony was rich, and like his father he had brought

The fountain in the stable courtyard designed by Henry Woodyer.

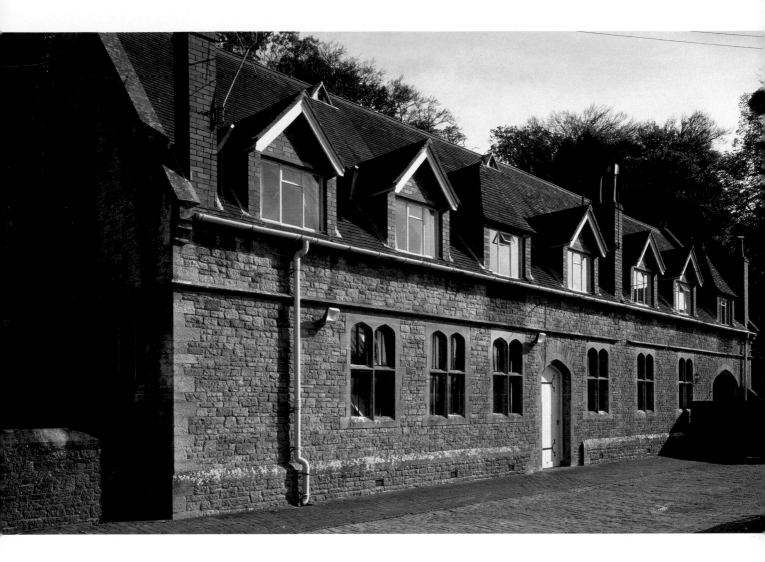

Buildings in the stable courtyard.

these riches to bear on Tyntesfield. He also continued the family's philanthropy. With his brother Henry he paid for the hall and library at Keble College, made substantial contributions to the building of Lancing College, and rebuilt Wraxall church to designs by Blomfield in the 1890s. He was the greatest and most cultivated owner of Tyntesfield. He also had an original mind. He invented a bicycle that stored energy whilst going downhill, to expend it when ascending: sadly it proved too heavy to pedal on the flat – it was not to pay the dividends of guano. This highly cultivated man died on 24 April 1907, aged only 65.

Tyntesfield Improved

Above: A detail of Minton's blue and white tiling, found in lavatories throughout the house.

Left: Inlaid writing-table attributed to Francesco Spinghi, here seen open.

In 1908 Mrs Antony Gibbs, seated in her invalid chair, swathed in a vast rug and dressed in widow's black tempered by an eye-catching hat, posed for the photographer outside the front door of Charlton. Also captured in the photographer's lens was the next generation: the nine sons and daughters who had grown up at Charlton and then at Tyntesfield. The family was still growing, and not just in terms of numbers. The days of private tuition followed by terms at Radley or Lancing were over: Antony and Henry Martin's sons went first to Eton and then to either Oxford or Cambridge, or into the army. The family's continuing wealth and estates had given them a position in society. Tyntesfield, now affectionately referred to as 'dear old Tyntesfield', was the centre of this. Here the happy country-house life of Edwardian England was enacted, with cricket weekends, shooting parties, hunting and even costume balls. At weekends, the young people would arrive from London as punctually as the fresh flowers and vegetables sent up from the walled gardens. The house provided comfortable relaxation from the serious business of life. As in the 1850s, it was full again of young people, who were no longer summoned to lessons and prayers, rather to tennis and tea on the lawns.

The family's business position had also shifted. Since William Gibbs's death, his nephew Henry Hucks Gibbs had presided over Antony Gibbs & Sons, developing the nitrate trade from the deserts of South America when the natural guano deposits had been exhausted. He had also diversified the company's activities into shipping, mining, trading in an encyclopaedia of commodities, and merchant banking. The company's success was closely linked to the country's imperial expansion of the late nineteenth century. Henry Hucks had been a director of the Bank of England since 1853, and its governor between 1875 and 1879. In 1891 he became Member of Parliament for the City, and in 1896 was created Baron Aldenham, the first member of the Gibbs family to sit in the House of Lords, taking his title from his

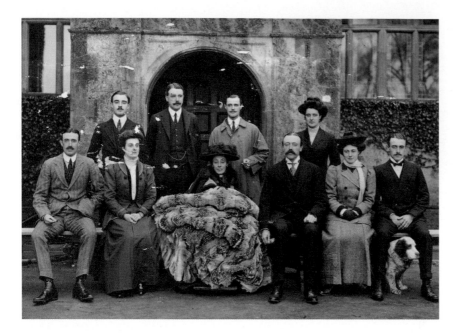

principal house, Aldenham in Hertfordshire. His eldest son, Alban George Henry Gibbs, who would inherit his title in 1907, was likewise elected Member of Parliament for the City in 1892; his younger brother Vicary, who would live at Aldenham and become editor of *The Complete Peerage*, became Member for St Albans in the same year. The family had taken its position at the heart of British commerce, government and society.

George Abraham Gibbs, Antony's eldest son and the heir to Tyntesfield, grew up in this new family world. His life, career, and the changes he would effect at Tyntesfield would reflect it. At a very early age he was given the attributes of natural authority in Edward Clifford's delightful portrait of him with his sister Albinia Rose and his brother Hubert. He sits amongst the spring flowers of Portbury Wood on the Tyntesfield estate, looking over the Bristol Channel, dressed in a sailor suit. He firmly holds the strings of his high-flying kite, pointing out its aerial progress to his siblings. Nine years later he went off to Eton and in 1888 to Oxford, to study at 'The House', Christ Church College. On leaving Eton, he acquired a series of photographs of the college to hang in his room at Tyntesfield, and when he left Oxford he came down with a degree and photographs of himself as a member of the Bullingdon Club, the university's most prestigious undergraduate society. He had been a popular undergraduate in a world of Zuleika Dobson rather than that of Charles Dodgson. Further photographs show him as an active member of the Christ Church Beagles – still to be found in the Silver Cellar at Tyntesfield is his silver hunting horn, given to him by his fellow beagling enthusiasts in 1896.

Mrs Antony Gibbs and her children outside Charlton, *c.*1908.

George Abraham Gibbs with his sister Albinia Rose and brother Hubert, by Edward Clifford, 1878.

At Tyntesfield he kept his own pack of beagles. He and his father also created a cricket field beyond the walled gardens, moving tons of earth to overcome the natural slope of the land: this would periodically have to be re-laid as the slope reasserted itself and 'mid-off' would go missing. The house team had a good reputation – George's brothers-in-law, Dick Bennett and Stafford Crawley, were both keen county players. Racquets could also be played on the court specially, if surprisingly, built into the centre of Belmont.

On 6 July 1894 George had celebrated his twenty-first birthday, his coming of age. Presents typical of the age were given, and again the photographer's lens did its work and captured the presents displayed on and around a table in the Library. In the foreground an elaborately illuminated testimonial, signed by all the staff, is surrounded by walking sticks, binoculars and the like, while above lie quantities of silver, including his uncle's present of a porringer, the household staff's rose bowl and the estate employees' silver jug. Shortly after these festivities, according to the *Times* correspondent, George 'spent some time travelling in Europe, Asia, Africa, and India, finding many opportunities for hunting and shooting. Travelling always remained one of his favourite pastimes.'[1]

These halcyon days were interrupted by the outbreak of the Boer War in South Africa. Since the Crimean War, Britain had largely been at peace – for nearly fifty years, if the campaigns of imperial expansion are ignored. Now the family had the anxiety of sons going to war. George left for South Africa in 1900 with the 48th Company Imperial Yeomanry, the North Somersets. Fortunately, he returned unscathed

except for an accident sustained playing polo. A print after Lowes Dickinson of *The Entry into Pretoria*, with George amongst the company, still hangs on the Nursery wall, his uniform is in a cupboard nearby (in surprisingly good condition), and his Queen's South Africa Medal with five bars is kept in the safe. He commissioned Charles Gatehouse to paint his faithful charger Boomerang, a Tyntesfield horse bred by Tomahawk out of his father's mare. The horse made the journey abroad unharmed, and returned to well-earned retirement in Tyntesfield, dying at the ripe old age of 22.

George Gibbs continued his regimental duties, and in 1909 commanded the North Somerset Yeomanry. His military service had two further consequences: marriage and a political career. Amongst his fellow officers in South Africa he encountered Charles Dungarvon, later 10th Earl of Cork and Orrery, Colonel in the North Somerset Yeomanry, and his nephew Walter 'Toby' Long, serving with the Royal Scots Greys. After the fall of Pretoria and their return home, this

George Abraham Gibbs (seated at centre) with his brothers in the uniforms of their various regiments, *c.*1910.

Above: George Abraham Gibbs in *The Entry into Pretoria*, a print by Lowes Dickinson.

Overleaf (at left): The Hon. Victoria Florence de Burgh Gibbs, known as Via (1880–1920) by Albert Henry Collins, 1908. 'In the evening she looked especially beautiful.'

Overleaf (at right): George Abraham Gibbs (1873–1931) in the uniform of the North Somerset Yeomanry, by Albert Henry Collins, 1908.

camaraderie soon extended to Toby's sister Victoria Florence de Burgh Long, always known as Via. The friendship between George and Via blossomed quickly, and on 26 November 1901 they were married at All Saints, Ennismore Gardens, South Kensington. His fellow officers of the North Somerset Yeomanry gave the happy couple a silver salver inscribed with all their names.

George's grandfather had delayed matrimony until he was almost fifty and then married his cousin; his father had married a friend of the family who shared the Gibbses' mercantile and Devonian roots; George's marriage was different. His reflected the wealth and education that had brought the family into the ambit of the landed aristocracy. Via's family, the Longs, had been settled at Rood Ashton in Wiltshire since the late seventeenth century. Rood Ashton was a picturesque Gothic pile impressively built on a rise of land south of Chippenham, with extensive views across the Wiltshire plain. Its decorative Gothic outline was, however, more a reflection of the family's sense of its antiquity than of its Christian faith. Nevertheless, like the Gibbses, the Longs had rebuilt the local church in the 1860s in Tractarian style, and both George and Via had grown up amid the Gothic architectural taste of their grandparents. The Longs had a distinguished record, with a member of the family always serving in the House of Commons from the sixteenth through to the twentieth century. Via's father had sat in the House since 1880, and was at the time of his daughter's marriage MP for Bristol. He would in due course become First Lord of the Admiralty and be made Viscount Long, whilst his younger brother would become Viscount Guisborough. Via's mother, Lady Doreen Boyle, was the daughter of Richard, 9th Earl of Cork and 10th Earl of Orrery, and his wife, Lady Emily Charlotte de Burgh-Canning,

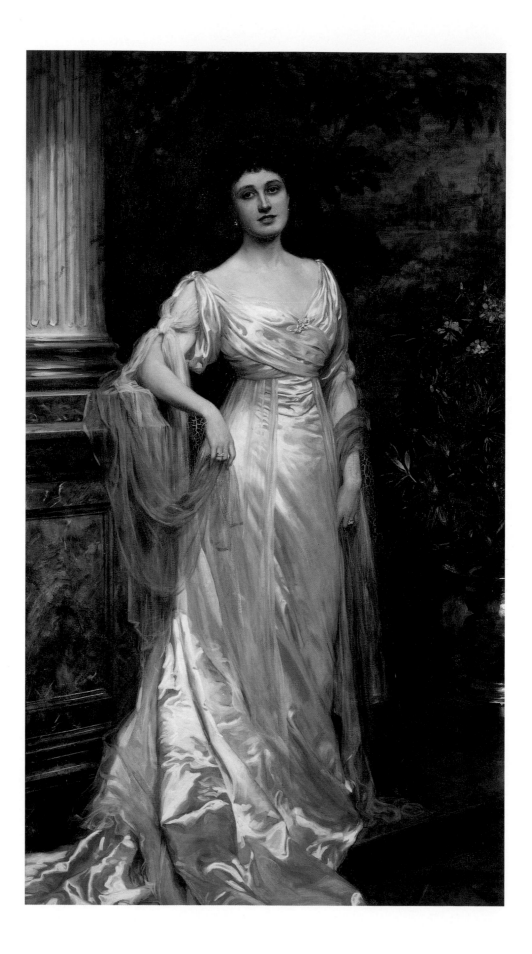

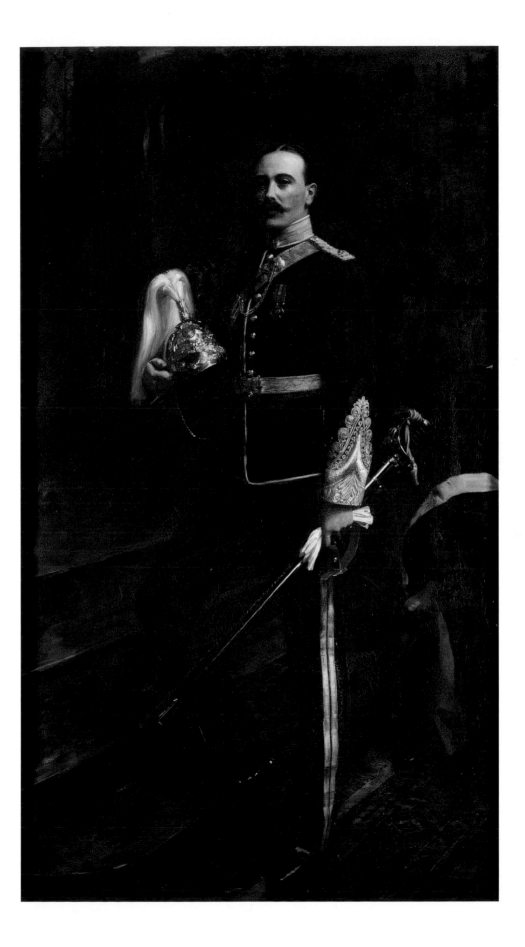

daughter of Hubert, 2nd Marquess of Clanricarde, and sister of Lady Harewood and Lady Allendale. Lady Doreen's brother was the rich, reclusive Lord Clanricarde, and the early nineteenth-century Foreign Secretary George Canning was her grandfather. As he spoke the words 'I do', George joined himself and the Gibbs family to this heady mixture of politics and power, wealth and social assurance.

After an extended honeymoon travelling in Europe and on to Egypt, the couple soon settled to a life in London, first in Hereford Street, Mayfair, and then at 35 Wilton Place in Knightsbridge. In town, George attended the House of Commons, as he had entered Parliament in 1906, following his father-in-law's example. This had not been easy, as the fortunes of the Conservative Party were then at a low ebb. Via campaigned with him in the local constituency of Bristol West and, in a straight fight against the Liberal candidate, Gibbs pulled off an unexpected victory by a margin of 365 hard-won votes. The bracelet he gave to Via to celebrate what was really their joint victory records this narrow margin. He proved to be a popular and highly respected Member of Parliament and the voters of Bristol returned him to the Commons at every election until he retired in 1924. In the

Above left: George Abraham and Via's bedroom with a delicately painted Hepplewhite tester bed.

Above: An electioneering poster for Colonel Gibbs.

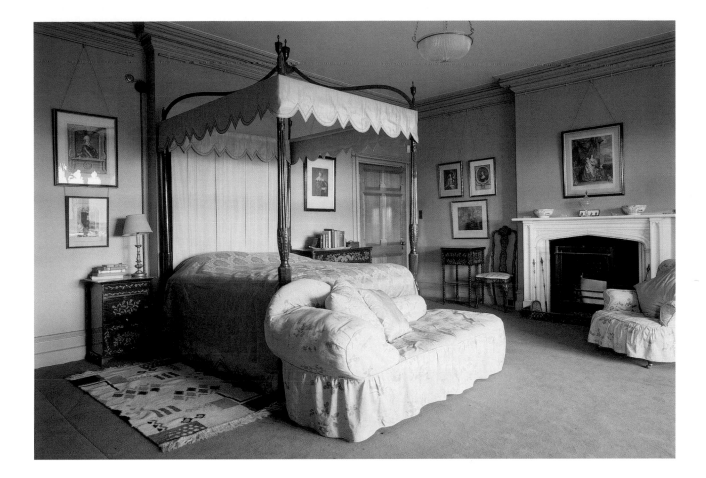

The Stuart Bedroom, showing Via's redecoration. The white marble fireplace formed part of the original Tyntes Place.

future the margin was not to be so narrow – he won one election by over 17,000 votes, the largest majority thus far recorded, which was celebrated in style at Tyntesfield.

Via's zest for political life also found an outlet in her work for the Primrose League, founded in the 1880s following Benjamin Disraeli's death and named after his favourite flower. Its aim was to spread Conservative principles amongst the voters, fighting off the threat of the Liberals and the fledgling Socialists. It had rapidly taken root, and between 1884 and 1891 its membership rose from under a thousand to over a million. In 1904 Via became President of the League in South Bristol, and during the ensuing decade the fortunes of the League continued to rise, with over two million members by 1910.

When Parliamentary time and charitable business allowed, George and Via loved to travel, taking regular trips abroad and to Scotland for shooting and fishing. The combination of trains and passenger liners, some financed and others owned by Antony Gibbs & Sons, meant that the world was their oyster. In 1903 they spent five months visiting India, making trips to both Mount Everest and Ceylon. At other times they visited Russia and North America, often on shooting expeditions,

which they both enjoyed. Trophies naturally followed, and the stuffed heads in the Billiard Room were later arranged there by Via.

On inheriting Tyntesfield, George followed a family tradition and set about transforming the house. In some ways it was an even more radical change than that made by his father, although it affected fewer rooms and there were hardly any external changes. George and Via wanted to create a house that was more akin to the ancestral houses of their friends: they did not want to bring Tyntesfield 'up to date', so much as give it a more complete sense of history; not Gothic church history but a history that reflected the slow acquisition of objects and shifts of taste that characterised so many English houses. The use of the rooms also altered: the great Drawing Room became the State Drawing Room, a room of display; the Library became the main Sitting Room, especially when guests were staying; and the Morning Room became the family's Sitting Room. George used his father's Study as his Business Room, with his secretary installed in the nearby Organ Room. Upstairs George and Via moved into the West Bedroom over-looking the gardens. The Flaxley Room, where his parents had slept in the four-poster bed with its twisted columns, was largely left as they had had it, although under dust-sheets. George was also immensely practical and adjusted the home to contemporary needs. A new front door was installed under the porch, a new private staircase was built from the garden passage to his bedroom above, and a new garden porch was added, as Via and George's daughter Doreen recalled, to 'prevent tennis rackets and other sporting paraphernalia littering the corridor'.

There was a freedom in their approach and an originality in George and Via's decorative schemes that gave their rooms a singular appearance and a wonderful sense of *joie de vivre*. In the words of Via's friend and biographer Madeline Alston, 'They both had very definite ideas of what was beautiful and appropriate.'[2] What they considered 'beautiful' and surprisingly 'appropriate' was a Venetian State Drawing Room. Undoubtedly George's grandfather's Drawing Room, left unaltered by his father, must have seemed old-fashioned and inappropriate for the new regime at Tyntesfield. Its quasi-religious quality, suggested by the brass candelabrum, stencilled walls, Gothic fireplace and antimacassared furnishings, would certainly have looked old-fashioned by the turn of the twentieth century. It would have been quite a daunting place to assemble in after a dinner party. George and Via had visited Italy, and while they were in Venice they had much admired the richly decorated *palazzi*. They felt that the Drawing Room at Tyntesfield had the right proportions to carry off such a style. On their trip to the city in 1908 they visited Guido Minerbi and

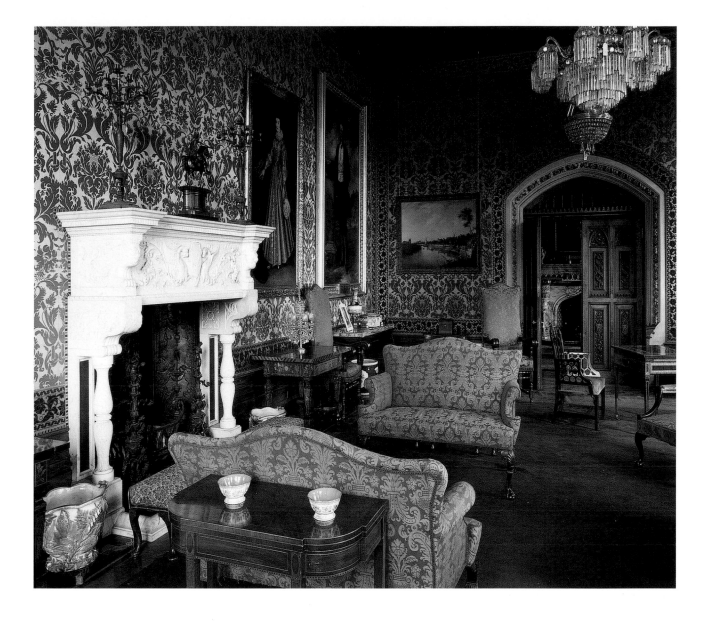

Part of the Drawing Room, showing the fireplace installed by George and Via.

ordered a white marble fireplace in the Renaissance style. This they had copied on a large scale specifically for the new Drawing Room. Crace's multicoloured fire surround together with its looking-glass and free-standing statues was taken down and put into store – rather appropriately in the Chapel crypt.

The new fireplace was installed with a pair of bronze andirons, originally bought in Italy by Antony in 1875 but seemingly never before having found a suitable home. The stencilling on the ceiling was covered by paper, and painted to ensure that no faint traces would start to appear. The stencilled walls were covered in crimson and ivory silk, in a seventeenth-century Venetian pattern, with deep borders of Florentine silk lampas. Crace's curtains came down and up went four pairs of deep-crimson velvet curtains with matching pelmets, and with

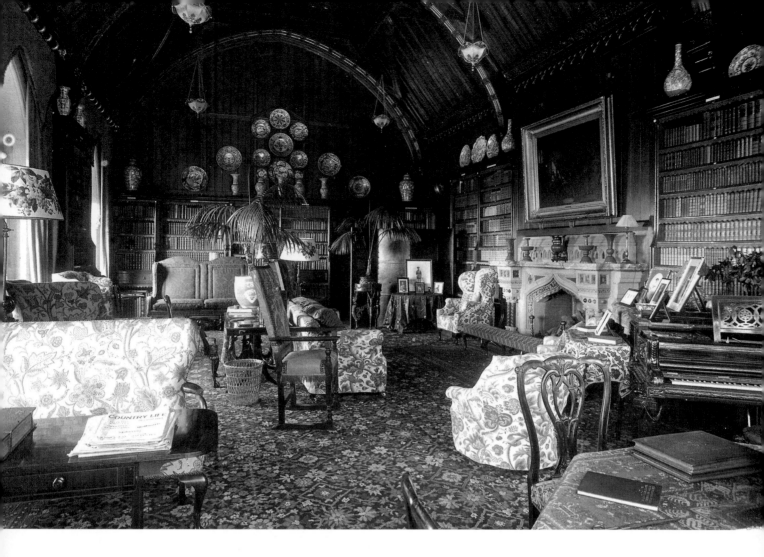

The Library as rearranged by George
and Via, with eighteenth-century
furniture, Oriental porcelain and art
nouveau lamps, c.1912.

borders to match those on the wallpaper. Crace's great carpet was in too
good a condition to abandon, so it was dyed crimson to match.
Mahogany sofas, arm- and side-chairs in early eighteenth-century style,
often with carved knees, cabriole legs and pronounced ball-and-claw
feet, were acquired. These were similarly upholstered and covered, and
intermingled with them was a growing collection of ebony and ivory
furniture, marquetry pieces and Venetian lamps. Electroliers illuminated
the gilt-framed pictures, including a painting by William Etty over the
fireplace, and the large lacquered screen that filled one side of the
room. Lit by the new glass chandeliers, the effect at night must have
been stunning.

Antique furniture completed the look of the room. Fortunately,
invoices survive for some of these years, recording visits to local dealers.
The most prominent supplier was Mallet's of Bath, who sent folders
of photographs of period furniture to whet the appetites of George
and Via. In London, there were visits to Messrs Edgley of Sloane
Street, and to Waring and Gillow, who presumably supplied them
with contemporary furniture in eighteenth-century style. They also
frequented the London salerooms: a walnut and seaweed marquetry
cabinet on a stand was acquired from Christie's on 26 July 1910.

George and Via's European tours gave them the opportunity to buy continental furniture; unusually, this was Italian rather than French. One of the finest pieces was a cleverly designed table that can act as both a writing-table and a dressing-table, and was made in Florence *c*. 1800. It is almost certainly the work of Francesco Spinghi, who had established his workshop in the city in 1767 and who was Court Maker from 1780 to 1798. The design is beautifully restrained and balanced, its parquetry in rosewood, amaranth and tulip wood brilliantly defining each area and playing optical illusions with simple geometric shapes around the top. Inside it is equally elaborate both in its decoration and in its technical ingenuity. Spinghi invented a complex mechanism to open and close the various compartments of his tables, allowing them to be used as either a dressing- or writing-table, depending on which parts were opened. Failure to follow the instructions would result in the table refusing to open or close. Later, Doreen sensibly wrote out instructions, 'How to open and lock', still placed beneath it to prevent problems in the future. Her parents also visited the dealer Orselli while they were in Florence in 1908, buying a large ebony and parquetry chest from him on 12 April. It still stands in the Hall, beside the fireplace, exactly where they had it placed on their return.

The process of softening Tyntesfield's Gothic edges continued. In the Dining Room, completed by George's father less than twenty years before, the old seat-furniture was replaced by a set of 30 new walnut chairs, similar in style to the claw-and-ball furniture of the Drawing Room. These retain their original trade labels, revealing that they were made by Charles Baker of the appropriately named Chippendale House, Wells Road, in Bath. He was a fine judge of timber, as can be seen from the beautifully grained walnut that forms the vase-shaped splats of the Tyntesfield chairs. The notion that these were less intrinsically valuable than original, early eighteenth-century chairs is not a judgement that would have been made at that time.

A photograph of the Library, probably taken in 1912, shows how a tempering effect could be achieved in even the most Gothic of rooms. As Madeline Alston observed, Via's 'love of order was another strong characteristic . . . she could not bear a disorderly room, after the children had gone to bed she herself would go around putting things straight'.[3] The Library is particularly tidy in the photograph. Delicate art nouveau lamps hang from the ceiling, oriental china is massed on the walls and shelves, and palms and photographs cover the table tops. Crace's Gothic furniture has been replaced by pieces evocative of the eighteenth century, with sofa-tables, settees and a set of eight mahogany dining-chairs with pierced, interlaced splats supplied by

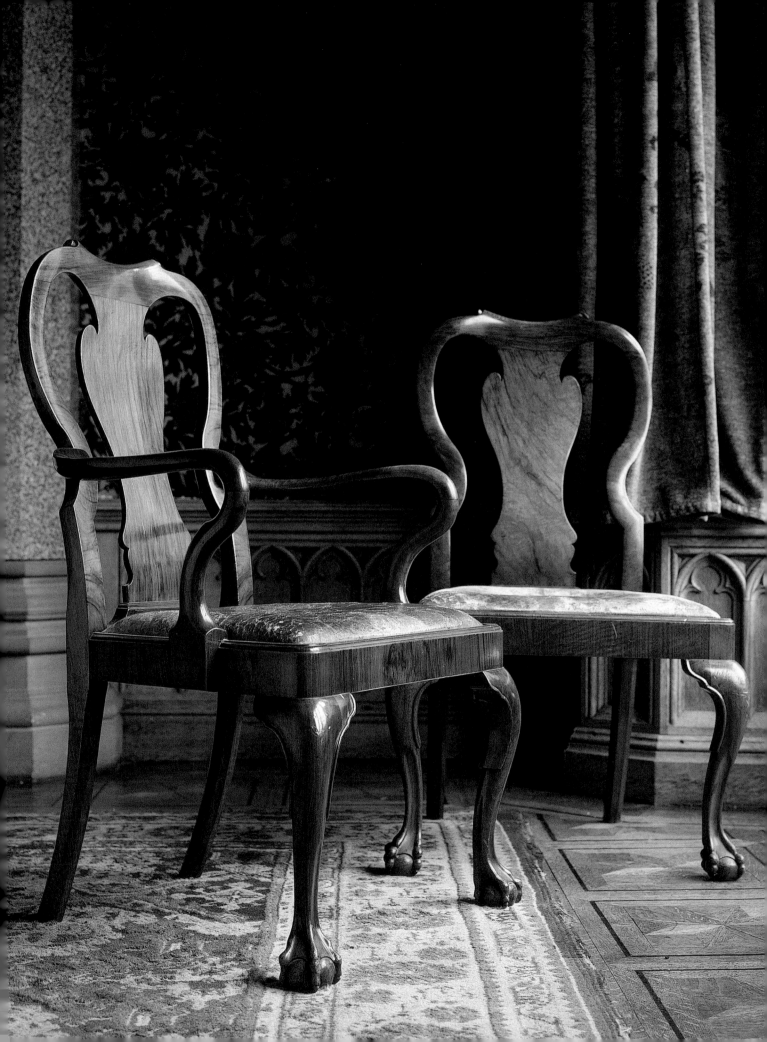

Hancock's. The chairs have received loose covers, the tables have been draped, and Crace's curtains have been replaced with gold satin ones woven to an early eighteenth-century pattern and supplied by Hammond & Sons of 165 Sloane Avenue on 19 October 1909.

Eighteenth-century furniture was introduced into the adjacent Study, Morning Room and what was now George's Business Room. Here the original Venetian marble fireplace bought from Minerbi replaced Plucknett's wooden one. A fine George III mahogany partners' desk was placed in the middle of the room with a small Chubb safe, encased in figured walnut, standing nearby for his papers. Via's Boudoir was on the first floor. There she could look across the terraces through brocaded linen curtains specially woven with a silver-thread lattice-work. The room was painted a shade of mid-green, much favoured by the contemporary decorators Lenygon and Morant, and a finely carved marble fireplace in eighteenth-century style replaced the original one that had been installed by the Reverend Seymour some eighty years earlier.

All the bedrooms gained eighteenth-century furniture, and new names, mainly taken from local villages. The most complete redecoration took place in what had originally been William Gibbs's Dressing Room, which became the Stuart Room. Here the walls were hung with a flecked brown paper, against which stood the collection of Dutch early eighteenth-century marquetry furniture, and on which were hung, over time, portrait prints of members of the House of Stuart. Here, as elsewhere, four-poster beds were introduced, including George and Via's beautifully painted tester, largely based on a design by George Hepplewhite published in his *Cabinet Maker's and Upholsterer's Guide* of 1788. Further bedrooms were also densely hung with historical prints, often grouped in themes, and largely acquired from Alfred Davis in the Kings Road and the St James Old Picture Company.

On the top floor the nurseries were redecorated for the anticipated children. The central room became the Night Nursery, with its richly grained furniture, and the Day Nursery was created in the adjacent room. Here the walls were hung with cream and beige floral paper and the woodwork and furniture painted a rich cream. Very sadly, the anticipated tribe of Gibbs children did not materialise. Via suffered a heart-rending nine miscarriages and the deaths of two infant sons, George Antony and Antony Eustace, the death in the First World War of her beloved elder brother Toby coinciding with her last son's death. Their only surviving child was their daughter Doreen Albinia de Burgh, who was born at Tyntesfield on 13 September 1913. She was, naturally, incredibly precious to her parents, whose protectiveness she found, equally naturally, irksome – mesh bars to the windows, and

Two of the set of eighteenth-century style walnut chairs made by Charles Baker of Bath for the Dining Room, *c.*1910.

watchful nursery maids. Nevertheless, she enjoyed the nurseries and, despite pleas to learn to sew, chose instead to carve, setting up her carpentry bench in the Window Turret (she had inherited her grandfather's woodworking skills). Her cupboards were full of toys – and a rocking horse stood prominently in the middle of the room, looking towards the wonderful views from the windows to the park and beyond.

In London, the family moved from Wilton Place to 22 Belgrave Square and in 1909, after his mother's death, George sold 16 Hyde Park Gardens, which by then had been in the family for over fifty years. London society had moved south of the park and the Gibbs family followed suit. An inventory was taken of Hyde Park Gardens before the objects were removed, some to Tyntesfield and others to Belgrave Square. The move necessitated a rehanging of the paintings, which was completed by 1912, when George had printed a second *Catalogue of the Paintings*. The area most affected was the Staircase Hall at Tyntesfield, now called the Gallery, which was hung with family portraits, as had become traditional in English houses. The largest were the full lengths of George and Via themselves, painted in 1908 by Harry Alfred Collings. George was depicted rather stiffly in the dress uniform of the North Somerset Yeomanry, holding his glistening helmet in one hand and his sword and gloves in the other. Via's more relaxed pose recalls the portraits of George Romney, and it is no accident that she and George acquired fine mezzotints of Romney's portraits to hang in the bedroom corridors. Via stands in front of a tapestry, beside a column, wearing a rich evening dress made of golden cloth, a gauze wrap meandering around her. The gushing words of Madeline Alston spring to mind: 'In the evenings she [Via] looked especially beautiful. She did not cling slavishly to fashion but always wore the right thing.'[4]

George's main additions to the picture collection were the historical portraits he acquired for the Morning Room between 1909 and 1911. The largest painting, which was hung above the fireplace, was a fine copy of *The Eldest Children of Charles I* after Van Dyck, which had come from the Duke of Sutherland's collection at Trentham Park in Staffordshire. Nearby hung the *Portrait of Lady Frances Cranford*, daughter of the Earl of Middlesex, who in 1637 married the Earl of Dorset: the original, by Van Dyck, is at the family seat at Knole in Kent. Eighteenth-century sitters included the actress Peg Woffington, painted by William Hoare of Bath, and Sir Robert Walpole, painted by Thomas Hudson. George also moved into the room the *Portrait of an Infanta*, which had been acquired by his father in 1897. Later in 1939 it was admired by Queen Mary when she visited Tyntesfield, and she

Via Gibbs with her infant daughter Doreen on the staircase, with the lower part of the portrait of Doreen's father behind, adjacent to the bust of her great-grandfather William. To the left, one of the gasoliers designed by John Norton is fixed to the balustrade of the staircase.

asked the Royal Librarian to identify the sitter. A letter from the Queen now attached to the reverse of the painting reads, 'This is what our Librarian at Windsor says "I believe the portrait represents Marie-Louisa, Infanta of Spain, Queen of Hungary and Bohemia, wife of Leopold II, Emperor of Germany She was the daughter-in-law of the Empress Maria Teresa."'[5] Just the kind of informed genealogical detail that one would expect from Queen Mary.

The year after Doreen's birth saw the outbreak of the First World War. Now a lieutenant-colonel, George commanded the 2/1 North Somerset Yeomanry and had the responsibility of deploying his men, though much to his frustration he never saw active service in France himself. He also continued his Parliamentary career and became private secretary to Walter Long when he was made Secretary of State for the Colonies. Via, who had worked ceaselessly for a raft of charities

during peacetime, redoubled her efforts. She was in charge of the Red Cross for the district and, once war was anticipated, she sent out detailed questionnaires to local families to establish the resources she had at her disposal. Tyntesfield itself became a convalescent home for wounded soldiers. Via also sat on many other committees, including the North Somerset's Unionist Association, which set up camps locally for refugees. Throughout the war Via ensured that every family had a nanny goat in milk to provide the estate children with milk, as cow's milk was required for the war effort. After the war she organised a New Year's dinner for all the men working on the estate who had served their country. Twelve of them either lost their lives or were severely wounded. In 1919 Via was made a Commander of the British Empire by George V for her outstanding work. The photograph of her leaving Buckingham Palace after her investiture shows her proudly wearing her Red Cross sash.

Worn out by the miscarriages and the unceasing demands of charity work, Via died in 1920 aged only 39: 'She had squandered her life in the service of others and never counted the cost.'[6] She left behind

Above: Via Gibbs with her young daughter Doreen.

Right: Via Gibbs (at right) leaving Buckingham Palace with a friend, Mrs Gascoyngne, after receiving her CBE in 1919 for services to the Red Cross.

a grieving husband and a very sad six-year-old daughter, a legacy of love amongst her staff, and a house that has subsequently been little altered. It is as if, with her death, time began to stand still at Tyntesfield. Her passing was marked by a further cross in the Chapel, a tradition still followed, with recent crosses by Ienan Rees commissioned by the present Lord Wraxall. He also commemorated George and Via's infant sons, a poignant reminder of the sadness of those years.

George Gibbs would sit in his Study in the evenings, often accompanied by his young daughter. They became very close, he delighting in her youthful companionship, she simply in his relaxed company. If they looked out of the window Tyntesfield looked the same, the great terraces stretching away to Paradise, the only scar of the war being the demolition of the Conservatory. It had continued to be used throughout the war, bananas still growing on its trees, but the government's appeal for more ironwork in 1919 fell on the dutiful ears of Doreen's parents and they allowed it to be dismantled.

George was often in London on Parliamentary business. He fought and won three elections and became a Government Whip: 'he discharged his difficult duties with such tact and efficiency that, whatever his personal inclinations may have been, he was persuaded to remain in the Whip's Room for the rest of his career in the House of Commons'.[7] In 1921 he took on yet further duties, becoming the Treasurer to the Royal Household. He quickly gained the admiration and respect of George V and Queen Mary and carried out his role with his customary efficiency.

These were busy years in London but quiet at Tyntesfield, where the house was presided over by Hemmings the butler and fourteen indoor staff. In the evenings, before going to bed, Hemmings would take a tray of whisky and soda with two glasses into the Oak Room and take a drink with his employer. They would often talk late into the night, and on one such occasion Mr Gibbs remarked that he was considering remarriage, to which Hemmings quietly replied that he was thinking of doing the same. They both did as they planned – Hemmings in the local church at Wraxall, George Gibbs at St Margaret's, Westminster.

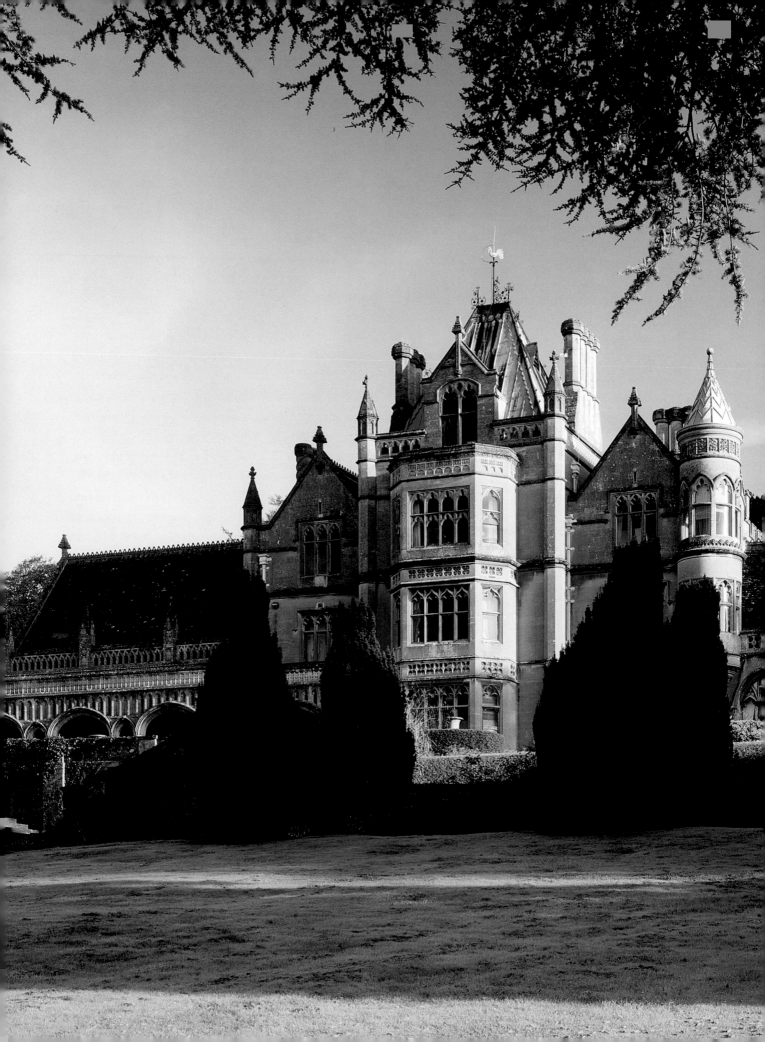

Tyntesfield Sustained

The marriage of George Gibbs to the Hon. Ursula Lawley may have been a match made in heaven. It was certainly made at Court. Ursula had been Maid of Honour to Queen Mary since 1912, and George Gibbs met her through his duties as Treasurer to the Royal Household. The King and Queen – naturally – attended their wedding on 21 July 1927, giving them a present of silver candlesticks. George had married a resourceful and intelligent bride. Her early life had been spent overseas with her parents, Sir Arthur Lawley, later 6th Lord Wenlock, and Annie, daughter of Sir Edward Cunard. Her father was an experienced colonial governor who, after acting as private secretary to his uncle, the Duke of Westminster, served in Matabeleland, Western Australia and the Transvaal before becoming Governor of Madras in 1905. Here young Ursula grew up in a hierarchical world where work and personal sacrifice went hand in hand with responsibility and reward. She was brave and capable. As it transpired, her talents were to prove invaluable for the future of Tyntesfield.

Her first talent, though, was to bear children and, within two years of marriage, two sons were born, Richard and Eustace, the Queen standing sponsor at the baptism of the elder. The nurseries were again reorganised. The Day and Night Nurseries were swapped over, allowing the two young boys to share a bedroom. Doreen, who was fourteen when her father remarried, moved along the corridor to the Marston Room. She and her stepmother liked and respected each other immediately, and their friendship endured for the rest of Ursula's life. Ursula's natural reserve did not initially endear her to all the Gibbses, who never abandoned that easy informality that had always been a family characteristic. When she was presented to them in London, 'She doesn't kiss' was the message that was passed quickly down the queue of relatives ascending the staircase – there was protocol to be followed. However, this slight distance was soon overcome and Ursula took her

Above: Victorian plant labels from the Conservatory.

Left: The Garden Front, Tyntesfield.

place amongst the cousinship of the family. She and George gave up the house in Belgrave Square and moved to 61 Eaton Square.

In 1928 George chose to retire from the House of Commons, relinquishing his Treasurership and his position as a Whip. In recognition of his long devotion to duty, he was made Baron Wraxall of Clyst St George, combining both his Somerset and his Devon roots – roots that had recently been researched and published in *The History of Antony and Dorothea Gibbs and their Contemporary Relatives* by John Arthur Gibbs, and *History of Gibbs of Fenton* by Herbert Cockayne, now Lord Hunsdon of Hunsdon. Both books contained extensive notes of the family's pedigree, and large genealogical trees celebrated the extent of the first Antony's numerous descendants. Lord Wraxall

The Hon. Ursula Lawley, later Lady Wraxall, in her wedding gown, designed by court dressmakers Handley Seymour, 1927.

George Abraham Gibbs in the uniform of the Treasurer to the Royal Household and carrying his wand of office.

retained the three battle-axes from the family's arms, still surrounded by a bordure nebuly, and chose as the supporters St Kilda's sheep, a reference to the breeding flock that Via had established at Tyntesfield. Retirement and marriage rekindled his interest in the family collection, and he started to buy again – jewels for his wife, including a dazzling diamond brooch in 1928, and a watercolour of his Oxford college by Joseph Nash for himself. In 1929 he acquired a fine Spanish table cabinet and the same year *A View of Amsterdam* by van de Velde. But just as life was gaining a new momentum, Lord Wraxall developed symptoms of throat cancer and within six months he died, on 28 October 1931.

Ursula did not retreat into protracted mourning, although she was unable to chaperone Doreen, who came out that year, attending 62

dances. She had two infant sons to care for and had to keep a tight grip on the reins of Tyntesfield. Running the estate was not to be an easy task, especially as the income from Antony Gibbs & Sons had sharply diminished. In the mid-1920s the race to make chemically manufactured nitrate-based fertiliser was won by the Germans, who could sell it at a price that undermined the economics of the South American imports. The collapse of Wall Street and the subsequent run on the London Stock Exchange did nothing for the wider prosperity of Antony Gibbs & Sons. For the first time, Tyntesfield had to look to the income from its own lands, with diminishing amounts coming in from elsewhere – a situation that was not to change over the following 70 years.

Ursula leaned heavily on the example of her own upbringing and on her experience at Court when she came to order life at Tyntesfield. Richard, her elder son and heir to the estate, was to be brought up to be aware of his position in society. Much was expected of him, there-fore courtesy was to be shown to him, and from infancy he was referred to as 'M'Lord', perhaps a daunting prospect for a boy of three. Hemmings, the butler, ignored this advice and called him 'Sir', just as he had always addressed his father. In 1934 Ursula arranged for

The Morning Room as arranged by Ursula, Lady Wraxall, with the historical portraits assembled by her father-in-law, Antony Gibbs.

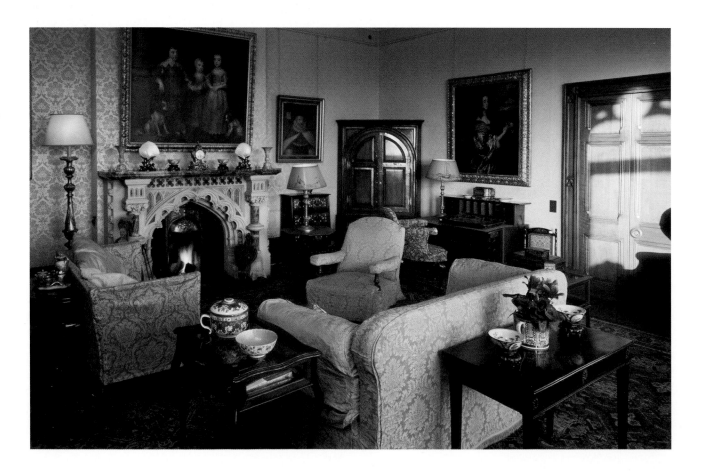

Richard, 2nd Baron Wraxall, as a boy, and his young brother, the Hon. Eustace Gibbs, with their baby cousin.

detailed inventories to be drawn up of the contents of Tyntesfield and 61 Eaton Square to establish what belonged to the young Lord; a separate list was prepared of her personal property.

In 1937 young Richard Wraxall was sent to preparatory school at Cothill, outside Oxford, where he was joined shortly afterwards by Eustace. Their mother took fresh eggs from Tyntesfield to supplement all the boys' meagre school diet. From there her sons went on to Eton, travelling home for holidays to a wartime Tyntesfield, full during term time with boarders from Clifton High School, Red Cross nurses assisting Ursula, and further members of the Gibbs family.

Ursula's father Lord Wenlock died in 1932. At the outbreak of war her mother moved to Tyntesfield, bringing with her mementoes of imperial rule. Lady Wenlock was a good amateur watercolourist, a talent she had deployed throughout her travels. With her husband she had also acquired objects associated with various postings, tribal artefacts from Matabeleland, and the ceremonial trappings for elephants from India. These were filtered into various rooms; the X-framed chairs by Messrs Smee, which had formerly seen service in a governor's residence in Perth, Western Australia, were now more humbly deployed amongst the upper guest bedrooms. Recent family portraits also arrived, edging their way along the Chapel corridor. And with the portraits came visits from more members of the family – Lady Wraxall's aunt Mrs Hay and, later, her sisters; Cecilia Dawson with her daughter Belinda. Hemmings the butler managed, with the help of a formidable parlour maid called Basset, to run the household with a diminishing number of ladies' maids, although the Servants' Hall was given up and the staff tended to use the Housekeeper's Room. Hemmings himself had the small mezzanine bedroom above the Butler's Pantry, where he would stay when the occasion demanded.

Ursula organised the house, the kitchen gardens, the woodland and the farms. The Oak Room became her office. She could pass easily from here through the false cupboard doors into the Morning Room, which she used as the principal sitting room. Gradually other ground-floor rooms were used less often, if at all, and some succumbed to dust-sheets. One casualty of these years was Norton's clock-tower – dry and wet rot broke out and in 1935 it was dismantled. With Lady Wraxall's usual competence the roofline was adjusted, the stonework altered and the roof's delicate metal spires, which had for so long adorned it, were carefully packed away in the outbuildings.

With the outbreak of war in 1939 came further disruptions. Like her predecessor, Ursula was a very active member of the Red Cross, becoming the Somerset president. During the war she ran the central hospital supply service for the Western Region, and the books were

evacuated from the Library to be replaced by bandages and medical equipment. Other evacuees, this time schoolgirls from Bristol, were found lodgings in other parts of the house. The cellars were used for storing the more vulnerable paintings, and as an air-raid shelter: Tyntesfield was at risk, as incendiary bombs were dropped by German planes targeting Bristol. Richard Wraxall found one of these in the garden, and walked into the house with it – to everyone's alarm. The small lake at the foot of the garden terraces, created by Antony, had to be drained as the moonlight it reflected might provide a useful beacon to enemy pilots. Its concrete base was subsequently cracked by the tremor of the bombs.

After the war, life returned to some degree of normality, though the London house was finally given up; it had been damaged in an air-raid. Its contents were brought to Tyntesfield and initially stored in the Chapel, cellars and stables. Rather incongruously, eighteenth-century mahogany side-tables were introduced into the Gothic Dining Room, but more appropriately the London Regency glass chandeliers were hung in the Drawing Room. Ursula also had Antony's elaborate Gothic cabinets in the Vestibule removed to the garden corridor. A small

Above: The original Day Nursery, which was converted into a Night Nursery for Lord Wraxall and his brother Eustace in the early 1930s.

Right: A family bear.

auction was held of extraneous furniture in late 1945. It took place on a Saturday morning with one hour of viewing and one hour of clearance. Sadly, amongst the lines of wash-stands and grass-cutting machinery was one of Crace's better tables, one of the few important pieces of furniture to leave the collection. William Gibbs's fine Broadwood piano also went under the hammer, although its matching stool remains in the house.

Lady Wraxall was now approaching 60 but showed no signs of slackening, nor of passing on the running of the estate to Richard. After he left Eton in 1946, Richard followed the path long pre-ordained by his father, and joined the Coldstream Guards, doing eight years' army service, posted for part of the time in North Africa. He took to the life, showed industry and enterprise and, despite pleas to come home, remained at his postings. Eustace, on leaving Eton and completing his national service in the Coldstream Guards, followed his father's example and went to Christ Church. On coming down from Oxford he contemplated a career in music, attending the Royal College of Music, where he surprised nobody but himself in brilliantly passing his ARCM exams in 1954 with over 90 per cent. It was clear that

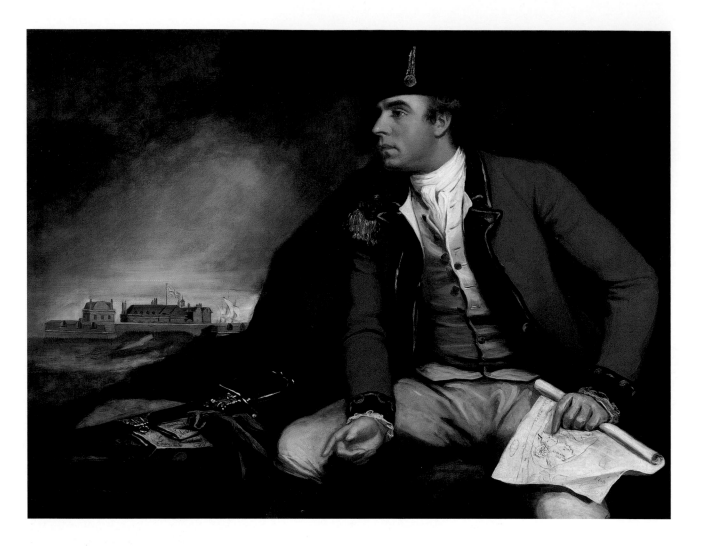

William's talent for singing, Blanche's dexterity on the harp and Antony's brilliance on the organ had found yet another musical outlet. From Christ Church, Eustace entered the diplomatic service and his career would range as far afield as his maternal grandfather's – Europe, South-East Asia and South America.

Whilst his brother's life was spent largely abroad, Richard settled permanently at Tyntesfield on leaving the army. Here he was to live continuously for almost fifty years, longer than any of his predecessors. The house that had been created by his ancestors and, remarkably, maintained by his mother was to be the background of his entire adult life. Slowly, decade by decade, it became his shell, almost a refuge from the outside world. It is not that he was a recluse, but that Tyntesfield was all that he could wish for.

Initially he sought to help his mother to run the estate, but she tended 'to know best' and it proved difficult for her to hand over the reins. Nevertheless, certain areas did become his preserve, notably the shooting and the woodlands, where he maintained traditional high

Sir Thomas Hyde Page by James Northcote, RA, which originally hung in the great hall at Flaxley Abbey. This ancestral portrait of the Crawley-Boeveys was bought by the 2nd Lord Wraxall.

standards, seeking to preserve and renew the works of his predecessors. He became a knowledgeable dendrologist and a good judge of cattle, invariably buying his own stock at the local markets. He also exhibited regularly at the Bath and West Show. In local affairs he also played his part – Chairman of the North Somerset Conservative Association and an active supporter of the Scouts. His contributions at meetings have been remembered as always commanding, although often controversial.

It was Richard's involvement with the Wells Cathedral Preservation Trust that led him to open the house and grounds on 8 October 1978 to paying visitors whose entrance fees benefited the Trust. This was a rare opportunity to see the estate that had, by that time, almost disappeared from public view. Its special souvenir programme, entitled *The Victorian House*, was largely written by Lord Wraxall. In the introduction he noted that: 'The house and garden bought at the time of his marriage are substantially the same as they were left by my great-grandfather one hundred years ago, after he had enlarged them both. Each generation of my family has enjoyed living here ever since.'[1] In the ensuing pages, the house, Chapel and garden were described with understandable pride. It is in the description of the garden that one gets the clearest sense of Richard Wraxall's commitment to continuity: 'To keep the garden full of variety, you will see young trees planted: New Zealand Beech, variegated Sycamore, flowering cherries and quince, golden Laburnum, Hemlock and Mimosa to name but a few. The weather, old age and disease produce inevitable gaps in the collection but we try and renew them with species of various sizes and colours.'[2] What visitors saw was a house and garden maintained to almost Edwardian standards of upkeep: rooms sheltered behind blinds, dust-sheets protecting the furniture; bedding-out and topiary on the terraces; and fully functioning hot-houses, with lines of vegetables parading in the walled garden beyond.

Richard Wraxall was also an enthusiastic collector, acquiring yet further pictures and porcelain. He had a particular penchant for English landscapes, and acquired works by William Marlow, Richard Wilson, Samuel Scott and Alexander Nasmyth. Two pictures in particular were bought on account of family associations. The *Panorama of Seville* by Manuel Barron y Carrillo had been painted in 1844 shortly before Richard's great-grandfather had visited the city for the last time, and depicts Seville as he would have known it. The portrait of Sir Thomas Hyde Page by James Northcote had two family connections. The painting was of a distant ancestor, and it had hung earlier at Flaxley Abbey. The portrait shows the sitter holding plans inscribed 'Townsend, Amhurst and Landguard Forts', a reference to his

celebrated engineering work at these garrisons on the south coast, carried out in the 1780s, when he managed to supply them with fresh water.

The upkeep of Tyntesfield took its toll on the collection, and found lying on a shelf in the basement after Lord Wraxall's death were two files, one inscribed 'Bought', the other, rather fatter, 'Sold'. The greatest loss was Turner's *Temple of Jupiter at Aegina Restored*, bought by Antony. During later years, sales from the collection became the easiest way to pay for necessary repairs and to cope with the rising cost of running the estate.

There was a definite sense in the years following Lady Wraxall's death in 1979 of the house closing in on itself. Richard had tried agricultural initiatives with pigs and chickens but these did not work, and the finances of the estate became less easy to balance. Nevertheless, shooting parties were a regular occurrence, even though guests were sometimes served steak and kidney pies still in their manufacturer's tins. The house was still 'home' to the family and when Doreen's and, later, Eustace's children were unable to join their parents abroad during school holidays, it was first Ursula and then Richard who welcomed them to Tyntesfield. Increasingly, however, this was only to some of the house, as certain doors would be locked and parts of the great building seemed out of bounds. Slowly, and rather inevitably, more distant rooms were left untouched and Lord Wraxall's life, spent behind a barrage of security alarms, began to oscillate between the Oak Study, the Dining Room and his one small bedroom. This, perhaps the plainest room in the whole house, had originally been his father's Dressing Room. It was here he hung his prints of the Coldstream Guards, recalling perhaps happier years, and it was here he was to die unexpectedly in July 2001.

Richard Wraxall knew he would be the last member of his family to own Tyntesfield. The diminishing income had not proved sufficient to keep up the estate, and still less would it be able to cope with the demands of inheritance tax. Some years earlier, with his brother's knowledge, he had drawn up a will leaving the estate to all his father's descendants – nineteen in total by 2001. This would inevitably mean that Tyntesfield would be sold; the house, and its collection, the estate and its way of life would come to an abrupt end. His executors were faced with this daunting task, and in the autumn of 2001 the quiet routine of the house was shattered as a stream of people came and went, giving advice on a myriad of subjects. Richard Wraxall's nephews and nieces, the people who had so enjoyed staying at Tyntesfield during their school holidays, took over the daily running of the house. Victoria Eyre, with her cousin Miranda Joliffe and her brothers

Tyntesfield seen from the air.

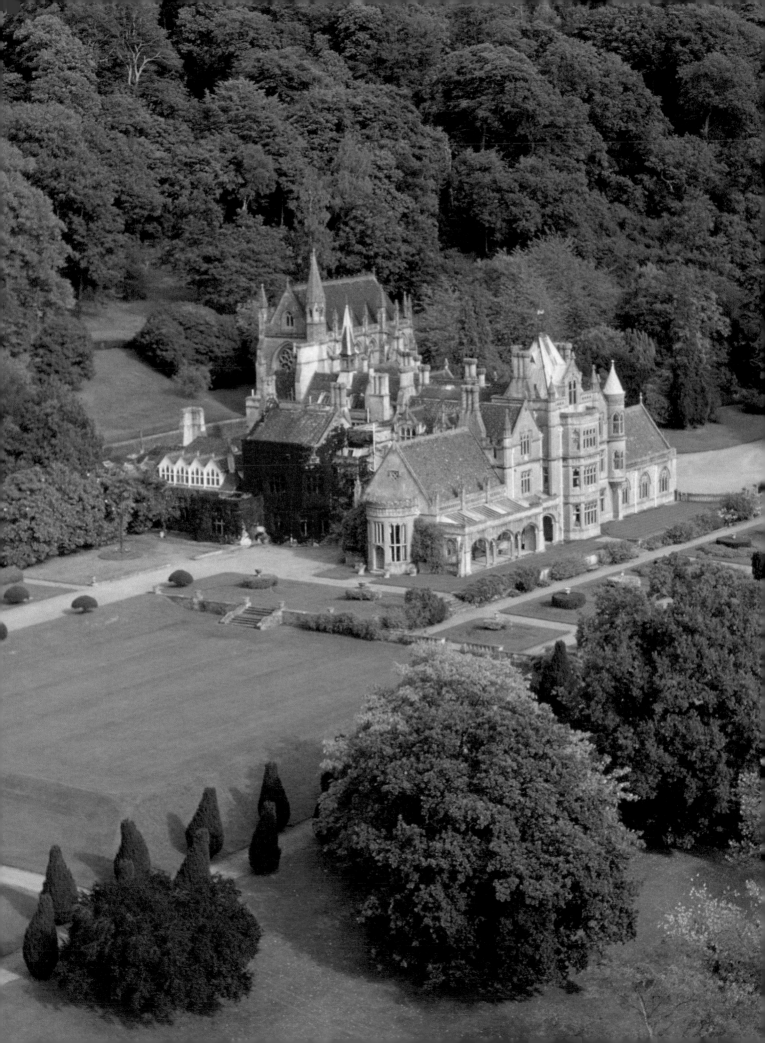

The woodland summer-house.

Andrew and Jonathan Gibbs, welcomed the fast-flowing stream of 'experts' together with members of the family who, conscious of what was happening, came to visit 'dear old Tyntesfield' once more. In the midst of all this sat Lord Wraxall's inspirational half-sister, Doreen. Although approaching ninety she had all the vim and vigour of the Gibbs family, and threw herself into question-and-answer sessions with the liveliness of someone half her age.

Valuers were everywhere. On the estate, fields were assessed, barns measured, and details taken of plantations, cottages and rights of way. In the house, all the contents were inspected and labelled, assessed and photographed. A group of cataloguers stopped in front of the Dining Room sideboard, scratching their heads, trying to decide when it was made (rather unusually it dates from two distinct periods, only 25 years apart). In the basement unlikely objects emerged – in one corner were stacked canopies for the Oratory organ, while in a box gilt incense-burners in the form of peacocks cried out for attention. It soon became apparent that not only was the collection extraordinary in its range and quality, but it was also remarkably intact. The majority of the works of art had survived the vicissitudes of changing tastes, as had

the ephemera of daily life. Still hanging from the lines in the Drying Room were dozens of stocking-stretchers, while in the corridor below a large chest opened to reveal the medicines required to stem family illnesses in the nineteenth century. Nearby hung plaster models of the Alhambra, and in cupboards lurked micro-mosaics brought back from Rome, souvenirs of the family's travels. Ancient hunting boots lined the Gunroom walls, and even the rugs, which had been tucked around the family as they journeyed by rail up to London, appeared out of the hall chests. Perhaps the oddest thing was Vicary Gibbs's tabard, worn on his official visit to Spain to present the King with the Order of the Garter, preserved as a glazed firescreen. The air was alive with whys, whats, hows and whens, as the shifting shoals of experts tackled the huge task of identifying everything. The realisation also dawned that everything was intrinsically interconnected with the history of this remarkable family, and the building and rebuilding of their house.

These discoveries might even have surprised the National Trust and their advisers. The importance of Tyntesfield had long been recognised, but the completeness of the collection was hardly to be anticipated. In the mid-1970s the eminent architectural historian Mark Girouard had visited the house and subsequently devoted a chapter to it in the second edition of his ground-breaking *The Victorian Country House*. At this early stage there had been a consciousness of its architectural merits and the fascinating history that lay locked in its collection. As a consequence the estate was registered on the Trust's list of places that should be 'saved' if their future was ever in doubt. Tyntesfield's position reflected, of course, its own importance, but also the sad truth that of the twenty or so great Gothic houses built in Britain between 1840 and 1880 all but Tyntesfield had been radically altered, stripped of their collections, or simply given up. Pugin and Crace's Alton Towers in Staffordshire had become an amusement park, Waterhouse's Eaton Hall in Cheshire had been demolished, Gilbert Scott's Kelham Hall in Nottinghamshire had become a school, and others had been transformed into prisons, mental hospitals and Buddhist centres. Was this the fate that might await Tyntesfield? Certainly not, if the National Trust could help it, although the problems attached to such an undertaking seemed at times to be insurmountable. The executors had a legal obligation to obtain the highest possible price, and this had to be achieved within a year. There was also no hope of a financial endowment. Not daunted, Fiona Reynolds, the relatively new Director-General of the Trust, and her staff felt the house was so important that a rescue attempt had to be mounted.

During the winter months the National Trust's committees assessed the house and its estate to establish what would be involved if the

organisation took it on, and what the likely costs would be. This hard-headed approach was essential, as it laid the basis for what was to follow. It was, however, matched from the beginning by an enthusiasm that was clearly contagious. Experts in every conceivable field kept reporting back to the Trust's London offices in Queen Anne's Gate with their findings, sprinkling their comments with the words 'fascinating', 'intact', 'important' and 'without parallel'. External bodies such as English Heritage and the Victorian Society visited and, in their turn, echoed this enthusiasm.

But enthusiasm alone would not secure Tyntesfield. What was needed was money, and lots of it. The Trust had access to some funds, but these were insignificant compared to what would have to be raised. It would have to rely heavily on a grant from the National Heritage Memorial Fund, a fund of 'last resort' providing grants for buying objects that are of outstanding interest and importance to the national heritage. The visit of its chair, Liz Forgan, together with the chief executive, Anthea Case, was therefore crucial. They had read the reports, been thoroughly briefed and were aware of the likely magnitude of the grant that would be needed. Appropriately, they arrived by Mr Gibbs's Great Western Railway and drove out from Bristol, just as he would have done, along the valley. It was a beautiful spring day, and Tyntesfield glistened in the sunlight. Their tour could not have been more thorough – from the cellars to the roofline, from the pleasure grounds to the decaying farm buildings. Walking back up to the house from the park it became apparent that no special pleading would have to be made. Clearly, if the National Heritage Memorial Fund existed for anything, it existed for Tyntesfield. However, time to raise the funds was needed, and time was slipping away. The property would be placed on the market within a month, and by mid-June the executors, having studied the alternative bids, would arrive at their decision: either a private sale of the house and an auction of the contents, or the acceptance of a bid from the National Trust.

SAVE Britain's Heritage, the architectural ginger group led by Marcus Binney and Andrew Wilkinson, formed a small committee to raise public awareness. Here the resourcefulness of a group of eminent art historians and connoisseurs, including Christopher Gibbs, Mark Girouard, John Harris, Richard Holder, Tim Knox and Dr John Martin Robinson was harnessed. Within weeks, articles appeared in the daily papers and in a host of periodicals including *Country Life*, friends in high places were lobbied, and slowly the fate of Tyntesfield became the public's concern. SAVE itself published *The Tyntesfield Emergency* – it was a battle cry to encourage all heritage bodies to rally around the campaign, and it worked. The Trust launched its own

A pair of American silver-gilt filigree peacock incense-burners made in Ayaucho, Peru, in the first half of the nineteenth century.

appeal and the effect was overwhelming. More than 70,000 people donated a total of over £3 million, making it the most successful of all their appeals. A small steering committee led by Martyn Heighton, director of the area, was simultaneously formed to co-ordinate the Trust's bid. Working tirelessly with Tim Knox, Merlin Waterson, Simon Jervis and John McVerry from the historic buildings department of the National Trust, assisted by their agents Sotheby's and Knight Frank, the committee refined their offer and, with the last-minute help of the Treasury, taking advantage of tax legislation regarding sales to national bodies, the bid was ready.

On 14 June 2002, the final negotiation commenced. The National Heritage Memorial Fund had pledged an outstanding £17.4 million and further substantial sums had been raised by the public appeal, significant private donations, and from the National Art Collections Fund. Nevertheless, nothing could be taken for granted. There were still formidable potential obstacles. The art market was extremely buoyant and other buyers had emerged to acquire the property itself. The executors remained insistent that the Trust's bid had to be the best financial offer. There was, however, goodwill on both sides. After

nearly 26 hours of continuous negotiation through the teams of lawyers, a deal was finally struck. It was not without its more unusual moments. A phone call at 5am to determine the likely individual value of altar frontals would perhaps have appealed to William Gibbs the businessman, but might have shocked William Gibbs the philanthropist.

Tyntesfield was secured. In that instant the world of Anthony Trollope, Charlotte M. Yonge and even John Galsworthy was made a physical reality for all time. For, while the estate is a private kingdom, reflecting the history, architecture, business life, taste and religious aspirations of one family, it is also a reflection of English life, generation by generation, over nearly two hundred years. In retrospect it seems incredible that its survival was ever in doubt. Certainly future generations will owe a debt to the National Trust and its supporters for Tyntesfield's salvation, but an even greater debt to William Gibbs and his successors for its creation and preservation.

John Norton's summer-house in the rose garden, decorated with Minton tiles.

Notes

An Unlikely Undertaking

1. John Lomax Gibbs, 'Reminiscences of John Lomax Gibbs 1832–1914' (unpublished memoir), p.2.

The Money

1. *The History of Antony and Dorothea Gibbs and of their contemporary relatives*, John Arthur Gibbs (1922).
2. E.M.G. writing in the *Manchester Guardian*, 1875, taken from *In Memoriam* (privately printed 1875, following William Gibbs's death).
3. John Lomax Gibbs, 'Reminiscences', pp.15–17.

A Country Estate

1. 'Painting etc done at Tyntesfield House near Bristol submitted to William Gibbs Esqre., John G. Crace, 16 Wigmore Street', 1854.
2. 'Painting etc done at Tyntesfield House near Bristol submitted to William Gibbs Esqre., John G. Crace, 16 Wigmore Street', 1855.
3. '1855–6 Upholstery Work done at Tyntesfield near Bristol, John G. Crace, 16 Wigmore Street'.
4. William Gibbs's Diary, 5 January 1856 and 13 October 1856.
5. William Gibbs's Diary, 24 November 1853 and 14 December 1853.
6. William Gibbs's Diary, 1 November 1853.
7. Henry Eckford's correspondence with William Gibbs, 1859.

Tyntesfield Rebuilt

1. William Gibbs's Diary, 14 December 1865.
2. William Gibbs's Diary, 2 November 1865.
3. The most notable of these churches are those of St Matthias in the West (1851) and St John's (1856), both in the purlieus of Bristol; St Audrey's, West Quantoxhead (1850); Holy Trinity, Stapleton (1857); St John the Evangelist, Highbridge (1858–9); St Mary Magdalene, Stoke Bishop (1860–4); St Luke's, Bedminster (1861); St Nicholas, Kilton (1862); St Anne's, Hewish (1864); Holy Trinity, Walton (1866); Emmanuel, Clifton (1865–8); and St Andrew's, Bridgwater (1870).
4. William Gibbs's Diary, 21 August 1860.
5. William Gibbs's Diary, 13 March 1861.
6. John Lomax Gibbs, 'Reminiscences', 1862.
7. *The Builder*, February 1866, p.99.
8. William Gibbs's Diary, June 1864.
9. William Gibbs's Diary, December 1865.
10. William Gibbs's Diary, September 1866.
11. *The Builder*, February 1866, pp.99–101.
12. John Ruskin, referring to the Oxford Museum, in 1859.
13. Archive accounts.

Detail of the shutters in the Drawing Room, with carving by James Plucknett.

14. *The Builder*, February 1866, pp.99–101.
15. Christobel Coleridge, *Charlotte Mary Yonge* (1903), p.310.
16. *The Builder*, February 1866, p.99.
17. *The Builder*, February 1866, pp.99–101.
18. Robert Kerr, FRIBA, *The Gentleman's House: or How to Plan English Residences from the Parsonage to the Palace* (London, 1864), p.99, cited in Mark Girouard, *The Victorian Country House* (Yale University Press, New Haven and London, 1979).

The Philanthropist at Work
1. John Lomax Gibbs, 'Reminiscences', 1862.
2. John Lomax Gibbs, 'Reminiscences', pp.44–5.
3. Christobel Coleridge, *Charlotte Mary Yonge* (1903), pp.309–10.
4. William Gibbs's Diary, 14 June 1870.
5. William Gibbs's Diary, 15 July 1872.
6. Correspondence in the Gibbs family archive.
7. 'Immortal, Invisible, God Only Wise', Robert Grant, *Hymns Ancient and Modern*.
8. William Gibbs's Diary, 19 December 1872.
9. Sir Arthur Elton's Diary, 3 April 1875.
10. Book of Proverbs, xvi, 31.

Tyntesfield Remodelled
1. John Lomax Gibbs, 'Reminiscences', p. 68.
2. John Lomax Gibbs, 'Reminiscences', 1862.
3. Antony Gibbs to Janet Merivale from 16 Hyde Park Gardens, letter headed 'Saturday'.
4. Antony Gibbs to Janet Merivale from 16 Hyde Park Gardens, 24 April 1871.
5. Melanie Hall. 'James Plucknett of Warwick and Leamington Spa', *Furniture History Society*, 1996, pp.159–78.
6. Brindley's account, Gibbs family archive.
7. Antony Gibbs's Diaries, 30 May 1890.
8. Newton's account, Gibbs family archive.
9. 'Antony Gibbs, Esq., MA, CA, JP', *Somersetshire Lives* (C.A.M. Press, undated).

Tyntesfield Improved
1. 'Lord Wraxall, Conservative whip and country gentleman' (obituary), *The Times*, 30 October 1931, p.7.
2. Madeline Alston, *Via Gibbs* (1921), her entry on the year 1907.
3. Madeline Alston, *Via Gibbs* (1921), pp.11–12.
4. Hammond & Sons' account, Gibbs family archive.
5. Madeline Alston, *Via Gibbs* (1921), p.13.
6. A note attached to the reverse of the painting.
7. Madeline Alston, *Via Gibbs* (1921), postscript.
8. 'Lord Wraxall, Conservative whip and country gentleman' (obituary), *The Times*, 30 October 1931, p.7.

Tyntesfield Sustained
1. *A Victorian Garden Day at Tyntesfield, Wraxall, Bristol, in aid of Wells Cathedral Preservation Trust – Woodsprings Committee* (1978), p.2.
2. *A Victorian Garden Day at Tyntesfield, Wraxall, Bristol, in aid of Wells Cathedral Preservation Trust – Woodsprings Committee* (1978), p.11.

Bibliography

'A Capital Fellow and a Serious Fellow Too: A Brief Account of the Life and Work of Henry Woodyer, 1816-1896', *Architectural History*, Anthony Quiney, no.38, 1965, pp.192-219

'Aldenham House, Hertfordshire, The Residence of The Hon. Vicary Gibbs', *Country Life*, anon., 23 February 1924, pp.282–90

Alumini Cantabrigienses, compiled by J. A. Venn, 1953

Alumini Oxonienses, compiled by Joseph Foster, 1888

Anglo-Peruvian commercial and financial relations 1820-1865 with special reference to Antony Gibbs and Sons and the guano trade, W. M. Mathew, 1964

Antony Gibbs & Sons Limited, Jones (forename unknown), 1958

'Antony Gibbs, Esq., MA, CA, JP', *Somersetshire Lives*, C.A.M. Press, undated

Charlotte Mary Yonge, Christobel Coleridge, 1903

The Church of St Michael & All Angels Exeter: A Short History and Guide

The Craces: Royal Decorators 1768-1899, edited by Megan Aldrich, 1990

Crockford's Clerical Directory for 1880, London, 1880

Diaries of Sir Arthur Elton, unpublished manuscript

Diaries of Antony Gibbs, unpublished manuscript

Diaries of William Gibbs, unpublished manuscript

Gibbs family correspondence, unpublished

Guano: The Analysis and Effects Illustrated by the Latest Experiments, William Clowes & Sons, 1843

A Guide to Lancing Chapel, published by the Hove Shirley Press, n.d.

The History of Antony and Dorothea Gibbs and of their Contemporary Relatives, John Arthur Gibbs, 1922

History of Gibbs of Fenton, in Dartington, County Devon, Herbert Cockayne. Baron Hunsdon, 1925

'James Plucknett of Warwick and Leamington Spa', *Furniture History Society*, Melanie Hall, Vol. XXXII, 1996, pp.159–78

Merchants and Bankers. A brief record of Antony Gibbs & Sons and its associated houses' business during 150 years, 1808-1958, compiled by Wilfred Maude

'Ormson's Conservatory', *The Gardeners' Weekly Magazine*, Vol. IV, Jan.–Dec. 1862

'Ormson's Paradigm Hothouse', *The Florist and Pomologist*, June 1967

'Reminiscences of John Lomax Gibbs 1832–1914', unpublished manuscript

'Tyntesfield House, Flax Bourton, The Seat of Mr. Antony Gibbs', *Country Life*, anon., 17 May 1902, pp.624–9

'Tyntesfield House, Near Bristol, Somerset', *The Builder*, 10 February 1866, pp.99–101

'Tyntesfield, Somerset', *West Country Houses. An illustrated account of some country houses and their owners, in the counties of Bristol, Gloucester, Somerset and Wiltshire*, Robert Cooke, 1957

'Vicary Gibbs', entry in *The Complete Peerage*, originally written by George Edward Cockayne, 1887–9, revised vols. I–IV

The Victorian Country House, Mark Girouard, 1979

A Victorian Garden Day at Tyntesfield, Wraxall, Bristol, in aid of Wells Cathedral Preservation Trust – Woodsprings Committee, 1978

Via Gibbs, Madeline Alston, 1921

Picture credits

Pictures are listed by page number, and have been reproduced by permission of the sources shown.

Ken Adlard: 38

Country Life Picture Library: 34, 65, 81, 103, 136, 137; Paul Barker 100, 132–33

Conway Library, Courtauld Institute of Art: 107

Gibbs Family Archive: 63, 75, 87, 103, 117, 152, 162, 163

by courtesy of The London Library: 96

Mary Evans Picture Library: 30–31

Derry Moore: 80, 105

National Maritime Museum, London: 32

National Trust Photographic Library: 85; Andrew Butler 6, 10–11, 108, 160; Martin Chainey 176; John Hammond 14–15, 18, 21 (x 2), 25, 27, 28, 40 (x 2), 43, 50, 51, 53, 55 (x 3), 56, 70, 77, 94, 98 (x 2), 112 (right), 113, 119 (left), 120 (x 2), 145, 146, 147, 178; Nadia Mackenzie 5, 19, 84, 86, 88, 121, 124, 161, 167; John Millar 46, 47, 82, 141, 149; James and Charles O'Reardon 148 (right), 157, 158, 159, 165; Steve Stephens 17, 58, 64, 69, 71, 73, 78, 102, 109, 111, 128–29, 130, 134, 135, 138, 139, 164, 171, 172; Andreas von Einsiedel 166

Royal Institute of British Architects: 60–61, 67, endpapers

Sotheby's: 29

SS Great Britain Trust: 36